Book about Female Type Designers

Edition 2

by Yulia Popova
2021

Amélie Bonet	Gayaneh Bagdasaryan	Émilie Aurat
Sabina Chipară	Nadine Chahine	Veronika Burian
Noopur Datye	Fernanda Cozzi	Joana Correia
Louise Fili	Maria Doreuli	Petra Dočekalová
Kimya Gandhi	Louisa Fröhlich	Mona Franz
Minjoo Ham	Carolina Giovagnoli	Roxane Gataud

TYPE DESIGNERS

PHOTO CREDITS ON PAGE 319

Noheul Lee Alexandra Korolkova Golnar Kat Rahmani

Sol Matas Zuzana Licko Tien-Min Liao

Elena Novoselova Ryoko Nishizuka Laura Meseguer

Mariya V. Pigoulevskaya Daria Petrova Diana Ovezea

Alice Savoie Fiona Ross Inga Plönnigs

Cymone Wilder Irene Vlachou Liron Lavi Turkenich

Table of content

Prologue ... 09

Chapter A
Biographies of Designers ... 13

Chapter B
Research on Gender Issues in Type Design ... 37
Numbers and Data ... 39
Women in Type ... 47

Chapter C
Early Female Type Designers ... 59
Endnotes ... 80

Chapter D
Interviews with Designers ... 89
Gayaneh Bagdasaryan ... 91
Veronika Burian ... 101
Maria Doreuli ... 113
Louise Fili ... 121
Martina Flor ... 127
Loraine Furter ... 133
Jenna Gesse ... 145
Golnar Kat Rahmani ... 151
Indra Kupferschmid ... 165
Briar Levit ... 179
Zuzana Licko ... 187
Ana Regidor ... 195
Fiona Ross ... 203
Carol Wahler ... 211

Chapter E
Showcase of Typefaces ... 219

Colophon ... 319

Prologue

"It is urgent to acknowledge the gender imbalance as it limits competitiveness in a global technological society. The greatest impact of women's absence from the world of type design may be on the success of typography as a discipline and its influence on society. Currently, the field is not in a position to draw on a pool of talent from the entire population."[1]

In 2017 I attended the TYPO Berlin conference. My interest at that time was focused on several areas of design, particularly on typography and gender in design. This combination of topics has appealed to me since my bachelor thesis. Therefore, I could not help but notice that the percentage of female speakers at the conference was quite low. Indeed, in 2017 only 29% of speakers were female.

Subsequently, I did some quick research and stumbled upon the webpage Yesequal.us created by Isabel Urbina Peña in 2015. Isabel decided to put this page together after her friend, Lila Symons, sparked a heavy discussion about the equality in type design by tweeting the following: "I just looked at the main conference schedule for @typecon and barely any women are speaking. Seriously, what's up with that?!" As a response to this debate, Isabel decided to gather some numbers. She collected information about the female/male ratio of students in the top US art schools, winners and judges of creative awards, and speakers at graphic design and typography conferences. A very general summary of this data would be that 55-70% of people studying art are women.[2] Nonetheless, there is a very small percentage of women who are the winners of design and type competitions, judges at these competitions, speakers at conferences and members of boards of directors. This looked like a paradox to me and I decided to dig into this issue.

My further research on this topic brought me

to the article "Where Are the Women in Type Design?" written by Verena Gerlach, a type designer, in 2011. It was published on Typographica.org. In this article, Verena talks about possible reasons why we see fewer women than men in type design. The article itself is only about 600 words long, yet it became a starting point for a longer discussion in the comments. One of the comments belonged to Julia Kahl, a co-owner of the company Slanted Publishers, which she runs together with Lars Harmsen. She wrote about her experiences releasing the Slanted magazine's 12th issue in 2010 titled "Beat That If You Can! Women, Typography, Graphic Design". She wrote, "It is obvious that women are less visible in the visual field (typography and other design fields) than men. It is astonishing, I think, because there are a lot of female students. The fact is that we did not have any problems finding an incredible amount of high-quality projects by women. The fact is also that we recognized that there were only a few women featured in the magazines before—without us thinking of the gender when choosing the projects […] So we made this a women issue."[3] It seemed odd to me that Julia had been working in this industry for a while and never noticed this problem. As a result, I wanted to inspect other typographic literature on this matter. The first book I decided to investigate was *The Elements of Typographic Style* by Robert Bringhurst. It was the 4th edition, to be more precise the 4.2 edition, published in 2016. This book is recommended as a must read for designers and is called "the Typographers' Bible". It had an Appendix where all the type designers mentioned in the book were listed.[4] Out of the total 115 designers only 3 were women. Why were there so few? Were there no women in type? Were they not good enough? And if there were some, why aren't they in these books? On the back cover of *The Elements of Typographic Style* it said, "All desktop typographers should study this book. […] It is, instead, a must for everyone in the graphic arts." Another book that caught my interest

was the *YEAR BOOK of TYPE 2* edited by Slanted Publishers and Julia Kahl as Creative Director. The book was published in 2016 and I was quite enthusiastic for a moment. The total amount of all type designers presented in it was 155[5]. Only 30 were women. From just reading the title, I assumed that this book was a collection of typefaces that were released in 2016. I thought that perhaps the reason for the missing women, was that not enough typefaces were released by women that year. After another quick glance it appeared that the book included typefaces dating back to 2013. As it could be seen from Julia's comment under Gerlach's article, she was familiar with this problem in 2010 and she said that they did not have any problem finding "an incredible amount of high-quality projects by women". So why were they not in the book dating back to 2016? These findings urged me to explore why typefaces designed by women are not well-known. Are there really fewer women in type design than men? Could it be possible that there are plenty of them and we just do not see them or maybe that we are not looking for them?

 My goal in this project is not to produce a theoretical work based on the feminist and gender theory, nor do I want to provide an exhaustive explanation to the current situation. My intention is to search for possible social, cultural and historical factors that might have had an influence on the career of women in type design. In this book, firstly, I will look into some works dealing with possible reasons behind the scarcity of female type designers. The next step is interviews with women currently working in the typographic field with the intention to get a point of view of the professionals in the industry. In addition, I will put together a collection of works by talented type designers to demonstrate the existence of a broad variety of typefaces designed by women. My objective is to make the work of women more visible. Lastly, this project's aim is not to create an editable database of female type designers as such lists already ex-

PROLOGUE

ist. Rather, my intention for it is to become a sort of documentation of the state we are in in 2019. This is a very rich field for academic investigation and I am excited to contribute to it. I would like to acknowledge the contributions and assistance of: Prof. Wim Westerveld, Dan Reynolds, Florian Hardwig, Jan Middendorp, Indra Kupferschmid and other people supporting me in this project.

Chapter A

Biographies of Designers

Biographies of Designers

The following chapter presents a collection of biographies from female type designers who contributed to this book.

Aa

AURAT, ÉMILIE

Émilie Aurat is a French graphic and type designer. Interested in African legacy issues, she studied at the Atelier National de Recherche Typographique based in Nancy, France, and its Missing Scripts program in 2018. She investigated the African and Creolian diasporas' writing systems, and the social impact of their integration in Unicode. With a militant approach, she inspired herself by the genealogy of this writing system from the African continent, and their contexts of creation in order to propose forms adapted to their valorisation.

Bb

BAGDASARYAN, GAYANEH

A graduate of the Moscow State University of Printing Arts, Gayaneh has designed Cyrillic localizations for most major type libraries, including Linotype, Bitstream, The Font Bureau, ITC, Berthold, Typotheque, Emigre, and ParaType. She began her type design career at ParaType in 1996 and started Brownfox in 2012. Her work has won awards from a number of international type design competitions, including Kyrillitsa'99, TDC² 2000, and Granshan 2013. Gayaneh is the mastermind behind Serebro Nabora, a prominent annual international type conference held in Russia.
www.brownfox.org

BERNET, SELINA

Selina is a graphic and type designer from St. Gallen, Switzerland. After graduating from Bern University of the Arts in Visual Communication she spent one year living and working in Buenos Aires, then undertook internships in Reykjavik and Berlin. She holds a Master of Design in Type and Media from the Royal Academy of Art, The Hague. Selina currently lives and works in Zurich as part of Studio Laurenz Brunner.
www.selinabernet.ch

BONET, AMÉLIE

Amélie is a French freelance type designer and font engineer, based in Berlin. She has previously worked for Dalton Maag as Senior Designer and for Monotype as Font Engineer. She developed a passion for type design with a focus on Indic scripts during her master's studies at the University of Reading, UK. Amélie has worked on several projects involving various writing systems, such as Bengali, Cyrillic, Devanagari, Georgian, Greek, Tamil. Her design, Nokia Pure Bengali received an award at the Granshan competition in 2014. Amélie also expands her practice of type to stone carving, lettering and calligraphy.
www.ameliebonet.com

BURIAN, VERONIKA

Veronika Burian studied Industrial Design and worked in this field in Vienna and Milan for a few years. Discovering her true passion for type, she graduated from the MA program in Typeface Design in Reading, UK, in 2003 and worked as a type designer at DaltonMaag in London for a few years. After staying for some time in Boulder, USA, and then her hometown Prague she is now enjoying life in sunny Cataluña. Veronika is a co-founder of the independent type foundry TypeTogether, publishing award-winning typefaces and collaborating on tailored projects for a variety of clients.
www.type-together.com

Cc

CHAHINE, NADINE

Dr. Nadine Chahine is an award-winning Lebanese type designer. She has an MA in Typeface Design from the University of Reading, UK, and a PhD from Leiden University, The Netherlands. She has two Awards for Excellence in Type Design from the TDC in New York in 2008 and 2011. Nadine's work has been featured in the 5th edition of Megg's History of Graphic Design and in 2012 she was selected by Fast Company as one of its 100 Most Creative People in Business. In 2016 her work was showcased in the 4th edition of First Choice which highlights the work of the 250 top global designers. In 2017, Nadine was selected by Creative Review as one of their Creative Leaders 50.
www.arabictype.com

CHIPARĂ, SABINA

Born near the seaside in Constanța, Romania, Sabina Chipară moved to Bucharest to study graphic design at the National University of Arts. Curious about letter shapes she started on a discovery journey that took her to Barcelona for her Advanced Typography Master's degree at EINA University, to London as a Monotype intern and Amsterdam as a freelance type and graphic designer.

While working as an in-house typographer for a package design studio creating letterings, logotypes and corporate display typefaces for various products she realized the importance and benefits of design features that make a typeface stand out. Now, she designs her own typefaces with a little twist, looking for smooth curves and sharp edges.
www.sabinakipara.com

CORREIA, JOANA

Nova Type was founded in Porto, Portugal in 2018 by Joana Correia, an already well-established and multi-award winning type designer. She creates

warm and vocal retail fonts and also leads other talented type designers toward successful releases. Their design collaborators and customers enjoy equal footing, and they spend concerted time and energy to mentor and educate those who they are interacting with.

Many font companies are run like a mere business machine, but the aim at Nova Type is to be an independent font foundry that cultivates authenticity—in trusted partnerships, in educational mentorship, in customer relationships, and, of course, in font design.
www.novatypefoundry.com

COZZI, FERNANDA

Talkative and passionate about letters, Fer is an independent type designer from Buenos Aires. She completed a degree in Graphic Design and a postgraduate specialization in Type Design at the University of Buenos Aires. She teaches, speaks and participates in various spaces around typography and her work has been selected for several typography exhibitions, such as Tipos Latinos, Pangramme, TDC and Founders Type.
www.fercozzi.com

Dd

DATYE , NOOPUR

Noopur Datye is a type designer and calligrapher from Mumbai, India. She is one of the co-founders of Ek Type, a collaborative type foundry that designs typefaces in eleven of the many scripts used in India. She mostly works with Devanagari, Bengali, Gujarati and Gurmukhi scripts. Her work includes custom Bengali and Devanagari typefaces for television channels Star Jalsa and LifeOk, open source type faces Mukta Vaani (Gujarati), Modak (Latin) and Baloo Bhai (Gujarati), Baloo Da (Bangla), Baloo (Latin).
www.ektype.in

DOČEKALOVÁ, PETRA

Petra is a type designer, letterer and sign painter. She is a member of a Suitcase Type Foundry and Briefcase Type Foundry team, working on all activities associated with foundries. She is focused on editorial work such as "Typo9010" and "Jaroslav Benda 1882–1970" books. She continues her studies at the Academy of Arts, Architecture and Design in Prague (UMPRUM) as a PhD candidate. The theme of her thesis is to revive traditional sign painting, create and offer contemporary script typefaces and boost street typography and the craft of sign painting in Prague.
www.petra-d.com

DOREULI, MARIA

Maria Doreuli is a creative director at Contrast Foundry, an independent studio with focus on multilingual type design. She works with letters in all their incarnations: original typefaces, lettering, typography and writing. At Contrast Foundry, she helps agencies and brands find the right typographic voice, working on custom typefaces, logos, lettering and consulting. When she's not sketching and drawing type at the studio, she is running various workshops and teaching. Traditional and experimental, self-initiated and commercial, her projects have been honored by many awards, such as Letter.2, Granshan, Morisawa and TDC2.
www.contrastfoundry.com

Ff

FILI, LOUISE

With a background as Senior Designer for Herb Lubalin, Louise Fili was Art Director of Pantheon Books from 1978 to 1989, where she designed close to 2,000 book jackets. She founded Louise Fili Ltd in 1989. It is a graphic design studio specializing in brand development for food packaging and restaurants. She has received Gold and Silver

Medals from the Society of Illustrators and the New York Art Directors Club, the Premio Grafico from the Bologna Book Fair, and three James Beard award nominations. Fili has taught and lectured extensively, and her work is in the permanent collections of the Library of Congress, the Cooper Hewitt Museum, and the Bibliothèque Nationale. She is a co-author, along with Steven Heller, of Italian Art Deco, British Modern, Dutch Moderne, Streamline, French Modern, Deco España, German Modern, Design Connoisseur, Typology, Stylepedia, Euro Deco, Scripts, Shadow Type, Stencil Type, and Slab Serif Type. Fili has also written Elegantissima, Grafica della Strada, Graphique de la Rue, Gràfica de les Rambles, The Cognoscenti's Guide to Florence, and Italianissimo. She has received the medal for Lifetime Achievement from the AIGA and the TDC.
www.louisefili.com

FLOR, MARTINA

Martina Flor combines her talents as both a designer and illustrator in drawing of letters. Based in Berlin, she runs one of the world's leading studios in lettering and custom typography, working for clients all over the globe such as The Washington Post, Vanity Fair, HarperCollins, Monotype, Etsy, Adobe, Mercedes Benz, Lufthansa, and Cosmopolitan, among many others.

Martina Flor earned her master's in Type Design from the esteemed Royal Academy of Art in The Hague. Since then she has dedicated a large part of her time to teaching lettering and type design. Martina travels extensively around the world to help designers cultivate their skills through workshops and to present her work and insights at conferences, such as TEDx and Adobe MAX.
www.martinaflor.com

FRANZ, MONA

Mona Franz is a type designer from Munich, Germany who has also been trained in branding. In 2018 she graduated from the master's program

TypeMedia held at The Royal Academy of Art in The Hague, The Netherlands. Her bachelor project at the Nuremberg Tech comprised the development and marketing of her first typeface FranzSans.de. Working as a corporate designer for Martin et Karczinski including several projects for the light design company Occhio and the rebranding for Lufthansa gave her the opportunity to gain various experiences in holistic and strategic thinking for premium brand designs. Mona likes connecting people and building bridges between several design disciplines to find the best solutions for individual projects.
www.monafranz.com

FRÖHLICH, LOUISA

Louisa Fröhlich is an independent graphic and typeface designer based in Wiesbaden, Germany. After her MA in Typeface Design at the University of Reading, her first retail typeface Lisbeth was published by the type foundry TypeTogether. Louisa specializes in the Latin and Greek scripts and has experience with some minority scripts. When she is not designing complete typefaces, she is very much enjoying the freedom and flexibility of lettering projects. As a graphic designer Louisa specializes in corporate communications and the design and re-design of logos and identities. It is very inspirational for her to have both perspectives: to be both a user and designer of typefaces. This way the ideas keep coming.
www.louisafroehlich.de

FURTER, LORAINE

Loraine Furter is a graphic designer and researcher based in Brussels since 2007, specializing in editorial design, hybrid publishing and intersectional xfeminism. She designs and edits paper publications as well as web and digital ones, and is particularly interested in the interaction between these media. Loraine is a co-organizer of the graphic design festival Fig. in Liège, Belgium since 2017. She teaches graphic design and artists' books classes

(BA+MA) at the Royal Academy of Arts and at École de Recherche Graphique in Brussels. Recently, she started a research project entitled Speaking Volumes—Art, Activism and Feminist Publishing and she is a part of the cyberfeminist collective..
www.lorainefurter.net

Gg

GATAUD, ROXANE

Roxane Gataud is an independent typeface designer from France. Her first typeface, Bely, started at Esad Type and released through TypeTogether's first Typeface Publishing Incentive Program, received the Certificate of Typographic Excellence by the TDC in 2017. SOTA awarded Roxane the 2016 Catalyst award for her current achievements. Roxane has collaborated with different foundries since graduation such as TypeTogether, Typefactory, Production Type, Typofonderie, and lately 205TF where she takes care of the production of a fonts catalogue. Roxane also designs her own typefaces, commissioned or self-initiated. She lives in Paris where she also collects fruit labels, dinosaurs, and pictures of type in the wild.
www.roxanegataud.com

GANDHI , KIMYA

Kimya Gandhi is a type designer from Mumbai, currently based in Berlin. She has a passionate interest in Indic letterforms and specializes in creating new and innovative Devanagari typefaces. Kimya is a partner at the type foundry, Mota Italic, with her husband Rob Keller where they design custom and retail typefaces for clients worldwide. When not drawing typefaces she spends her time teaching, or conducting workshops on typography and type design at various design institutes. Her typeface Lini received the Certificate of Typographic Excellence by Type Directors Club.
www.motaitalic.com

GIOVAGNOLI, CAROLINA

Carolina Giovagnoli is a type designer from Rosario, Argentina based in Berlin. She holds a degree in Typeface Design from Universidad de Buenos Aires, Argentina, where she is currently a guest professor. Since 2008 she has been running her own studio, focused on editorial design. She is also a co-founder and partner at Huerta Tipográfica—an independent font foundry established in 2010. Andada ht, a typeface she designed as a part of her degree, was awarded the BID_10 prize at the 2010 competition. She has given lectures in type design and typography in Argentina and Europe. Her work has been part of several exhibitions such as Tipos Latinos (Latin America), MAMM (Argentina), MDML (Portugal), BID (Spain).
www.huertatipografica.com

Hh

HAM, MINJOO

Minjoo Ham is a type designer from South Korea. She studied graphic design at the Seoul Women's University, where she discovered her interest in type design. After graduation, she worked for several years as a type designer. In 2015 she completed the Type-Media master's course at the Royal Academy of Art (KABK) in The Hague, concentrating on research and type design of the Latin and Hangul double script. She is now an independent type designer in Berlin, producing multi-script font families for corporate clients and various foundries.
www.minjooham.com

Kk

KAT RAHMANI, GOLNAR

Lives and works in Berlin as a creative director and artist in the field of typography. Born and raised in Iran, graduated from Tehran University

and Academy of Art Berlin Weißensee in Visual Communication. 2016 founder of Studio Katrahmani—a Berlin-based multidisciplinary design practice focusing on Persian/Arabic typography.
www.katrahmani.com, www.typeandpolitics.org

KOROLKOVA, ALEXANDRA

Alexandra is a type designer, type researcher and type consultant based in Moscow, who participated in the "Public Types of Russian Federation" project (2009–2011, includes PT Sans and PT Serif) as a leading designer. She is an art director of Paratype, the oldest and largest Russian type foundry.

She wrote a book on typography for beginners (in Russian, the title can be translated into English as "Live Typography") which was first published in 2007 and re-published in 2008, 2010 and 2012, and a series of type-related articles. Alexandra spoke at ATypI, TYPO Berlin, TypeCon, TYPO Labs, Serebro Nabora, Typofest, Typetersburg. She was the 9th recipient of Prix Charles Peignot (2013) and also a jury member of Modern Cyrillic 2014 type design competition.
www.paratype.com

KUPFERSCHMID, INDRA

Indra Kupferschmid is a freelance typographer and professor at HBKsaar, University of Arts Saarbrücken. Fueled by specimen books, she is occupied with type around the clock in all its incarnations—web fonts, bitmap fonts, other fonts, type history, DIN committees, writing, design work, and any combination of these. She is a co-author of "Helvetica Forever" by Lars Müller Publishers and wrote "Buchstaben kommen selten allein", a typographic reference book (Niggli). She consults for the type and design industry and other clients who need help choosing fonts, as well as writes for several different magazines and blogs.
www.kupferschrift.de

Ll

LEE, NOHEUL

Passionated by type design, Noheul Lee graduated from the Type and Media program at the KABK, The Hague. Currently she is working as a Hangul & Latin multi-script type designer and a partner of 'lo-ol typefoundry', a studio based in Switzerland & Seoul. Her work has received recognition and acclaim; she won the 6th Bang Il Young Cultural Foundation Fund Competition for her Hangul design called 'Arvana', available on Future Fonts. She also received Gold medal in the Morisawa Type Design Competition for the Latin design of 'Areon'.
lo-ol.design/

LEVIT, BRIAR

Briar Levit graduated from San Francisco State University, with a BA in Graphic Design, and from Central Saint Martin's College of Art and Design (UAL, London), with an MA in Communication Design. Now Briar is an assistant professor at Portland State University, where she teaches typography, page layout, and studio design classes. Her passion is designing for content-driven projects—primarily in the publishing and cultural institution sphere. Recently, she directed and produced a documentary film—"Graphic Means: A History of Graphic Design Production". "Graphic Means" premiered on April 15th, 2017. It is now touring nationally and internationally.
www.briarlevit.com

LIAO, TIEN-MIN

Tien-Min Liao is a New York-based independent designer specializing in logotype design and brand typography. She studied typeface design at The Cooper Union and previously held positions as a senior designer at Siegel+Gale where she had a pleasure of working on various logotype development and refinement projects from consumer brand

to global organization.
www.typeji.com

LICKO, ZUZANA

Zuzana Licko was born in 1961 in Bratislava, Czechoslovakia and immigrated with her parents to the US in 1968. She graduated with a degree in Graphic Communications from the University of California, Berkeley in 1984. Together with her husband, Rudy VanderLans, Licko started the design company Emigre Graphics in 1984.

Eventually, the exposure of the typefaces in Emigre magazine resulted in demand for the fonts which lead to the creation of the Emigre Type foundry. In 2011, five digital typefaces from the Emigre Type Library were acquired by MoMA New York for their design and architecture collection.

Licko is the recipient of an honorary PhD degree from the Rhode Island School of Design (2005), and a Typography Award from the Society of Typographic Aficionados (2013).
www.emigre.com

Mm

MATAS, SOL

Sol Matas is a Graphic and Type designer who graduated from the Universidad de Buenos Aires. Since 2001 she has been running her own studio Sonnenshine specializing in branding and custom type design, working for companies from Latin America, Europe and the United States.

She is also a co-founder of the type foundry Huerta Tipográfica. She has developed font projects in Latin, Cyrillic, Devanagari and Greek. Her type projects were selected for the Bienal Tipos Latinos 2010 and 2012 and the 5th International Typography Congress in Valencia. She has lectured on type design, and gave workshops in diverse events and institutions in Latin America, Europe and Asia.
www.solmatas.com, www.huertatipografica.com

MEJÍA, FABIOLA

Fabiola Mejía is an independent type designer from Costa Rica. In 2017, she completed the Type@Cooper Condensed Program in NYC, and in 2019, she received an MA in Typeface Design from TypeMedia. Besides working remotely with Dinamo Typefaces, she recently founded SUPERCONTINENTE, a platform dedicated to her type design practice and collaborative graphic explorations.
www.supercontinente.com

MESEGUER, LAURA

Laura Meseguer is a freelance designer, typographer and type designer. She specializes in any kind of projects based on typography, from lettering for monograms and logotypes to custom typefaces and book design. In 2003 she studied type design at the postgraduate course Type and Media at the KABK in The Hague. In addition to her practice, Laura has been teaching Type Design and Typography in Barcelona, and running workshops and giving talks everywhere. She is the author of "TypoMag. Typography in Magazines." Some of her typefaces like Rumba, Lalola and Qandus, had received the TDC Award. She is a member of Type-Ø-Tones where she publishes all her typefaces.
www.laurameseguer.com

MUNGUÍA, MÓNICA

Mónica Munguía is a type designer and graphic designer based in Mexico. She has a Master degree in Typographic Design and is the co-author of the book Elementype. Founder of Momutype Foundry and Studio, where she works and produces custom and retail fonts. She is part of the TypeThursday Mexico City team as a dialogue leader. She has been a national and international speaker at conferences such as ATypi, TypeLab, Tipografía México, Tipografilia and Mi TipoEs. She received the international Clap and Tipos Latinos award.
www.momutype.com

Nn

NISHIZUKA, RYOKO

Ryoko Nishizuka received her degree in Type Design from Musashino Art University in 1995. She joined Adobe in 1997, and is currently a Senior Designer of Japanese Typography. Ryoko was a member of the team that designed and developed the first Adobe Originals Japanese typefaces, Kozuka Mincho and Kozuka Gothic. She designed the typeface Ryo family, the world's first full proportional OpenType Japanese font Kazuraki, Source Han Sans and Source Han Serif as the Pan-CJK typeface family and Ten-Mincho. Ryoko has won several awards including NY TDC, Tokyo TDC and the Morisawa Awards International Typeface Design Competition.
www.behance.net/RyokoNishizuka

NOVOSELOVA, ELENA

Elena Novoselova is a type designer and calligrapher. She is a graduate of the Moscow State University of Printing Arts (2006), having studied in the type design workshop of Alexander Tarbeev. She also teaches at the British Higher School of Art and Design in Moscow. Since 2007 she has been a member of the jury for the Zapf Games, a calligraphy competition. In 2006–2011 she worked as a type designer and calligrapher at the Art. Lebedev Studio. She was a part of the Letterwork.ru project as a designer of logos.
www.newvillagetype.com

Oo

OVEZEA, DIANA

Diana Ovezea is a Romanian-born type designer and typographer, who embraces being international. In 2013, she graduated from the Type and Media master program of the Royal Academy of

Arts in The Hague (KABK).

Her studio is currently based in Amsterdam (Netherlands), where she enjoys developing complex typeface systems and creating typographic specimens. You will also often see her in The Hague, where she regularly works for BoldMonday and teaches typography at the KABK.
www.acutestudio.nl

Pp

PETROVA, DARIA

After graduating from the KABK TypeMedia course in 2016, Daria spends her days working at LucasFonts and her nights drawing odd typefaces and praying for Victorian typography to come back and take over again soon.
www.dariapetrova.com

PIGOULEVSKAYA, MARIYA V.

Mariya was born in Minsk, Belarus or Byelorussian SSR at that time. Her creative journey began as an art trainee at the Belarusian State Academy of Arts under of supervision of the professor V. I. Kolomiets. With his help and encouragement, Mariya enrolled in the design course at BSAA. In 2006 she moved to the UK and continued her studies at the Teesside University in Middlesbrough. Mariya graduated with a BA and MA in Graphic Design and Illustration. In 2012 she completed an apprenticeship with TNB type foundry and joined the creative team as a type designer. In 2014 she took part in the Type Design Intensive Program at Reading University led by Gerry Leonidas, Gerard Unger, Fiona Ross, Eric Kindel, Ewan Clayton and Vaibhav Singh. Her practice is focused on Latin and Cyrillic type design and production. In 2014 she moved to Wylam, England.
www.thenorthernblock.co.uk

PLÖNNIGS, INGA

Inga Plönnigs is an independent type designer, dividing her time between commissioned work for international clients and self-initiated projects. Her work is inspired by history, necessity and the vernacular. She holds a bachelor's degree in Communication Design from Braunschweig University of Art (HBK).

After two internships at FontFont and LucasFonts she did the Type and Media master program at the Royal Academy of Art in The Hague, The Netherlands. She graduated in 2016.
www.ingaploennigs.com

Rr

REGIDOR, ANA

A Spanish-born event coordinator Ana Regidor has always been passionate about organizing events. After living and studying in Paris, London, Madrid and Vienna she acquired a vast experience in different event management fields. She joined Monotype in 2015 and organized TYPO Berlin (2015–2018) and led the TYPO Labs conference (2016–2018), Europe's biggest conferences dedicated to graphic design and font technology. Based in Berlin since 2009, she now works independently for events such as re:publica—an event about the digital society and EDCH—The Idea Salon: editorial design and visual storytelling.

ROSS, FIONA

Fiona Ross specializes in non-Latin type design and typography, having a background in languages and a PhD in Indian Palaeography. She works as a consultant, type designer, author, and lecturer; and is Associate Designer at Tiro Typeworks, and part-time Professor of Non-Latin Type Design at the University of Reading (UK).
www.reading.ac.uk/typography/about/Staff_list/f-g-e-ross.aspx

Ss

SAVOIE, ALICE

Alice Savoie is an independent typeface designer and researcher. She studied typography in Paris, and in 2006 graduated from the MA Typeface Design program of the University of Reading, UK. She has collaborated with international type foundries (Monotype, Process Type Foundry, Tiro Typeworks, Frere-Jones Type, OurType etc.).

Between 2008 and 2010 Alice joined Monotype as an in-house type designer, working on custom projects for international clients and on new typefaces for the Monotype library. In 2014 Alice was awarded a PhD from the University of Reading for her research on typeface design and production during the phototypesetting era. In 2018, she released Faune, a commission by Centre National des Arts Plastiques. She teaches at Atelier National de Recherche Typographique and ENSBA.
www.frenchtype.com

Tt

TURKENICH, LIRON LAVI

Liron Lavi Turkenich is an independent typeface designer and researcher based in Israel. She holds a B.Des in Visual Communications from Shenkar College in Tel Aviv and an MA in Typeface Design from the University of Reading, UK. Liron designs multilingual typefaces for international companies, specializing in Hebrew and Amharic. Among them is Aravrit, a new hybrid writing system which merges Hebrew and Arabic, and has received wide recognition for its ingenuity and scope. In addition to design, she writes about letterforms, interviews designers, teaches, and researches Hebrew type design. Liron is an events coordinator at ATypI, organizing the yearly conference.
www.lironlavi.com

Vv

VLACHOU, IRENE

Irene Vlachou is a typeface designer working between Athens and Bristol. In 2004 she gained her Masters in type design at the University of Reading and since then she has been collaborating with international type foundries and corporations as a type designer and as a Greek type consultant. From 2013 to 2019 she was a senior designer and variable font expert at Type-Together (Protipo, Portada, Bree, Catalpa). In 2017, in collaboration with Laurenz Brunner, she designed the Greek counterpart of the Documenta exhibition's identity font, Bradford Greek. In 2019, together with Laurence Penney, she launched FauxFoundry, a webfont service using variable font technology that provides automatic fallback fonts when the main font lacks characters.
www.ivtype.com, www.fauxfoundry.com

Ww

WAHLER, CAROL

Carol Wahler has served as Executive Director of the Type Directors Club since 1983. Carol's type background stems from her work in her family's various businesses that began in the period of Ludlow typesetting in the 50s and lasted through today's digital world. For her contributions to the field she was given the SoTA 2018 Typography Award by the Society of Typographic Aficionados. Carol has been integrally involved in all the committees, especially the annual competition annual "Typography" and the traveling exhibits. Additionally, Carol Wahler has become in-demand as a lecturer bringing the TDC history to universities and schools around the globe, including Taichung, Taiwan; Paris, France; Shanghai, China; and Sao Paulo, Brazil. Prior to her position at the TDC, Carol was busy raising two children, Adam and Samantha, while graduating Magna Cum

Laude from William Paterson University where she received her BA degree in Art History. She has four grandchildren. Carol lives in Westport, Connecticut with her husband Allan.
www.tdc.org/officers/carol-wahler

WILDER, CYMONE

Cymone Wilder is a full-time brand designer and part-time freelance lettering artist based in Nashville. Since 2013 she has collaborated with amazing clients (see Netflix, HBO Max, Cosmopolitan, and the Warren Campaign) – creating custom lettering artwork for established brands, books, apparel, and much more. She is fiercely passionate about producing meaningful and long-lasting work, drawing inspiration from the black experience.
www.simonandmoose.com

Image provided courtesy of Archivio Tipoteca. All rights reserved.

Chapter B

Research on Gender Issues in Type

Numbers and Data

In this chapter I would like to present some data that I have collected during my research project. Although I do not believe that the statistics provide a complete picture of the situation, I find it necessary to look at the numbers in this project.

COMPETITION AND AWARDS

I have decided to look at various competitions and awards given to type designers for their contribution to the type design field.

In 2003 the Society of Typographic Aficionados created the Typography Award[6] to acknowledge the outstanding members of the type community and their creative achievements. It was awarded every year and out of 15 awards, 4 of them were given to women. Yves Peters, a graphic designer, wrote an article in 2015 on this very subject. He observed that, "[...] even though the two last winners of the SOTA Typography Award were both women—digital type design legend Zuzana Licko in 2013 (2 decades too late) and a foreign script specialist and lecturer Fiona Ross in 2014 (also overdue)—the list preceding them consists exclusively of men."[7] The situation has changed since 2015 and the award was given to Paula Scher in 2017 and to Louise Fili and Carol Wahler 2018.

ATypI awards the Prix Charles Peignot for Excellence in Type Design to a designer under the age of 35 who has made an outstanding contribution to type design. Starting from 1982 the award is given every four or five years. Out of 10 recipients in the last 36 years, only 2 women won the ATypI's prestigious Prix Charles Peignot. Alexandra Korolkova was the second woman to receive the prize in 2013, after Carol Twombly in 1994.[8]

A similar situation can be seen with the Type Directors Club (TDC) Medal Winners. The Medal is awarded to individuals and institutions who have made major contributions to the field of typogra-

phy. The aim is to express collective gratitude to those who have shown the value of a heightened awareness of typography in communication. The first medal was awarded to Hermann Zapf in 1967. From the total 31 medals over the last 50 years, 4 were given to women: Paula Scher (2006), Louise Fili (2015), Emigre that includes Zuzana Licko (2016) and Fiona Ross (2018).[9]

Every year the TDC organizes a competition where a jury selects an outstanding typographical work. This year (2018) the jury—Sahar Afshar, Verena Gerlach, YuJune Park, Dyana Weissman—selected eighteen typefaces from 225 entries from 39 countries. Some typefaces were designed by more than one person. Out of all people that were listed as typeface design winners 32% were women and 69% were men.[10] No doubt that the selection process is anonymous. Yet at the same time it is fascinating to see the numbers.

As of yet, no woman has received the Gerrit Noordzij Prize. It is given to type designers and typographers for extraordinary contributions to the fields. It is awarded every three years by the Royal Academy of Art in The Hague together with the Museum Meermanno and the Koninklijke Bibliotheek under the auspices of the Dr. P. A. Tiele Trust.[11]

DESIGN AND TYPE CONFERENCES

Paula Scher once said, "Designers get famous by speaking at conferences." In 2012, Susanne Dechant explained that despite many typographic achievements, women remained underrepresented at type conferences. She said, "TypoBerlin (2009: 5% female presenters) or Atypl (2009: 12%), as well as in various type foundries (Linotype 2005: 12.3%; Myfonts.com 2008: 14%). Today an equal number of women and men are studying type design—so we can expect or at least hope for a levelling of the playing field."[12]

A group of activists—Alphabettes—emerged in 2015 as a reaction to the imbalance in the typography field. They showcase and research women

Алфавette

We salute those type conference organisers who decided to use their an opportunity to improve their speakers lists towards gender equality and we cannot wait to see this dedication inspire the ones that are still failing to keep pace. (Alphabettes)

CONFERENCES 2017

59%	**Ultrafett, DE**
56%	**Typism, AU**
54%	**Typographics, US**
50%	**7ET, PT**
49%	TypeCon, US
46%	Lure, FR
44%	FEED, ES
43%	Everyday Reading, FR
34%	ATypI, CA
33%	Dia Tipo, BR
33%	FURE, DE
32%	ISType, TR
31%	BITS, TH
31%	Tipografilia, MX
29%	TYPO Berlin, DE
29%	Granshan, AM
26%	Typo Day, IN
25%	Face/Interface, US
25%	Typotage, DE
24%	AGI Open, FR
22%	Dia Tipo, BR
22%	Letrástica, MX
21%	Dia Tipo, BR
17%	Typo Day, DE
17%	TYPO Labs, DE
13%	Kerning, IT
8%	Typetersburg, RU

CONFERENCES 2016

58%	**Sans Everything, FR**
52%	**ICTVC, GR**
50%	**Typographics, US**
47%	AIGA Design, US
47%	BTS Away Days, DE
43%	TypeCon, US
40%	6ET, PT
38%	Beyond Tellerrand, DE
37%	Lure, FR
37%	Typofest, BG
36%	ATypI, PL
35%	7CIT, ES
34%	TYPO, DE
33%	BITS, TH
33%	DiaTipo, BR
30%	Dynamic Font Day, DE
25%	Typo Day Köln, DE
23%	Granshan, EG
22%	DiaTipo, São Paulo, BR
20%	Typo Day Hamburg, DE
15%	Automatic Type Design, FR
14%	Typo Day Basel, CH
12%	Kerning, IT
12%	DiaTipo, Campinas, BR
11%	Walbaum Wochenende, DE
10%	TYPO Labs, DE
5%	Serebro Nabora, RU

The image above is a header used on Alphbettes.com in July, 2020. It spells "Alphbettes" using cirylic letters. Typeface: "Rezak" designed by Anya Danilova.

NUMBERS AND DATA

in lettering, typography, and type design in order to bring the topic to light. In addition, the Alphabettes have been watching out for gender equality at conferences and putting together lists of type conferences that took place in 2016 and 2017, indicating the percentage of female speakers. Looking at statistics from 2017 we can see that out of 27 conferences there are 4 that had over 50% of female speakers—Ultrafett in Bielefeld (59%), Typism in Gold Coast (56%), Typographics in NY (54%), Encontro de Tipografia Conference in Faro (50%). TypeCon conference in Boston almost made it with 49%. For the other 22 conferences, the number varies from 46% to 8%. For example, at both the ATypI conference in Montréal (34%) and at TYPO Berlin (29%) only one third of their speakers were women.[13]

When comparing this data to the statistics on Yesequal.us provided for the year 2015, we can see that the number has been slowly growing.[14] For instance, TypeCon had 49% of female speakers in 2017, but in 2015 had only 12%. I do not claim that the statistics revealed on the Yesequal.us are the reason why the number grew to 43% in 2016, still this thought seems intriguing. TYPO Berlin had 18% of female speakers in 2015, and reached 35% in the following year but after that it dropped again to 29% in 2017. I interviewed Ana Regidor who claimed that in 2018 she managed to reach an equal amount of male/female speakers at TYPO Berlin conference.[15] The continued growth of female representation is visible in the past years, especially if we compare Typo Berlin 2018 to Typo Berlin 2004. In the latter, only 7% of the total invited presenters were female.

Yesequal.us webpage does not have any information about ATypI speakers in 2015. In 2016 Alphabettes reported 36% female speakers at ATypI that took place in Warsaw, Poland. The number dropped to 34% the following year when the conference happened in Montréal, Canada. Nonetheless, the conference in Antwerp, Belgium (2018) had 41% of women and 59% of men presenting.

The event with the lowest share of speakers

was the Typetersburg conference in 2017 in St. Petersburg, Russia with only 8% female speakers. Meanwhile, Susanne Dechant in the book *Women in Graphic Design* argues that, "an exceptionally high percentage of female type designers can be found in Russia."[16]

It also seems necessary to draw the attention to the different selection processes of conference speakers. More often than not, conferences are curated. In this case, the list of participants is determined by the organizers. Other conferences are proposal-based. They invite designers to submit proposals for presentations and workshops for the upcoming event. Yet the final selection is made by the curators. In other words, the gender balance of the conference panel is in the organizer's hands.

TYPE DESIGN EDUCATION

There are not many universities that offer Type Design as a separate major. Despite this, a lot of type designers have gained their knowledge from typography classes offered in graphic design programs. For this reason it is hard to identify exactly how many students pursue careers in type design. For my research I decided to focus on two schools that are known for offering a master's degree in Type Design—the University of Reading in the UK and the Royal Academy of Art in the Hague—and to analyze the changes in the gender representation over the last years.

UNIVERSITY OF READING, UK

In her essay in 2005, Sybille Hagmann wrote that the 2002–2004 student lists revealed an equal participation of females and males in the Type and Media master's program at the Royal Academy of Art in the Hague. The same is true of the University of Reading in the UK class of 2004. In her opinion "these numbers point to a more balanced gender representation of future contributors in the field, anticipating that these women will be practicing type designers."[17]

I got in touch with Associate Professor Gerry Leonidas, the Program Director for the MA in Typeface Design at the University of Reading. He kindly shared with me what the gender balance has been in MA Typeface Design post-graduate course for the last 19 years. Since the total amount of students is very low (it varies from 12 to 15), I decided to look at blocks of five years in order to eliminate annual random variations. In the period of 2000–2004 there were 62.5% of men and 37.5% of women graduating.[18] Then the percentage of women graduating from the course reached 50% in the next block of five years (2009–2014). More recently, the last group of years (2015–2019) shows a less balanced number—56% of men, 44% of women graduating.[19] The general development shows us that the early years confirm the male bias in the industry, whereas the current trend shows that the amount of men and women entering the profession has become more or less balanced. Leonidas writes that he "has not been able to isolate a pattern—largely because of the overwhelming importance of funding availability." In this case, the geographic origin of applicants, regardless of the gender or age, may be the critical factor. He believes that whether there are scholarships and postgraduate loans available or not, can serve as an important factor. For example, he says that "in 19 years of the MATD there were only 13 UK students. Last year the government in Britain opened up new loans for master's students, so this year I had 3 British students out of 13."[20]

 It would be interesting to look at the statistics of applicants to type courses. This would give us an impression of who is interested in pursuing a career in type design. In our email exchange, Leonidas told me that he received a list of 560 names of applicants that did not become students. Unfortunately, he could not calculate the female/male ratio as "not all names tell you whether it is a male or female applicant—Israeli, Korean, Chinese names in particular can be for both genders."

In contrast to Sybille Hagmann's hope that there will be more women practicing type design after graduating from the Type Design programs, Leonidas thinks that "these numbers are not indicative of a career progression!" He argues that it is much more difficult to collect reliable data for the question, "What is the gender balance for people whose main income relates to typeface design?" Regarding this question Chris Lewis shared relevant information in his comment to Gerlach's article "Where are the Women in Type Design?" In 2011 Lewis said that the number of female designers that released their fonts with MyFont in the digital era hangs around 13–14%. Over 20% of the fonts that debuted at MyFonts in 2000 and 2001 belonged to female designers, but since then the number has been below 15%. Next, he highlights that the percentage of female designers releasing fonts with MyFonts has been slowly but steadily increasing for the last 4–5 years. This information depends on the quality of the information MyFonts received from the foundries and designers.

THE ROYAL ACADEMY OF ART IN THE HAGUE

Judging from the Type and Media alumni list online, I was able to calculate the percentage of female and male students in 2 five-year blocks of 2009–2014 and 2015–2019. The numbers are a bit worse than those of the MA Typeface Design course of the University of Reading. If in the Reading University it reached a perfect 50% of female graduates in 2009–2014, the Royal Academy of Art had 42% of women graduating during the same period. In the next 5 years (2015–2019) the amount of women graduating from the Royal Academy dropped to 37% while Reading had 44% during the same period.

Despite this, Hagmann mentioned in her essay that "judging from the institution's online information, TypeMedia's faculty is almost exclusively male."[21] Even today (2019) the situation remains unchanged. The only female faculty member is Françoise Berserik, who is teaching stone carving.[22]

WEISSENSEE ACADEMY OF ARTS, BERLIN

Weißensee Academy of Arts does not offer a degree in Type Design, yet it has typography courses. It was interesting for me to see the ratio of students in the university I am studying at. Out of the total amount of students in Weißensee from all the departments there are 68% women and 32% men. If we only look at students studying visual communication we will see that the situation is quite similar. The distribution is 69% female and 31% male students.[23]

Women in Type

Not surprisingly, some researchers have already contributed to the research on gender imbalance in typography. Nonetheless, the amount of books and essays addressing this topic is limited. In this chapter I introduce some works that are significant for this project. Interestingly enough some essays are spread out in time and have a five- and ten-year gap between them, thereby creating a great basis for analysis and tracing the development of the situation over the past years.

DESIGN RESEARCH UNIT (WD+RU)

In 1994 the Women's Design Research Unit (WD+RU) was created "as a response to the male-dominated speakers' panel at the typography conference Fuse 94."[24] WD+RU was set up by design historians and educators: Teal Triggs, Sian Cook, and Liz McQuiston. As Triggs recalls it, at some point at Fuse 94 the speakers were invited for the final round of applause. When all of the speakers were visible on the stage, she noticed that the "line-up was all white, middle-class men, many with glasses."[25] Triggs raised her hand and asked the jury what the selection process was and where all the women were. The jury was shocked and had no reasonable answer. The WD+RU group evolved to stress on the gender imbalance of speakers and highlight the role of women in design because the profession "was not accurately represented in terms of female contributors."[26] As Madeleine Morley describes it in her article "The Women Redressing the Gender Imbalance in Typography" the goal of the WD+RU group "was to question and subvert traditional male power structures within the overwhelmingly new and transitional context of technological innovation; it was a bold and necessary motivation."[27]

Shortly after the Fuse 94 conference, WD+RU were asked to contribute to FUSE—the experimental digital typography magazine—for the issue on the

subject of "propaganda." They saw it as an opportunity to raise awareness about women working. WD+RU created an experimental typeface called Pussy Galore after the fabulous character played by Honor Blackman in the James Bond film "Goldfinger." It is a conceptual typeface intended to address gender stereotypes using the language used by, for, and against women.[28] It encourages users to challenge and reassess how women have been represented in language. Its letters include "pouting lips, Eve's snake, and a floppy Monroe 'dumb blonde' hairdo." WD+RU still see themselves primarily as educational activists and hope to provide a platform where others can "contribute to an emerging discourse on design and feminism."[29] They have recently set up a WD+RU archive site.

WOMEN TYPEFACE DESIGNERS

Another work addressing the issues of female type designers emerged shortly after: a dissertation written by Laura Webber in 1997. Her thesis project submitted in fulfillment of the requirements for the MS degree at the School of Printing Management and Science at the College of Imaging Arts and Sciences of the Rochester Institute of Technology. The title of her work was "Women Typeface Designers."

During her research, Webber could not find "a single, exclusive publication containing biographies, type specimens, and photographs of the many women typeface designers."[30] She claimed that from source to source she would stumble upon the same names of male type designers. Webber had to refer to many various sources to complete a list of female type designers. In her opinion, "In an age of rapid access to all sorts of reference information [...] it seems silly that one must be forced to search many sources."[31] Therefore, the aim of her project was to provide a single reference source of women typeface designers and samples of their typefaces as of December 1996.

She put together a list of names of women typeface designers with the help of books, maga-

zines, electronic searches, typeface catalogs, and people in the field of typography and typeface design. Furthermore, she collected the names of their typefaces, their addresses and phone numbers. After that she mailed questionnaires to 24 of the designers out of the 41 she found. Eight designers answered and returned their questionnaires. Webber used published sources, books on type and Internet to put together information on the remaining designers. The result of her thesis project is the manuscript for a reference book on 41 women typeface designers "who, by definition, create individual letters, numerals, punctuation marks, and/or other symbols produced by machine which are arranged by hand, photomechanically, or electronically."[32] It also contains 134 typeface samples.

"NON-EXISTENT DESIGN: WOMEN AND THE CREATION OF TYPE" BY SIBYLLE HAGMANN

In 2005 Sibylle Hagmann, a type designer and founder of Kontour, wrote an essay for the Visual Communication journal called "Non-existent design: women and the creation of type." Hagmann found herself in a similar situation as WD+RU. She was invited to participate in a typeface exhibition called Fresh Type. It took place in 2004 in Zurich. She was the only female out of 25 participants. Hagmann was struck by this lack of gender diversity and started to look for an explanation. Having done some research, she reported that in 2005 the Linotype type foundry had only 59 women out of 478 font designers it represented, or 12.3%. According to her survey on speakers' gender at international typographic conferences, the numbers disclosed strikingly unequal representation, for example, "ATypI (2003, 2004) and TypeCon (2003, 2004) had an average of 15% female contributors."[33] At the TYPO Berlin (2004) there were only 5 female presenters out of the total of 68 invited. Hagmann said that "the current climate still prevailing at type conferences is one of male 'type gurus'."[34]

With her essay, Hagmann wanted to illumi-

nate the reasons behind the lack of female type designers and offer "strategies for remedying the situation." She suggested that the result of today's gender inequality in type design is rooted in the historically male-dominated world of printing. Hagmann explains that women got access to training in art and design only in the 19th century. Yet they were encouraged to acquire skills in weaving, textile painting, pottery, illustration, stained glass, calligraphy. In other words, professions focusing on decoration. She believes that "acquisition of these stereotypical feminine skills" happened due to the traditional involvement of women with crafts.[35] At the same time, the center point of the art education for men usually was printing and typesetting. For Hagmann, type design is a process that involves cold, black-and-white lines and "lacks the stereotypical female features—images and colors."[36] She points out that type design is time-consuming, demands patience, careful and persistent work.[37] While I do not deny the fact that type design demands patience and diligence, I like how Gerlach in one of her articles argues that patience is also required for needlework and knitting that are classic female handcrafts.[38]

Next Hagmann says that by the 19th century women were employed in the printing industry "to polish imperfection from metal type."[39] Due to the development of the pantogrnapic punch-cutting machine it became possible to produce punches in different sizes from a single pattern. "The drawings from which the patterns for punch-cutting were produced, were prepared in the type drawing office. [...] these tasks were carried out by less-skilled labor (token women), while the actual design of letter forms remained a male domain."[40] Hagmann makes this conclusion based on images revealing the working process at Monotype documented in the book *Type and Typography*.[41]

By the 1980s when personal computer became omnipresent, changes took place in the type design field. The dirty and physically difficult work

that was involved in the production of metal type was not necessary anymore. The gap between type design and production got smaller and designers could design their own fonts. Hagman notes, that "these technological advancements led to an increased 'democratization' of type production."[42] Consequently, this increased the amount of self-trained type designers. Although Hagmann believes that women received more opportunities to work in the typography field due to a more woman-friendly working process of type creating and producing, "type design nevertheless remains predominantly a white, Western, male working field."[43]

WHERE ARE THE WOMEN IN TYPE DESIGN

When browsing the Internet on the topic of women in type design, one stumbles upon the same articles. One of the first reference points was the previously mentioned Gerlach article "Where Are the Women in Type Design?". In this article she shares her thoughts about possible reasons why there are few women in type design. She does not accept the most common explanation that type design is a "technical" profession and explains that "font production does involve some programming, but, as a whole, does not type design have much more to do with the patience required by classic female handcrafts, like needlework and knitting?"[44]

Next she touches on the aspect of confidence. Gerlach explains that the working process of a type designer involves decision making. She points out that it is difficult to define the moment when the typeface is finished. It becomes even more challenging for female designers who constantly think that "they could do better."[45] She believes that it might lead to the situation when great type designs get hidden in the drawers. Public speaking is another situation when self-confidence is crucial. Verena assumes that public speaking is easier for men than for women because men "are used to show off about every little bit they produced, knowing they will get rewarded—and if not, well, it is no big deal."[46]

She describes networking as something that is "still a male thing, and which women typically aren't taught." Women, in this case, tend to work alone and this has a negative effect on their professional careers.

Gerlach claims that even if the career of the female type designer progresses, "our social structure simply makes it very difficult" for them to incorporate family life with work since a mother is often the main person taking care of the child.[47] This leads to the fact that a lot of talented type designers choose financially secure positions and end up doing production for type foundries.

TYPE PERSONAS WHO HAPPEN TO BE FEMALE

When Susan Dechant was asked how she would assess the current situation regarding gender balance in type design, she answered "Good".[48] However, she believes that "The Future Generation" group—young female designers that are finishing their education and starting their careers from a very high level—need to prove it. As Dechant says, "[...] the design history in general and that of women in particular remains to be written."[49] She contributed to the question why there are so few women in the typeface design field with her project "Type Personas Who Happen to Be Female." She claims that, the amount of women working in type design field is not that small.[50]

Dechant says that, "[...] another prejudice is the notion that women are afraid of technology or lack the necessary technical understanding."[51] In the history of typography, purely technical requirements were fulfilled by women. She gives an example of an 'office girl' that was working at Monotype in the early 20th century who would transfer the typeface design to the new machine for the production of matrices. As Susanne describes, this task required being very precise, understanding the idea of typeface and in the end it influenced the appearance of the letter. Thus the final shapes of letterforms were actually produced by women. At

52 RESEARCH

the same time this task was considered to be for less skilled workers—"in other words, for women."[52]

In her research, Dechant defined six groups of type designers. One of them is "The Early Pioneers of Typography" such as Margaret Calvert, Freda Sack, Veronika Elsner, Rosmarie Tissi, Gudrun Zapf-Hesse, Rosemary Sassoon, and others. She states that the achievements of those pioneering female typographers in history are "in urgent need of consideration" and sees them as excellent interview subjects. They cannot only tell about their impressive careers but obstacles, which they can now explain and assess.[53] Dechant gives an example of Margaret Calvert, who is a British graphic designer and typographer. She designed the typeface Transport which is still used on road signs in Great Britain today. Unfortunately, she only began to receive recognition in the recent years—"after the death of her studio partner."[54] Dechant also mentions Carol Twombly, an American designer known for her contribution to the design of typefaces such as Trajan, Myriad and Adobe Caslon. She worked at Adobe for about 10 years, retiring in 1999 from not only the company, but also from type design, deciding to focus on other design interests. Dechant finds the fact that Carol Twombly decided to switch to pottery "suspicious, disappointing and curious."[55] She compares this situation to Adrian Frutiger who would suddenly announce his decision to switch to woodcarving.

Dechant points out another group that she calls "The Invisible Ones" and sees them as a lost group of potential role models. She defines them as people who specifically worked during the brief prospering of digital typeface design in the 1970s and 1980s. According to her, they gained recognition at the time, but were forgotten. In this group she includes such designers as Linnea Lundquist and the designers who worked for Adobe: Barbara Lind, Kim Buker, Laurie Szujewska and Carol Twombly. For example, Linnea Lundquist worked in a type design team in Adobe for 12 years. In this group she also includes Zuzana Licko and Fiona

Ross, although they are still in the business and recognized in the public sphere. Ross, for instance, just recently got a medal from the TDC and held a talk at ATypI.

"The Enablers", the name Dechant gave to a group of indirectly active women that had a certain degree of public exposure.[56] These are the women who have been successfully managing some of the big companies in the industry such as Joan Spiekermann, Cynthia Batty, and Carol Wahler. However, Susanne points out that "The Enablers" mostly supported men since the percentage of women in their companies did not increase during their tenure.

The next group is "The Successful Professionals." These were the women who not only designed typefaces that became popular, sold well and were honored, but also managed to foster their career through networking. All of them are present in the typography scene, yet as Dechant claims, some of them "(unfairly) acquired a negative reputation" due to their excessive ambition.[57] In this group she includes Sybille Hagmann, Verena Gerlach, Veronika Burian, Andrea Tinnes, and Laura Meseguer.

Dechant mentions that one can find a lot of female type designers in Russia. In her opinion this is due to cultural policies that have brought some advantages to women.[58] As a designer from Russia, my intuitive guess would be that type design did not exist in Russia as a separate major, rather it was offered as a course in art schools. Art universities in Russia are mostly occupied by women. Unfortunately, gender stereotypes are still quite present in the educational system and therefore men choose a profession connected to technology, mathematics and women pursue careers in art and literature.

FEMALE TYPE DESIGNERS

Another work dealing with the question of women in typography called "Female Type Designers" (Gestatten, Schriftgestalterin). It was written by Michael Rosenlehner in 2012 as a part of his thesis at the University of Applied Sciences in Potsdam

under the supervision of professor Lucas de Groot.[59] The PDF of his work can be find online. It was uploaded by PAGE. This work gives a short overview of the situation and has a list of 289 female type designers. It includes short biographies of most of the designers and presents some samples of their work. There is also a chapter dealing with women working in printing, bookbinding and book design in the 15th century.

TYPEQUALITY ONLINE PLATFORM

Stockholm-based student Kim Ihre was stunned by the lack of information on women while researching typographers. She decided to turn her frustration into an opportunity for change, and chose this issue as the subject of her graduation project in Beckmans College of Design. In 2015 she launched the online platform Typequality—a database of typefaces designed by women. This platform can be edited by anyone. As the author mentions in one of her interviews, she realized that it was important to her to create an open platform that anyone can contribute. As Ihre says, she "felt tired of the notion that one person could have the privilege to decide what's to be seen and what's not, or to decide what's good enough."[60]

BADASS LIBRE FONTS DESIGNED BY WOMXN

Among the most recent works created there is an online database called Badass Libre Fonts designed by Womxn.[61] It was curated and coded by Loraine Furter. Her work aims at giving visibility to fonts designed by women. As the name suggests, all the fonts on the site are shared under Free and Open Source licenses. This allows anyone to download and use them for free. In contrast to Typequality, Badass Libre Fonts has a preview of all typefaces and allows you to type in any text into the preview line. As part of my research for this project, I interviewed Furter. See page 133 of this book.

Image provided courtesy of Monotype Imaging Inc. All rights reserved.

Early Female Type Designers

Early Female Type Designers

"While the field of type design is predominantly male, several women have made contributions so significant, they touch the experience of nearly anyone living in the Western world today."[62]

During my research, I came across the names of Zuzana Licko and Carol Twombly as early female type designers repeatedly. Both of them are known for their achievements in the typography field. I was sure that there were other women working as type designers during the same time period or even earlier. This sparked my curiosity to find out who the first female type designers were.

Luckily, I was not the only one interested in this topic and I landed at the Alphabettes webpage. The first relevant article titled "First/Early Female Typeface Designers" was written by Indra Kupferschmid in September 2017.[63] Kupferschmid was interested in only the women who were credited with a typeface design. She was not concerned with those who contributed to this field in some other way. The list that Kupferschmid published in this article looks as follows (name, first released typeface, type foundry, release date):

- *Hildegard Henning, Belladonna, Klinkhardt, 1912*
- *Elizabeth Colwell, Colwell Handletter, ATF, 1916*
- *Maria Ballé, Ballé Initials, Bauer, 1920s*
- *Elizabeth Friedländer, Elizabeth, Bauer, ±1937*
- *Ilse Schüle, Rhapsodie, Ludwig & Mayer, 1951*
- *Gudrun Zapf von Hesse, Diotima, Stempel AG, 1952–54 (Ariadne 1953, Smaragd 1954, etc.)*
- *Anna Maria Schildbach, Montan, Stempel AG, 1954*

Kupferschmid mentioned her discussion with Dan Reynolds and wrote, "After the war, West German type foundries published a couple of typefaces designed by women, but of the pre-war typefaces, Dan could so far not find more than the two mentioned

above—the Belladonna and Elizabeth types."[64] Also there are a lot of debates about whether the Ballé Initials count as a typeface. Some sources state they were "not actually cast as a foundry type, but rather electrotypes mounted on metal."[65] Further, Kupferschmid writes that, she finds the idea that Anna Simons might have designed some types of the Bremer Presse intriguing, however, it seems to be speculation, not actually a fact.[66] Therefore, she does not include Simons in this list. There are couple of designers that are mentioned in the comments under the article.

- Franziska Baruch, Stam, Berthold, 1920s
- Friedel Thomas, Thomas-Schrift, Typoart, 1958

This list provided me a great basis for my further research. My aim was to learn more about these women and find others. The amount of information I managed to collect on these designers varies from person to person. In some cases it was quite easy to find it, owing to the fact that some researchers already wrote about them. Yet some names were more challenging and had a very limited amount of literature available about them. Therefore, I would like to share the information I found. This chapter offers information about female type designers working in the 18th and 19th century. By no means is this a comprehensive biography of each designer. Rather, I would like to share the data that I have gathered about these individuals and give an overview of the field during this time and women's role within it.

EDUCATION FOR WOMEN

I met with Dan Reynolds who recently finished his PhD about type foundries in the 19th century to discuss his research and find overlaps with this list of women. He has become a great advisor for me in this project and helped me to understand the conditions that were surrounding women at that time. He recommended the book

From the Piano Type to the Line Setting Machine: Setting Machine Development and Gender Issue 1840–1900 by Brigitte Robak.[67] This book is about the introduction of typesetting machines in Germany and women workers in this time frame. Reynolds explain that when typesetting machines were first created they were not viewed as serious things. Therefore, women were operating them. In the 1890s Linotype machines were introduced. These were considered serious for the first time. These were also the same machines that put typesetters out of work because it eliminated the need for manual typesetting. During this time male typesetters would typically say, "We are going to get those jobs. If we are going to be replaced by machines, we are going to operate those machines. We are not going to be replaced by machines and by women workers."[68] Women made only small inroads into the printing industry in the 19th century with these machines before they became normal.

Moreover, it was not until the early 1900s that women were allowed to study arts and design in Germany. In many European countries, women got access to education earlier than in Germany (for example, in Russia—in 1860; in France—in 1863).[69] In 1870 the University of Leipzig allowed women to attend lectures only as non-degree students. Only in the summer semester of 1906 were women given the opportunity to enroll in a regular university. To put that into perspective, by that time, Marie Curie had already received a professorship at the Sorbonne in Paris. The situation with education varied a lot across Germany because, just like today, the universities were controlled by the individual federal states. So, every federal state had a slightly different policy. Prussia, as one of the states, occupied almost two-thirds of the country's territory. In Prussia women were not allowed to study until 1906.[70] Famous designers and typefaces started to appear around 1900. These designers were people who went to school in the 1880s and 1890s and had successful careers in design. To be hired as a de-

signer by a type foundry, a person needed a relevant education. Foundries did not just take people from the street. Even when women got access to education, they were limited in their choices. Indeed, at the Bauhaus—a place open to "any person of good reputation, regardless of age or sex," a space where there supposed to be "no differences between the fairer sex and the stronger sex"— at the beginning women were allowed to study weaving.[71] Walter Gropius's (founder of the Bauhaus School) declaration of gender equality was never realized in the way he initially professed.[72] Architecture, painting, and sculpture were reserved for the "stronger sex", while the "fairer sex" was offered other disciplines that were not, in the founder's opinion, so physical. According to Walter Gropius, women were not physically and genetically qualified for certain arts because they thought in two dimensions, compared to their male partners, who could think in three.[73]

This is one of the reasons why there were not many women involved in developing typefaces before the First or even before the Second World War. There just were not many opportunities for women to be trained at the level that would allow them access to these kinds of jobs.

ANNA SIMONS (1871–1951)

Although Kupferschmid excluded Anna Simons from her list of early typeface designers due to the fact that she did not design a typeface, I believe it is crucial to mention her name. She was a very important figure in typography in that period. In our conversation, Dan Reynolds mentioned that, "The person who was really important during this time is Anna Simons. She's not a type designer but she is one of the most important people in type at the time." In order to fully understand "the development and the ensuing achievement of this artist it is necessary to remember that at the end of the last century it was still almost impossible for women in Prussian Germany to enter State School or Academy of Art or Arts & Crafts."[74] In 1896 Simons

went to study at the Royal College of Art in South Kensington where women were freely admitted, and where Walter Crane was Principal at the time. She was a student there when Edward Johnston started teaching calligraphy.

Simons said, "At the time of Mr. [Edward] Johnston's appointment [in 1902] to the Royal College of Art I had the good fortune to be a student there for at that time women students were not admitted to Prussian Arts and Crafts Schools."[75] Edward Johnston is responsible for a worldwide calligraphic revivalry. He worked with Eric Gill and was an important figure in the British typography and printing in the early 20th century. Simons was one of his students. As early as 1905 she was entrusted, in place of Edward Johnston, who was unable to come to Germany himself, with courses in writing and lettering which had been recently organized by the Prussian Ministry at the Art Academy in Düsseldorf where Peter Behrens was a director. Simons was Behrens's assistant and later, together with him, produced the lettering of the German Reichstag.[76]

Anna Simons came to Germany from time to time and taught at different schools on a temporary basis. She still had her main residence in London until the First World War broke out and she had to go home. She started teaching in Düsseldorf, but she ended up everywhere. Simons taught in Halle, in Zurich, and in Munich. Eventually she was made a professor both in Prussia and Bavaria. Back then the "professor" title was very important. She had been teaching for a long time—through the 1920s and 30s. Although she never designed any typefaces herself almost all typeface designers who worked in Germany after 1907 until the Second World War attended some classes of hers. Even if the class lasted for just two or three weeks. She

Fig. 1. Calligraphy by Anna Simons in Elective Affinities by Goethe

introduced writing with a broad pen as a design tool in Germany. Her influence was very significant and it is hard to imagine things turning out the way they did without her. For example, Weiß-Antiqua, designed by Emil Rudolf Weiß, is still one of the most used serif typefaces in Germany. Dan Reynolds truly believes that "it's really hard to imagine him having designed Weiß-Antiqua without sort of being "woken up" to these kinds of letterforms by Anna Simons."[77]

There is a lot of speculation on why Anna Simons did not design any typefaces. Simons was a working calligrapher, which is really close to type design. It is hard to imagine that she could not make a typeface. Perhaps no one ever asked and that is why she did not do it. It is also possible that she was not interested in typeface design because it was too removed from calligraphy. This is just speculation. Everyone is going to have a different theory on why people did not ask her to design a typeface. However, she must be mentioned as an important figure in typography of that time. When you talk about design and letterforms, type design is just one area. There are many other areas where letters were being made. Reynolds does not believe that "you can make a top 5 list of anyone having to do with letters in Germany between 1900 and 1950 and not have Anna Simons among one of these five names, even though there are no typefaces from her."

There is a book called "Titel und Initialen für die Bremer Presse" in the Berlin Art Library.[78] It is a portfolio of prints of initial letters and titles that she drew for the Bremer Presse. The Bremer Presse was one of the German private presses and they were located in Munich. All their books were printed in their own typefaces. That is also why there is some speculation whether Anna Simons might have played a role in the typefaces' design. However, the owner of the press wrote a lot about how the type-

Fig. 2. Calligraphy by Anna Simons in La Divina Commedia by Dante

faces were created and Simons was not mentioned in his texts. She created initial letters for chapters or title lettering for the title pages. They're entirely typographic. Simons did not believe in ornamentation. Usually, medieval initial letters are colorful with people and ornament inside. Simons thought that the letter was decoration enough in itself. She would pick a letterform or a combination of letters and there were no extras, no leaves growing around the letter—just a letter. If you look at it, especially at the titles, you can certainly imagine them as a typeface.

HILDEGARD HENNING (UNKNOWN)

Hildegard Henning is the first name on the list compiled by Kupferschmid. She designed the Belladonna typeface released first by the Julius Klinkhardt type foundry in 1912.[79] Until now Henning is considered the first women to design a typeface. Not much is known about Henning. One of the sources that mention her name is the webpage luc.devroye.org. It was launched in 1993 and is still edited by Luc Devroye himself who lives in Montreal, Canada. This encyclopedic page offered the following information about Henning: "German type designer at Julius Klinkhardt. She designed Belladonna-Kartenschrift (1912, Julius Klinkhardt)."[80] Another source that has information about Henning is the type archive of Klingspor museum. The PDF that I found there had the image of the Belladonna typeface. It is a scan of the sample from the H. Berthold AG who acquired the Julius Klinkhardt type foundry in 1920.

When I asked Dan Reynolds about Hildegard Henning, he assumed that she was a student in the Art Academy in Leipzig, because they started to offer type classes in 1905 and women were allowed to study there. During my research I discovered that she exhibited some work at the International

Fig. 3. Typeface Belladonna by Hildegard Henning

EARLY FEMALE TYPE DESIGNERS 67

Fig. 4. Das Haus der Frau at Bugra Exhibition

Exhibition for the Book Trade and Graphic Design called "Bugra" (Internationale Ausstellung für Buchgewerbe und Graphik in Leipzig) that opened in May 1914, shortly before the war started. "Bugra" had special exhibitions for certain professions and interest groups that had their own pavilions. One of them was dedicated to women in the industry and was called "Die Frau im Buchgewerbe und in der Graphik" ("Women in the Book Industry and Graphic").[81] It was located in a separate building named "Das Haus der Frau" ("The House of the Woman"). Intensive research in the library led me to a separate catalogue of this particular pavilion under the title "Das Haus der Frau auf der Weltausstellung für Buchgewerbe und Graphik. Leipzig 1914" ("The House of the Woman at the World Exhibition of Book and Graphic Arts"). This book has a photo of the exhibition hall that was built according to plans of Emilie Winkelmann. A precise floor plan of the building and division of the space is included. Furthermore, it has introduction texts for each theme (in total 25) and lists of participants and their items. Room number 12 was dedicated to artistic typefaces (Künstlerische Schrift). The abstract explains, "This section shows the activity of the women in the field that has only recently been opened to them."[82] On the following page I found the name of Hildegard Henning. She exhibited 2 handwritten books. One is called "Ossian: Death of Cuthulin. Original" and the second one "Goethe: Die Geschwister. Original". At the end of the catalogue in the chapter "Adressentafel" (Address Panel) the name of Henning, Hildegard popped up again with her address in Leipzig—Sophienplatz 5. "Bugra" exhibition was closed on October 18, 1914 and left the city of Leipzig with half a million Reichsmarks in debt. All buildings had to be demolished to make room for the drill fields for military exercises. Most of the exhibits were safely stored in the museum. However, the museum

was severely hit during the World War II bombing of Leipzig in 1943 and about three-quarters of the "Bugra" saved books and artifacts were destroyed.[83]

ELIZABETH COLWELL (1881–1954)

Elizabeth Colwell designed Colwell Handletter and Colwell Handletter Italics in 1916. Yet she was not only typeface designer, but also a painter, printmaker, and author.[84] She is remembered for her watercolors, etchings and woodcuts. Martha Elizabeth Colwell was born in Bronson, Michigan, on May 24, 1881.[85] Colwell studied at the School of the Art Institute of Chicago (AIC). Her teacher, Bror Julius Olsson Nordfeldt, taught her Japanese woodblock printing. In 1899 she met Thomas Wood Stevens and started contributing illustrations and poetry to editions of the magazine "The Blue Sky." She also worked in advertising in Chicago and her clients included Marshall Field's department store and the W.K. Cowan & Company furniture store. She was known for her hand-lettered newspaper advertisements. There is a blog page called "Tenth Letter of the Alphabet" by Alex Jay.[86] It has surprisingly detailed information about Colwell's life and career. It also contains samples of her work, many of which are hand-lettered advertisements for W.K. Cowan & Company. Colwell also published books of her poetry with hand-lettered text and her own illustrations. One of them was a book of poetry called *Songs & Sonnets*.[87] In addition, she was a member of the Chicago and New York Societies of Etchers and the Chicago Society of Artists. Colwell's work was exhibited widely throughout her career in Boston, Chicago, New York City, San Francisco, Washington, Rome and other cities. She was the only woman to have her typeface exhibited at the American Institute of Graphic Arts

Fig. 5. Italic Alphabeths by Elizabeth Colwell

1948 exhibit "American Type Designers and Their Type Faces on Exhibit." In the book *American Type Designers and Their Work* by Carl Purington Rollins published in 1947, she is listed as a letterer and as "the only American woman type designer known."[88]

MARIA BALLÉ (UNKNOWN)

Maria Ballé was a designer of fonts such as Ballé Initials, a series of light floral initials, at the Bauer Type Foundry. Ballé Initials are widely known in design circles. There are several webpages that have samples of her initials. The digital version can be found on MyFonts as Maria-Ballé-Initials and Alea. Andreas Seidel made a digital version of Ballé Initials in 2005 and called it Alea. Maria Ballé and Andreas Seidel are both mentioned as the designers. The description says, "Alea is based on the drawings of Maria Ballé. The floral, organic look of these bastard script initials will play well together with nearly all Didone designs and will give them a special note." In 2007 ARTypes created another version called Maria-Ballé-Initials. It was published on MyFonts in 2007 and cost €27. The webpage Fonts In Use also has information about Ballé Initials. It states that the Initials were drawn as "a festive decorative complement to Bernhard Schönschrift."[89] Moreover, it has further information about revivals and digital version of the typeface: "VGC revived it for the Photo Typositor. Digitized by David Rakowski as Wein-Initials (Intecsas, 1994), by Paulo W as Bailarina (Intellecta Design, 2007) and by Dick Pape as Pepin Press Caps FA143 (freebie, 2009)."[90] As was already mentioned earlier there are a lot of debates whether the Ballé Initials count as a typeface. Some sources, including the Wikipedia page of Bauer, say that Ballé Initials were "not actually cast as a foundry type, but rather electrotypes mounted on metal."[91]

Fig. 6. Ballé Initials by Maria Ballé

Florian Hardwig helped me find additional information about Maria Ballé. He shared a link to a digital archive of German magazines. Several issues of the "Das Plakat" ("Poster") magazine mentioned Maria Ballé's name. It seems that Ballé participated in various competitions. For example, in the magazine from June 1919 she was shortlisted. It also had her address—Keplerstraße 35, Frankfurt am Main.[92] The issue from May 1920 had the results of a poster competition for the artists living in Frankfurt. Maria Ballé shared the first place with Ulbert Fuß and received 1500 Marks as the prize. Unfortunately, the magazine does not include her work.

Fig. 7. Design of the cigarette package by Maria Ballé

In the next issue she is again shortlisted as the author of one out of 20 best designs for the Schönberger Cabinet Mainz (German Champaign Company).[93] Besides that she was the winner of the best cigarette package competition for the company J. Pilnik & Cie., Stuttgart. Her sketch is included in the magazine (Fig.7). The next magazine that has information about Ballé is "Gebrauchsgraphik, International Advertising Art" ("Commercial Graphics, International Advertising Art"), April 1932, editor H.K. Frenzel. This magazine presents the Beton type and its specimen from the Bauer Type Foundry. Maria Ballé is named as the designer of the German Beton Type Specimen. It says, "The German edition, got up by Heinrich Jost, the inventor of the type, assisted by Maria Ballé, is astonishingly versatile and extremely practical. This girl artist displays her typographic talent and her feminine feeling for an enchanting play of line above all in the rhythmical setting in which she uses the lighter forms of Beton and in her gaily-colored vignettes."[94] This suggested that Maria might have been working in Bauer while Heinrich Jost was an art director there (1923–1948). The next advertisement magazine I found proved my assumption. It is called "Die Reklame" ("Advertising") and had a text about commercial art written by Albert Windisch.

EARLY FEMALE TYPE DESIGNERS

He writes that Maria Ballé is doing quite proficient work and has already won several competitions. He also states that Maria Ballé together with another artist Änne Müller-Knatz work as illustrators at Bauer Type Foundry.[95]

FRIEDEL THOMAS (1895–1956)

Friedel Thomas is a type designer who was recommended to me by Florian Hardwig. She designed the typefaces Thomas-Schrift and Thomas-Versalien released by VEB Typoart in 1958. One would not guess that it is a woman since "Friedel" is not a common female name. There is a short biography of her life in the book Women in Graphic Design. It says that Thomas was one of the first students in the lettering course of Anna Simons in Halle in 1917. Later in 1921/22 Thomas was an assistant in Simons' studio in Munich. Later in 1922 Thomas "was named Director of the newly established printing workshop at Burg Giebichenstein [...] In 1950 she returned to Burg Giebichenstein and taught typeface design as well as graphic design from 1954."[96]

FRANZISKA (FRANZISCA) BARUCH (1901–1989)

Franziska Baruch designed Stam—a Hebrew typeface for Berthold in the 1920s. Baruch studied between 1919 and 1925 at the Educational Institute of the Prussian Museum of Decorative Arts in Berlin, where she attended a class for graphics and book art by Ernst Böhm. In addition, she took private courses in type design writing with Else Marcks-Penzig.[97] She worked as a graphic designer and designed typefaces for the pavilion of the German League of Free Welfare for the "GeSoLei" exhibition in Düsseldorf in 1926.[98] In 1928 Baruch was commissioned by Edwin Redslob to be responsible for the typographic aspects of state self-expression at the "Pressa" exhibition in Cologne.[99] Baruch's Hebrew typeface Stam was designed as a revival font. The letterforms were inspired by a Haggadah, a Jewish text dating back to 1526, printed with wooden type by the Gersonides

family of printers in Prague. The typeface Stam was published in 1928 by the H. Berthold AG. It is used on the letterhead of official letters of the State of Israel. Baruch created a lighter version of Stam for Leo A. Mayer, professor teaching at the Hebrew University of Jerusalem.[100]

There is a short overview of the exhibition, which had works by Moshe Spitzer, Franziska Baruch, and Henri Friedlaender in Leipzig by Dan Reynolds where he writes, "While it was not mentioned in the exhibition, I suspect that Baruch was commissioned to design Stam by Oscar Jolles, who was Berthold's director in the 1920s. Jolles was a prominent figure in the Berlin Jewish community, and Berthold's publication of Hebrew type specimen took place during his tenure."

Baruch worked for the publisher Schocken. In 1940, on the request of Gershom Schocken, Baruch designed the typeface Schocken. It was used, for example, for the printed autobiography of Israel's first president Chaim Weizmann. Schocken-Baruch was released by Monotype in 1949.[101] Baruch immigrated to Palestine in 1933. A lot of her graphic design for the State of Israel and for her Israeli clients was significant, but she never wrote about it. For instance, she designed the title lettering for the daily newspaper "Ha'aretz" published by Salman Schocken in 1936, which is still used today.[102] In 1948, Baruch designed some of the official insignia of the recently-declared state of Israel: from the state emblem to the cover of the Israeli passport, to the emblem of the city of Jerusalem and the emblems of other institutions.[103]

Franziska Baruch was in a similarly vague situation as Elizabeth Friedlander. Both of them were young women whose careers started in Germany and then the nightmare of the Holocaust happened. They had to leave. They both built successful careers as designers in new countries—Baruch in Israel

Fig. 8. Stam by Franziska Baruch

בראש אשמורות
ולכל בני ישראל

and Friedlander in England. It worked out for them. However, this is the point where their stories took a dark turn. Baruch's family members were murdered in Theresienstadt in 1943.

ELIZABETH FRIEDLANDER (1903–1984)

Elizabeth Friedlander designed typeface Elizabeth released by Bauer in around 1937. She is one of the more well-known women type designers. It is easier to find information about her since she has been a focus of some interest recently, in part due to her complex story and the fact that she was a Jewish woman born in Berlin. There are several articles about her online. For example, on the webpage "It's Nice That" the article with the title "Elizabeth Friedlander: One of the First Women to Design a Typeface" written by Billie Muraben was published on the International Women's Day in 2018.[104] Additionally, there was an exhibition in Ditchling Museum of Art + Craft between January 6th 2018 and April 29th 2018. It included her type design work, wood engravings, decorative book papers, maps and commercial work. It also told the story of her life through such events as her escape from Nazi Germany and her friendship with a printer and poet Francis Meynell, together they collaborated with a wartime British black propaganda unit. This exhibition was co-curated by a video artist and author Katharine Meynell, granddaughter of Francis Meynell. Katharine was also represented in the exhibition with her own work. She has recently scripted and produced a 23-minute film "Elizabeth" that depicts the little-known story of Elizabeth Friedlander's life.[105] Moreover, there is a gorgeous book by Pauline Paucker "New Borders: The Working Life of Elizabeth Friedlander" published by Incline Press in 1998. It has a detailed description of her life and reproduced samples of her work. Paucker decided to make this book after

Fig. 9. Unissued display face by Elizabeth Friedlander © Incline Press

she discovered an archive of materials related to Friedlander at the University of Cork. The book is based on the workbooks which Friedlander kept throughout her life. There is also an overview of her life and work on Princeton's website "Unseen Hands."

Elisabeth Betty Friedländer (later she spelled her name Elizabeth Friedlander) was born on October 10th, 1903. Her parents were German Jews living in Berlin-Charlottenburg. She studied art at the Berlin Academy and specialized in typography and calligraphy, with Professor Emil Rudolf Weiss. After graduating she worked with a big publishing house named Ullstein in Berlin and was responsible for article headings and layout for their leading publication—the women's magazine "Die Dame" ("Lady").[106] She also freelanced and her most important commission took place in 1927—the invitation to design a typeface for the Bauer Type Foundry in Frankfurt am Main by the firm's director Georg Hartmann. "It was not so usual for a woman to design a type, the introduction may well have been via her teacher, Weiss, who himself designed types for Bauer."[107] Based on Hartmann's letters to Elizabeth it is obvious that she and Hartmann had known one another for some time. "He proved himself as a supportive and understanding, true friend in hard times."[108] Sadly, production of the Elizabeth typeface was held up by the depression after the Stock Market crash, and by the time Hartmann was ready, the Nazis were in power and Hartmann realized there was just no way he could publish a product that was called Friedländer-Antiqua. Normal practice would have been to name the typeface after the designer's last name, but in Germany "Friedländer" was considered a distinctively Jewish name. The typeface was originally meant to be named Friedländer-Antiqua. However, Adolf Hitler came to power just as

Fig. 10. Elizabeth Bold by Elizabeth Friedlander © Incline Press

EARLY FEMALE TYPE DESIGNERS

the type was ready to be cast. Hartmann suggested using Friedlander's first name instead of her Jewish last name and this meant that at least some mark of the designer's identity was retained, with the hope that the type could still be promoted in Nazi Germany. The font was cut in 1939, after Friedlander left the country. She moved to Italy for a while and later to England, where she lived and worked for 22 years. She made a successful career in more than one country. Her name is associated not only with the elegant Elizabeth typeface, but also with her patterned papers for Curwen and Penguin Books, decorative borders for the Linotype Corporation, printer's flowers for Monotype, and calligraphy for the Roll of Honour at Sandhurst.[109]

ILSE SCHÜLE (1903–1997)

Ilse Schüle is a German type designer mostly famous for her lettering, book jackets, covers and a typeface Rhapsodie. She was born in 1903 in Vaihingen as Ilse Brentel. Schüle studied graphics at the School of Arts and Crafts in Stuttgart and her teacher was Friedrich Hermann Ernst Schneidler.[110] After graduating Schüle herself became an instructor there and was assisting Schneidler from 1925 to 1929.[111] After her marriage (1929) and the birth of twins (1930) she continued her freelance career as a punch cutter, typographer and designer.[112] In particular, she produced a lot of book covers for the German publisher Deutsche Verlags-Anstalt Stuttgart. I often came across the book *Kunst und Macht* (*Art and Power*) by Gottfried Benn published by Deutsche Verlags-Anstalt in 1934. Ilse Schüle designed a calligraphic cover for this book. Another book cover that she designed is for the Max Frisch's novel *Jürg Reinhart. Eine sommerliche Schicksalsfahrt* (Jürg Reinhart. A Summery Fate Ride).

Schüle created the bastarda font Rhapsodie she is most known for in 1949-1951 that was cast by Ludwig & Mayer, Frankfurt, Germany.[113] Rhapsodie

Fig. 11. Kunst und Macht Cover by Ilse Schüle

was relatively often used in hot metal typesetting and is comparable, for example, with the typeface Salto by Karlgeorg Hoefer. It can be found as a lead type font today. In the Berlin Art Library I found a small magazine dedicated to the Rhapsodie font that is called "Rhapsodie. Nach Zeichnung von Ilse Schüle" ("Rhapsodie. By the Drawing of Ilse Schüle"). It is a kind of type specimen printed on old paper with uneven edges. It includes illustrations of people, buildings and ornamental borders printed in color. Text appears in various sizes and colors. Unfortunately, no information about the author of the font is available.

Ralph Unger designed his Rhapsody (2006) based on Rhapsodie that is available on MyFonts for €31.99. The description mentions that "Rhapsody, had its origins in the 50s, was redesigned, completed and expanded by Unger for the URW++ FontForum." However the name of Ilse Schüle is not mentioned. There is also a free font based on Rhapsodie called XmasTerpiece.[114]

Fig. 12. Rhapsodie by Ilse Schüle

GUDRUN ZAPF VON HESSE (GZVH) (1918–2019)

Gudrun Zapf von Hesse is another talented female type designer. In contrast to designers mentioned above she designed many typefaces. For almost 70 years she has been designing typefaces for metal, photo and digital type technologies. She turned 101 years old on January 2, 2019.

Between 1937 and 1940 she did an apprenticeship as a bookbinder with Prof. Otto Dorfner in Weimar.[115] During this time, Zapf von Hesse started learning calligraphy using books by Rudolf Koch and Edward Johnston.[116] After finishing her master's degree in bookbinding she worked in Berlin and joined the lettering lessons of Johannes Boehland (Schriftunterricht bei Johannes Boehland an der Meisterschule für Graphik und Buchgewerbein Berlin 1941).[117]

After WWII Gudrun von Hesse was not able

to move back to her hometown. In 1948, equipped with a portfolio, she introduced herself at the Bauer Type Foundry, based in Frankfurt am Main. The foundry director Georg Hartmann gave her a chance to maintain an in-house hand bookbindery and allowed to work for other clients as well. "At Bauer, Zapf von Hesse met art director Heinrich Jost and type designer Konrad F. Bauer and learned much about the manufacturing process of metal type. Her kind nature was much appreciated and her skills were highly valued."[118] At one point in time Zapf von Hesse approached the punch cutters at Bauer and observed them at work. Moreover, she was brave enough to ask if she could try to do it herself. "Punchcutting was not practiced by women until that time—if there were exceptions, they were remarkable."[119]

Without much training, in 1948 she designed her first capital alphabet as well as accompanying figures and ornaments in 36 point. "The letters were first used for the titling of the anniversary book, published by the Bauer Type Foundry on the occasion of Georg Hartmann's 75th birthday (printed in 1946, bound a year later)."[120]

Between 1946 and 1954 she taught lettering at the Städelschool, State Institute of Fine Arts in Frankfurt. There during one exhibition in 1948 she met her future husband Hermann Zapf and also David Stempel, the owner of the type foundry D. Stempel AG.[121] Zapf von Hesse was commissioned to design her first Diotima Roman by the Stempel foundry. "The Diotima, Diotima Italic, Ariadne Initials and the headline type Smaragd (Emerald) came out as metal types during the years 1951-1954."[122] Later she designed several other alphabets: Shakespeare Roman and Italic as an exclusive type for Hallmark Cards Inc. in Kansas City, and Carmina for Bitstream Inc. in Cambridge/Mass., followed by Nofret and Christiana for H. Berthold AG in Berlin and Alcuin and Colombine Script for URW in Hamburg.[123]

Fig. 13 Diotima Classic by Gudrun Zapf von Hesse © Monotype

In 1991, Hesse became the second woman to receive the Frederic W. Goudy Award, the distinguished award in the field of book- and type design in the United States. An exhibition in honor of the contributors Hermann and Gudrun Zapf "Calligraphic Type Design in the Digital Age" took place in San Francisco in the fall of 2001.

Later to mark her 100th birthday in 2018 Monotype released the titling typeface Hesse-Antiqua. It is based on an alphabet for book jackets she designed in the late 1940s. "She developed her alphabet during her time in Frankfurt, where she punch cut the letters onto wooden handles and used them for title lettering on leather book covers and spines."[124] Ferdinand Ulrich worked closely with Hesse to digitize her alphabet. "This is a transformation of the Hesse-Antiqua from a lettering alphabet into a typeface," he explained. He visited Hesse in Darmstadt several times. There is an article on FontShop called "Hesse Antiqua—Typeface Release at 100" written by Ferdinand Ulrich where he describes the process in detail. For a more complete biography of Gudrun Zapf von Hesse watch Ferdinand's closing talk at TYPO Berlin 2016.

ANNA MARIA SCHILDBACH (1924–UNKNOWN)

Anna Maria Schildbach designed a bold condensed titling font Montan (1954).[125] She worked at Stempel in the 1950s before becoming a teacher.[126] In one of the Stempel AG reports out of 48 type designers listed there were only 2 women—Anna Maria Schildbach and Gudrun Zapf von Hesse. According to my research, Montan was digitized by Carmen Mauerer in 2012, based on original stencils and is still unreleased. Sadly, I did not manage to find more information about Anna.[127]

Endnotes

[1] S. Hagmann, "Non-existent design: women and the creation of type," *Visual Communication*, vol. 4(2), 2005, p.192.

[2] I. Urbina Peña, "About the gender gap," *Yesequal.us*, 2015, http://www.yesequal.us/112-2/. Accessed February 24, 2019.

[3] V. Gerlach, "Where are the Women in Type Design," *Typographica*, 22 February 2011, http://typographica.org/on-typography/where-are-the-women-in-typedesign/. Accessed February 4, 2019.

[4] R. Bringhurst, *The Elements of Typographic Style*, 4th ed., Vancouver, Hartley and Marks Publishers, 2016, p.240.

[5] Slanted Publisher, *Year Book if Type 2*, Karlsruhe, Slanted Publishers, 2016, p.386.

[6] "SOTA Typography Award," *The Society of Typographic Aficionados*, http://www.typesociety.org/typography. Accessed February 14, 2019.

[7] Y. Peters, "Women in Type," FontShop, March 19, 2015, https://www.fontshop.com/content/women-in-type-design. Accessed February 24, 2019.

[8] "Prix Charles Peignot," *Association Typographique Internationale*, https://www.atypi.org/about-us/prix-charles-peignot. Accessed January 20, 2019.

[9] "TDC Medal Winners," *The Type Directors Club*, https://www.tdc.org/medalists. Accessed January 20, 2019.

[10] "Typeface Design Winners," *The Type Directors Club*, https://www.tdc.org/tdc-typeface-design-winners. Accessed January 12, 2019.

[11] *Gerrit Noordzij Prize*, http://gnprize.org. Accessed March 23, 2019.

[12] S. Dechnat, "Type Person Who Happen to be Female Women," in Breuer, G. and J. Meer (eds.), *Women in Graphic Design 1890-2012*, Berlin, Jovis, 2012, pp.193-198.

[13] Conferences 2017, *Alphabettes*, January 4, 2017, https://www.alphabettes.org/conferences-2017. Accessed December 16, 2018.

[14] I. Urbina Peña, "About the gender gap," *Yesequal.us*.

[15] See interview with Anna Regidor in this book page 195.

[16] Dechnat, "Type Person Who Happen to be Female Women," p.196.

[17] Hagmann, "Non-existent design: women and the creation of type," p.194.

[18] Peters, "Women in Type," *FontShop*.

[19] Associate Professor Gerry Leonidas, email message to author, November 9, 2018.

[20] Leonidas, email message.

[21] Hagmann, "Non-existent design: women and the creation of type," p.10.

[22] Mona Franz, email message to author, December 16, 2018.

[23] Leoni Adams, email message to author, February 23, 2018.

[24] Hagmann, "Non-existent design: women and the creation of type," p.188.

[25] M. Madeleine, "The Women Redressing the Gender Imbalance in Typography. Fonts that subvert sterotypes," *AIGA Eye on Design*, September 28th 2016, https://eyeondesign.aiga.org/the-women-readdressing-the-gender-imbalance-in-typography. Accessed January 12, 2019.

[26] Hagmann, "Non-existent design: women and the creation of type," p.188.

[27] Madeleine, "The Women Redressing the Gender Imbalance in Typography. Fonts that subvert sterotypes."

[28] "WD + RU," *Grafik*, https://www.grafik.net/category/feature/wd-ru, March 9, 2015. Accessed December 12, 2019.

[29] "WD + RU," *Grafik*.

[30] L. Webber, "Women Typeface Designers," *Master Thesis*, Rochester Institute of Technology, 1997, p. viii.

[31] Webber, "Women Typeface Designers," p. 10.

[32] Webber, "Women Typeface Designers," p. 10.

[33] Hagmann, "Non-existent design: women and the creation of type," p. 187.

[34] Hagmann, "Non-existent design: women and the creation of type," p. 187.

[35] Hagmann, "Non-existent design: women and the creation of type," p. 189.

[36] Hagmann, "Non-existent design: women and the creation of type," p. 189.

[37] Hagmann, "Non-existent design: women and the creation of type," p. 189.

[38] Gerlach, "Where are the Women in Type Design," *Typographica*.

[39] Hagmann, "Non-existent design: women and the creation of type," p. 189.

[40] Hagmann, "Non-existent design: women and the creation of type," p. 189.

[41] Hagmann found these images in *Type and Typography*, Baines and Haslam, 2002 (as cited by Hagmann).

[42] Hagmann, "Non-existent design: women and the creation of type," p. 188.

[43] Hagmann, "Non-existent design," p. 188.

[44] Gerlach, "Where are the Women in Type Design," *Typographica*.

[45] Gerlach, "Where are the Women in Type Design," *Typographica*.

[46] Gerlach, "Where are the Women in Type Design," *Typographica*.

[47] Gerlach, "Where are the Women in Type Design," *Typographica*.

[48] Dechnat, "Type Person Who Happen to be Female Women," p. 191.

[49] Dechnat, "Type Person Who Happen to be Female Women," p. 196.

[50] Dechnat, "Type Person Who Happen to be Female Women," p. 196.

[51] Dechnat, "Type Person Who Happen to be Female Women," p. 194.

[52] Dechnat, "Type Person Who Happen to be Female Women," p. 194.

[53] Dechnat, "Type Person Who Happen to be Female Women," p. 194.

[54] Dechnat, "Type Person Who Happen to be Female Women," p. 195.

[55] Dechnat, "Type Person Who Happen to be Female Women," p. 195.

[56] Dechnat, "Type Person Who Happen to be Female Women," p. 195.

[57] Dechnat, "Type Person Who Happen to be Female Women," p. 196.

[58] Dechnat, "Type Person Who Happen to be Female Women," p. 194.

[59] M. Rosenlehner, "Gestatten, Schriftgestalterin," *Bachelor Thesis*, University of Applied Sciences Potsdam, 2012.

[60] K. Ihre, "Guest blogger: Kim Ihre," *Hall of Femmes*, http://halloffemmes.com/author/ihre. Accessed November 23, 2018.

[61] L. Further, *BADASS LIBRE FONTS BY WOMXN*, http://design-research.be/by-womxn. Accessed November 4, 2018.

[62] E. Lupton, "Women in Graphic Design" in Breuer, G. and J. Meer (eds.), *Women in Graphic Design*

[63] I. Kupferschmid, "First/early female typeface designers," *Alphabettes*, September 21 2017, http://www.alphabettes.org/first-female-typeface-designers. Accessed January 2019.

[64] Kupferschmid, "First/early female typeface designers," *Alphabettes*.

[65] Kupferschmid, "First/early female typeface designers," *Alphabettes*.

[66] Kupferschmid, "First/early female typeface designers," *Alphabettes*.

[67] B. Robak, *Vom Pianotyp zur Zeilensetzmaschine: Setzmaschinenentwicklung und Geschlechterfrage 1840–1900*, Jonas Verlag, Marburg, 1996.

[68] Dan Reynolds, interviewed by Yulia Popova, 2018.

[69] I. Costas, "Der Kampf um das Frauenstudium im internationalen Vergleich. Begünstigende und hemmende Faktoren für die Emanzipation der Frauen aus ihrer intellektuellen Unmündigkeit in unterschiedlichen bürgerlichen Gesellschaften," in A. Schlüter (ed.), *Pionierinnen—Feministinnen—Karrierefrauen?*, Pfaffenweiler, Centaurus-Verl.-Ges., 1992, pp. 115–144.

[70] K. Krause, *Alma mater Lipsensis: Geschichte der Universität Leipzig von 1409 bis zur Gegenwart*, Leipzig, Leipziger Uni-Vlg, 2003, p. 250.

[71] M. García, "The Lost History of the Women of the Bauhaus," *ArchDaily*, May 22 2018, https://www.archdaily.com/890807/the-lost-history-of-the-women-of-the-bauhaus. Accessed November 2018.

[72] García, "The Lost History of the Women of the Bauhaus," *ArchDaily*.

[73] García, "The Lost History of the Women of the Bauhaus," *ArchDaily*.

[74] E. Hölscher, *Anna Simons*, Berlin, Heintze & Blanckertz, 1934, p. 15.

[75] A. Simons, *Edward Johnston and English Lettering*, Berlin-Leipzig, Heintze & Blanckertz, 1937, p. 12.

[76] F. H. Ehmcke, *Anna Simons*, München-Berlin-Zürich, R. Oldenbourg, 1934. p. 15.

[77] Reynolds, interviewed by Popova.

[78] A. Simons, *Titel und Initialen für die Bremer Presse*, München, Verlag der Bremer Presse, 1926.

[79] "Hildegard Henning," *Klingspor-Museum archive*, http://www.klingspor-museum.de/KlingsporKuenstler/Schriftdesigner/Henning/HHenning.pdf. Accessed January 2019.

[80] L. Devroye, "Hildegard Henning," *Type Design Information Page*, http://luc.devroye.org/fonts-54530.html. Accessed October 2018.

[81] *Das Haus Der Frau auf der Weltausstellung für Buchgewerbe und Graphik*, Leipzig, Des Deutschen Buchgewerbevereins, 1914.

[82] *Das Haus Der Frau*, p. 182, p. 181.

[83] "Glimpses into the past. BUGRA 1914 Leipzig," Howard Iron Works, Printing Museum and Restoration. http://www.howardironworks.org/hiw-article-bugra-1914.html. Accessed September 2019.

[84] "Elizabeth Colwell," *Fine Arts Museums of San Francisco*, https://art.famsf.org/elizabeth-colwell. Accessed September 2018.

[85] According to "Who Was Who in American Art" (1985).

[86] A. Jay, "Creator: Elizabeth Colwell," *Tenth Letter of the Alphabet*, March 14 2016, http://alphabettenthletter.blogspot.com/2016/03/creator-elizabeth-colwell.html. Accessed February 2019.

[87] E. Colwell, *Songs&Sonnets*, Frederic Fairchild Sherman, 1909.

[88] R. Carl Purington, "American Type Designers and Their Work," *Print* (magazine), Vol. 5, No. 4, 1948, pp. 1-20.

[89] "Balle Initialen," *Fonts In Use*, https://fontsinuse.com/typefaces/23343/balle-initialen. Accessed September 2018.

[90] "Balle Initialen," *Fonts In Use*.

[91] "Bauer Type Foundry," *Wikipedia*, https://en.wikipedia.org/wiki/Bauer_Type_Foundry. Accessed March 2019.

[92] "Wettbewerbs. Entscheidungen," *Das Plakat*, Verlag Das Plakat, vol. 10, no. 4, 1919, p. 307.

[93] "Ergebnis unseres Preis-Ausschreibens vom Juli 1920," *Das Plakat*, Berlin, Verlag Das Plakat, vol. 11, no. 12, 1920, p. II.

[94] "Beton. Type and Specimen the Bauer Type Foundry," *Gebrauchsgraphik, International Advertising Art*, April, 1932, p. 62.

[95] A. Windisch, "Gebrauchsgraphik in Frankfurt," *Die Reklame*, no. 158, March, 1923, p. 88.

[96] G. Breuer, J. Meer, *Women in Graphic Design 1890-2012*, Berlin, Jovis, 2012, p. 573.

[97] P. Messner, "Von der Kalligraphie zum Schriftentwurf: Franzisca Baruch in Berlin." in *New Types: Drei Pioniere des Hebräischen Graphik-Designs. Moshe Spitzer, Franzisca Baruch und Henri Friedlaender*, Deutsches Literaturarchiv, Marbach, 2017, p. 11. Exhibition catalogue Museum für Druckkunst Leipzig.

[98] In German: Pavillon der Deutschen Liga der freien Wohlfahrtspflege.

[99] "Franziska Baruch," *Wikipedia*, https://de.wikipedia.org/wiki/Franziska_Baruch. Accessed September 2018.

[100] P. Messner, "Von der Kalligraphie zum Schriftentwurf: Franzisca Baruch in Berlin," p. 13.

[101] U. Thiede, "Was für Typen. Eine Ausstellung über drei Berliner, die Schriftarten für das moderne Hebräisch entwickelten," *Jüdische Allgemeine*, December 1, 2015, https://www.juedische-allgemeine.de/kultur/was-fuer-typen. Accessed September 2018.

[102] C. Dorin, "New Types Franzisca Baruch (1901–1989)," *Goethe-Institut Israel*, https://www.goethe.de/ins/il/de/kul/sup/nwt/20844488.html. Accessed December 2018.

[103] C. Dorin, "New Types Franzisca Baruch (1901–1989)," *Goethe-Institut*.

[104] B. Muraben, "Elizabeth Friedlander: One of the First Women to Design a Typeface," *It's Nice That*, March 8, 2018, https://www.itsnicethat.com/features/elizabethfriedlander-graphicdesign-internationalwomensday-080318. Accessed November 2018.

[105] R. Steven, "Ditchling exhibition celebrates book cover artist Elizabeth Friedlander," Creative Review, January 1, 2018, https://www.creativereview.co.uk/elizabeth-friedlander-ditchling-exhibition-designer-nazi-germany. Accessed March 2019.

[106] P. Paucker, *New Borders: The Working Life of Elizabeth Friedlander*, Oldham, Incline Press, 1998, p. 7.

[107] Paucker, *New Borders,* p. 7.

[108] Paucker, *New Borders,* p. 7

[109] Paucker, *New Borders,* p. 7.

[110] In German: Schriftgestaltung und Gebrauchsgrafik, Kunstgewerbeschule, Stuttgart.

[111] "Biography of Ilse Schüle," in Breuer, G. and J. Meer (eds.), *Women in Graphic Design 1890-2012*, Berlin, Jovis, 2012, p. 545.

[112] "Ilse Schüle," *Wikipedia*, https://de.wikipedia.org/wiki/Ilse_Schüle. Accessed Arpil 2019.

[113] L. Devroye, "Ilse Schüle," *Type Design Information Page*, http://luc.devroye.org/fonts-54530.html. Accessed October 2018.

[114] "Rhapsody," MyFonts, https://www.myfonts.com/fonts/profonts/rhapsody/. Accessed December 2018.

[115] G. Zapf von Hesse, M. Taylor-Batty, *Gudrun Zapf von Hesse: bindings, handwritten books, type faces, examples of lettering and drawings*. West New York, NJ: Mark Batty, publisher, 2002.

[116] G. Zapf von Hesse, "Bookbinding, Calligraphy and Type Design: Remarks and Musings About My Design Process (excerpted from

ENDNOTES

Goudy award acceptance address by Gudrun Zapf-von Hesse)". *Calligraphic type design in the digital age: an exhibition in honor of the contributions of Hermann and Gudrun Zapf : selected type designs and calligraphy by sixteen designers.* Corte Madera, CA: Gingko Press. pp. 31–35.

[117] *Ein Leben für die Schrift*, Talk of F. Ulrich at TYPO Berlin 2016 Beyond Design, Saturday, 14 May, 7:00 pm, Hall. Accessed October 2018.

[118] F. Ulrich, "Hesse Antiqua—Typeface release at 100," *FontShop Type Essays*, January 2, 2018, https://www.fontshop.com/content/hesse-antiqua, https://www.typotalks.com/videos/a-life-for-type. Accessed December 2018.

[119] Ulrich, "Hesse Antiqua," *FontShop*.

[120] Ulrich, "Hesse Antiqua," *FontShop*.

[121] Zapf von Hesse, "Bookbinding, Calligraphy and Type Design: Remarks and Musings About My Design Process".

[122] A. Sherin, "Hesse, Gudrun Zapf von." Grove Art Online. Oxford Art Online. Oxford University Press, accessed November 7, 2019.

[123] "Biography Gudrun Zapf von Hesse," *Linotype Font Designers*, http://designers.linotype.com/gudrun-zapf. Accessed October 2018.

[124] F. Ulrich, "Hesse Antiqua—Typeface release at 100," *FontShop*.

[125] "Anna Maria Schildbach," *Klingspor-Museum archive, Klingspor-Museum archive*, http://www.klingspor-museum.de/KlingsporKuenstler/Schriftdesigner/Schildbach/AMSchildbach.pdf. Accessed April 2019.

[126] "Anna Maria Schildbach," http://www.klingspor-museum.de/KlingsporKuenstler/Schriftdesigner/Schildbach/AMSchildbach.pdf.

[127] P. Glaab, "Montan—eine verschollene Auszeichnungsschrift," *Typografie + Visuelle Kommunikation*, May 13, 2015, https://peter-glaab.de/2012/05/montan-eine-verschollene-auszeichnungsschrift. Accessed Dec. 2018.

List of Figures

Figure 1. Hildegard Henning, *Kartenschrift Belladonna*, 1912. From the type specimen Schriften für feinste Druckarbeiten geschäftlichen und privaten Charakters (Fonts for the finest commercial and private printing), Leipzig, Julius Klinkhardt, 1912.
© Library of Art History at the Kulturforum Berlin, photo: Yulia Popova.

Figure 2. Emilie Winkelmann, *Das Haus der Frau* ("House of Women") — building at Bugra exhibition. From Das Haus der Frau. Sondergruppe der Weltausstellung für Buchgewerbe und Graphik, Leipzig, Des Deutschen Buchgewerbevereins, 1914, p.181.
© Library of Art History at the Kulturforum Berlin, photo: Yulia Popova.

Figure 3. M. Elizabeth Colwell, *Italic Alphabets*. In Thomas Wood Stevens, Lettering for Printers & Designers, The Inland Printer Company, 1906, p. 60.
From Hathi Trust Digital Library, accessed January 10, 2020 https://babel.hathitrust.org/cgi/pt?id=chi.087327807&view=1up&seq=60.

Figure 4. Maria Ballé, *Ballé Initials*, 1920s. From Daily Type Specimen accessed January 10, 2020 https://dailytypespecimen.com/post/65531098443/balle-initials-type-specimen; photo by James Puckett.

Figure 5. Maria Ballé, *Design of the cigarette package J. Pilnik & Cie.* From the article "Ergebnis unseres Preis-Ausschreibens vom Juli 1920" ("Result of our competition from July 1920"), in Das Plakat ("Poster") magazine, Berlin, Verlag Das Plakat, vol. 11, no. 12, 1920, p. II.

Figure 6. Elizabeth Friedlander, *Letters of an unissued display face*, clearly based on some of the letters forms developed for "Die Dame" magazine. From Pauline Paucker, New borders : the working life of Elizabeth Friedlander, Oldham, Incline Press, 1998, p. 16. © Incline Press; photo: Yulia Popova.

Figure 7. Elizabeth Friedlander, *Elizabeth Bold*. From From Pauline

84 RESEARCH

Paucker, New borders : the working life of Elizabeth Friedlander, Oldham, Incline Press, 1998, p. 16. © Incline Press; photo: Yulia Popova.

Figure 8. Franzisca Baruch, *Magere Stam*. In the type specimen Magere Stam, Stam, Rambam, Rahel, Berlin, H. Berthold AG., 1930, 30x21 cm. From the private collection of Philipp Messner, Zürich; photo: Philipp Messner.

Figure 9. Anna Simons, *Calligraphy in the novel Elective Affinities by Johann Wolfgang von Goethe*. From Eberhard Hölscher, Anna Simons, Berlin, Heintze & Blanckertz, 1934, p. 15. © Library of Art History at the Kulturforum Berlin, photo: Yulia Popova.

Figure 10. Anna Simons, *Calligraphy in the poem Divine Comedy by Dante Alighieri*, 1921. From Anna Simons, Titel und Initialen für die Bremer Presse, München, Verlag der Bremer Presse, 1926. © Library of Art History at the Kulturforum Berlin, photo: Yulia Popova.

Figure 11. Gottfried Benn, *Kunst und Macht*, Stuttgart, Berlin, Deutsche Verlags-Anstalt, 1934. Design of the front and back cover by Ilse Schüle. © Library of Art History at the Kulturforum Berlin, photo: Yulia Popova.

Figure 12. Ilse Schüle, *Rhapsodie*. From the type specimen Rhapsodie : nach Zeichnung von Ilse Schüle, Frankfurt am Main, Ludwig & Mayer, ca. 1951. © Library of Art History at the Kulturforum Berlin, photo: Yulia Popova.

Figure 13. Gudrun Zapf von Hesse, Diotima, 1951-1954. From www.linotype.com. © Monotype GmbH. All rights reserved.

*Department of Typographic Development at Linotype (UK), 1983:
Georgina Surman, Lesley Sewell, Sarah Morley, Gillian Robertson, Ros Coates,
Fiona Ross, Donna Yandle. Photo: Courtesy of Fiona Ross.*

Chapter D

Interviews with Designers

PHOTO BY: VIKA BOGORODSKAYA

Gayaneh Bagdasaryan has designed Cyrillic localizations for many major type libraries, including Linotype, Bitstream, The Font Bureau, ITC, Berthold, Typotheque, Emigre, and ParaType. Gayane began her type design career at ParaType in 1996 and started Brownfox in 2012. Her work has won awards from a number of international type design competitions, including Kyrillitsa'99, Granshan 2013 and TDC² 2000. She is the mastermind behind Serebro Nabora, a prominent annual international type conference held in Russia.

INTERVIEW CONDUCTED IN BERLIN, FEBRUARY 2018

When did you become interested in typography?

In 1992 I graduated from the Art College in Ryazan, Russia. My specialization was painting. That was a hard time for Russia: total unemployment, poverty, people could hardly put food on the table. You can imagine, there was no work for painters. At the same time, it was the beginning of the rapid development of design. After the stagnation period during the Soviet time, it was kind of a revolution. This coincided with the digital revolution and the falling of the Iron Curtain. Thus, turning from painting to graphic design seemed to be opening many new horizons in every way: there was a demand, there was a development. So, I decided to continue my education in the Moscow State University of Printing Arts to study book and graphic design. I had to take the entrance exams including the type exam. I knew nothing about type, started to learn about it and became very interested. By the time the studies at the university began I already knew that I wanted to be a type designer.

> There were six male and twenty-four female students in our class.

Do you have any special type of attitude to letters (love, hate, confusion...)?

When somebody asks me if I love letters, I usually answer that I love handsome men and letters are just my work. I do not fetishize letters—no chocolates in the form of letters, letter pillows, letter jewelry, letter lamps, etc. For me letters and type are for writing and reading. There are many other things for eating, sleeping and love.

How was the education at the Moscow State University of Printing Arts? What did you learn there? What techniques, what computer programs?

The University gave me the most important thing in our profession—the idea that you can apply the same rules of composition and shaping to all the visual genres. I do not know of any other educational institution which would teach that same world view. Probably the Moscow State University

of Printing Arts was a unique place in that regard. Unfortunately, this approach seems to be gone by now. Luckily, I learned it when it was still there and now I feel very confident that when I get tired of type design, I will easily turn to any other visual genre.

However, in a practical sense, the education was not very helpful. We learned all the techniques of printed graphics, such as etching, linocut and woodcut. I never used those skills again. The vision of design was out of date. And there were just a few computers at the University at that time. I would not say I mastered any computer programs there. We made almost everything by hand. I learned type design not in the University, but on a real job at ParaType—I started with them when I was a first-year student.

Are there any other places where one can study type design in Russia?

Stroganov School for Technical Drawing, British Higher School of Design, The National Research University Higher School of Economics, Educational projects of Alexander Vasin and Natalia Velchinskaya and many others.

Do you remember what the female/male ratio of students was in your group at the University?

There were six male and twenty-four female students in our class.

When I look at type design students in Russia, they are almost only women. Do you agree with this? What do you think is the reason behind it?

Yes, I agree. A few years ago I was invited to teach typography at the Higher School of Economics and there were two groups of students. In the first group there were twenty-four female and one male student, in the second one there were twenty-five female students. I had a weird psychological feeling during my teaching time and finally I left the school. I used to teach students in balanced mixed groups and that was a good experience. I still keep in touch with them, they use my typefaces.

I do not know what is the reason behind the

over representation of female students. I'm not a sociologist to answer this question. I would also like to know the answer. Maybe women are more inclined to systematic learning while men prefer to learn directly at work?

Who were your idols or role models while studying?

I had no idols and still have none. I think it is important to be free of such a strong influence. You can learn from other designers, you pay your respects to them, make friends with them, but you always have to go your own way.

Can you name any inspiring woman in typography?

Zuzana Licko.[1]

Are there any current type designers whose work impresses you? Who are they?

The type designer I like the most is Laurenz Brunner. I am also very impressed by the typeface LL Brown. I am of the opinion, that it is the type of the century.

Are you often invited to talk at conferences?

Yes, quite often and not only to talk at conferences, but also to give lectures for small groups of people. I have one today.

Have you ever applied to talk at any conferences?

No, never.

Do you like to talk in front of an audience?

In general, yes. But it depends on the audience. I am not one of those speakers who entertain the audience and make a show out of their presentation. When the audience is not interested in the topic or not prepared and I do not get any feedback, it can be exhausting. Good listeners give the energy to the speaker, bad listeners take it from them. It is the same with students.

Do you believe it is necessary to have an equal share of female and male speakers at conferences?

I believe it is very harmful to take care of that. It is not feminism, it is rather anti-feminism. A few years ago every time I was invited to give a talk, I was sure that I am invited because of my professional achievements. Now that everybody became crazy about this equal share, it looks like hypocrisy,

a

"Well Gayaneh, we know you are not a pro, but we need more women at our event." Sometimes people want to support me because I am a woman. I always want to say, "Maybe I could support you? I guess I earn more than you do and I'm more successful in general." I take all that as an insult.

I know that you have been organizing conferences yourself. Could you share your experience? How do you put the program together and how do you find the speakers? Where do you look for the speakers?

Putting a program together is a very creative and exciting work. I take that as a challenge. The agenda has to be ambitious, clear, and inspiring; the speakers have to be excellent. To be a good organizer you not only need to keep abreast of the development in the field, but also to have a good intuition. I did not know many of the invited speakers personally before that, so I had to predict and guess their style of speaking. The proper order of the speakers is very important. There is a huge amount of small invisible details which you have to consider. When you do your work perfectly everything seems very natural, as if it happened by itself. Every year after the conference I would analyze my mistakes and finally I was completely satisfied only with my fifth one.

> It's not feminism, it's rather anti-feminism.

To find speakers you have to be very well-informed about what is going on in type design and typography. First, I made a list of topics which I would like to get covered and then I started to think who would be the most appropriate person for that. I invited famous designers, as well as beginners. Sometimes I asked my colleagues for advice, but usually I made decisions myself. Sometimes people asked me to include them in the list of speakers, but I usually refused because it would have destroyed my vision of the program. I would say, my conference was kind of my own artwork.

There are a lot of statistics showing that a lot of women

study typography. However, there are much more men in the leading positions in this industry and among speakers at conferences. What is up with that?

Everybody is talking about the leading positions and giving talks as if they were kind of privileges. Meanwhile, the leading positions mean, first of all, a huge responsibility and a lot of risks. I know that very well from my personal experience. It is much more convenient to be an ordinary employee, get the salary and take no risks. As for giving talks at conferences, it is a big unpaid work with a big stress.

Again, I am not a sociologist and cannot answer this question but I can make an assumption. Women are already overloaded with responsibility in their private life. They simply have no more resources for something else. At least in Russia. Unmarried women are obsessed with the idea of marriage because of the incredible pressure from the society and their families. Married women become responsible for everything: for the children, for the household. They have to work, to earn money, to look like models, to be good mothers, good wives, to be educated, to be trendy, to be well-dressed, to be fit, to speak foreign languages. Moreover, a Russian woman has to pretend to be weak for her husband, someone who needs him and would die without his support. Do you think such a woman has any energy and free time to give an unpaid speech at a conference?

> Women are already overloaded with responsibility in their private life. They simply have no more resources for something else.

Next, I was asked many times in my life, what I choose—a family or a career? Why should I choose? Can I have both, please? Why do not men ever get asked this question? And we still have that vision of a woman's success—a family and children. A ca-

reer is for losers, i.e. single and childless women. If a woman is professionally successful, everybody immediately assumes that she is a poor thing and is looking for comfort in her work. Some people think that such women are just channeling their unspent energy into their careers. It can be very insulting. As a consequence, those women have a subconscious fear of looking professionally successful because that can mean that they are losers in their private lives and not attractive enough as females. So, if you want to have more female speakers, more female bosses, you have to start not from the conferences and from the work itself, but from the revision of gender roles in the family. You have to start from changing the vision of what a women's success is. Women should deeply feel that they already have value as individuals and not only if they have somebody to confirm that: a husband and children. This is already happening in the Western world, but we need time to change the situation. It is a long process. We have to be patient.

> What do I choose—a family or a career? Why should I choose? Can I have both, please?

About the statistics: to make any conclusions we usually need much more information than we have. Many of them are superficial. I'll give you a small example. The page of my type studio on Facebook has 66% male and 34% female followers. The likes to my posts come from 95% male and 5% female users. What do these statistics mean? Actually, we can make any conclusions which we like.

For example:
- Men are interested in type design more than women;
- Men are interested in professional development more than women;
- Men have more free time than women;
- Women work more than men and have no

time for social networks;
- Men feel lonelier than women and need social networks;
- Men sleep less than women and spend those sleepless hours on social media;
- Men tend to express their friendliness more than women;
- Women are more envious than men;
- Women are more modest than men;
- Women do not like other women;
- My male followers are in love with me

The list goes on and on. The thing is that all the conclusions are wrong. To make the right conclusion we need much more versatile information and a deeper investigation. So, please be careful with rash judgments.

I am currently working on the list of female type designers that worked during the 20th century. Are there any you can think of who worked in Russia?

There were many female type designers in the 20th century, I cannot list all of them. When we are talking about the USSR the most famous was Galina Bannikova.

1. Interview with Zuzana Licko in this book page 187.

PHOTO BY: NORMAN POSSELT

Veronika Burian is a type designer and the co-founder of the independent type foundry TypeTogether with José Scaglione, publishing award-winning typefaces and collaborating on tailored typefaces for a variety of clients. She is also involved with Alphabettes.org, a showcase for work and research on lettering, typography, and type design by women. Veronika frequently gives lectures and workshops at international conferences and universities.

INTERVIEW CONDUCTED VIA SKYPE, MARCH 2018

It seems like both typeface design and industrial design are generally more popular with men than women. How did you come to study Industrial Design?

Yes, especially back when I started in 1995, most famous industrial designers were all men. Actually, I cannot think of a single historically famous woman in industrial design, even now. However, I have been out of this field for quite a while. Already quite early on I knew that I wanted to do something artistic, something creative but at the same time I knew that I am not an artist in a traditional sense. Although I did not start studying industrial design right away after school, the combination of creativity with functionality and purpose did appeal to me.

I spent a gap year studying Italian and Czech, working and going to art school in preparation. Photography was my big hobby then and my original idea for profession. However, back in the 90s photography was still analogue, which meant spending a lot of money on the materials only, besides the tuition fees. So this was out of question. Architecture was not quite right either, given the heavy engineering part. For some reason I did not consider graphic design. At that point it did not feel quite right. I thought that industrial design is a good combination of creative input mixed with functionality, and good career prospects. Also I always had a bit of a naive idea of helping people.

> It seemed rather pointless to me to design yet another pretty object of no real purpose.

I thought that design can improve their lives. I applied, submitted my portfolio, had an interview and two days of tests. This is how I ended up studying industrial design. Although quite soon I realized that my way of imagining 3D shapes in my head, which is actually very important for an industrial designer, was not ideal.

Do you think your background in industrial design helps

you to design typefaces today?

> Yes, I do think that there is a relationship between the two fields. Both are industrial processes that have a similar approach to a project where functionality is an intrinsic value. Both are considered to be a part of an interface between humans and a machine or concepts, developing a system to solve problems. Both are ways to express and contribute to contemporary culture, additionally to sculpting forms. Industrial design certainly helped me to form an understanding, appreciation for beautiful shapes and curves.

In one of your interviews you said that your friend showed you the world of typography and you fell in love with it. What fascinated you about letters and why did you decide to switch to typography?

> At that point I was really disillusioned with the reality of product design. It was the early 2000s, the time when a lot of superfluous nonsense was produced. A lot of plastic waste. It seemed rather pointless to me to design yet another pretty object of no real purpose other than consumerism. At least that was my professional experience and I did not want to take part in it. By that time I had moved a little bit more into graphic design and was exposed to typefaces in general. Andrea [friend] showed me some books about typography, Fontlab [font creation software], and how to design type. It just felt very natural to me to draw curves and to think about the system, application and function for the typeface. I also really liked that typefaces have a cultural function. I felt very much at home and liked this idea that typography is part of our visual environment and I wanted to contribute to this visual landscape. It seemed very attractive to create something beautiful and purposeful.

Did you like your studies in Reading University? Do you remember the ratio of female/male students?

> It was actually pretty good. I think there were 10 people and more or less 50/50.

Who were your idols or role models while studying?

> Well, I knew about Zuzana Licko.[1] Before I

started at Reading University, she was pretty much the only woman in type I was aware of. It might be that I knew her because of my friend Andrea, who was a graphic designer interested in Emigre. Later at Reading, I discovered a lot of Czech type designers and since I have Czech roots, they fascinated me. However, all of them were men. Fortunately, nowadays the type industry is changing and many more women are involved and successful in this area of interest. But back in the 20th century type was a very much male-dominated area.

Studying at Reading University was a life changer for me. It was very gratifying to be in a group of people with similar passions and sharing knowledge with them. In industrial design there seemed to be more competition and less of a feeling of community. What I also really liked at Reading were the academic challenges of the program, doing research and writing two essays and a dissertation.

You are often invited to talk at conferences. Have you ever noticed that there is an imbalance in the amount of female and male speakers? Do you think it is important to have 50% of female and 50% of male speakers?

I think it has become much better. Definitely, there was a huge imbalance before and a tendency to invite just men. All organizers used to be predominately men. Very likely they knew more men than women and were not prepared to step outside of their comfort zone. However, now you cannot get away with it anymore and conference organizers feel the pressure to be more inclusive on all levels. I do believe that there should be a gender balance among conference speakers. Ideally based on the speaker's merits and not their gender, though. Being a quota woman is a strange thing. I used to dislike that feeling, I am certain that I was invited to a few events because of being one of the rare women in type design. One should not get upset though but instead play with it, laugh it off, turn around and show everyone how good you are and what kind of work you do.

Have you ever applied to conferences yourself or were

you always invited by organizers?
Most of the time I was invited. I think I did apply a few times too. ATypI was one of them.

Do you personally like to speak in front of an audience?
Yes, I actually do. Of course, I am always a bit nervous at the beginning but otherwise I do like the challenge.

I also know that you offer a scholarship program for people who just graduated from school. When and why did you start it and who can apply for this?
The first scholarship was offered in 2014. With José [business partner] we were always keen on aiding education and sharing knowledge. We saw that a lot of very good projects ended up in the drawer for years and years and never came out, or only got finished 20 years later. Quite often what happens is, you do something type-specific during your master's studies, but then you have to make a living. Jobs within the type industry are still rather limited. So people get very busy with other things and their student project falls back in priority. We wanted to help good students and at the same time steer the design in the direction that we believe would be useful and successful. It is kind of a two-way street. They need mentoring because it is their first typeface. We do a lot of sessions with them. The first mentorship recipient was Roxane Gataud. She designed her typeface Belly.[2] The design was great but needed a heavy fine-tuning. I think, she learned a lot and her design improved visibly. However, it took her a while as she was simultaneously working full-time. Unfortunately, we cannot fund a person for two years. We give them a bit of money, the contract and our time. We like to give back to the community. I do appreciate the type community and think it did a lot for me. It is important to support young people

> There exists this stereotype that women design fancy, curly, soft and warm shapes.

when they start out if they are promising and keen. Like Roxane, for example, she works for us now and she is wonderful. If your question is about gender then I would say that we do not look at gender when we choose a student. We really look at the quality of the work and we would not choose the work only because it is done by a woman.

What is your favorite glyph to work on?

I really like the lowercase and uppercase "K's". It is my favorite letter. I do not really enjoy working on punctuation. And in general I love doing italics. They give me more freedom to play as they are a bit more experimental. Also you can do a great "K" in italics.

Do you have a certain approach to choosing names for typefaces you design?

Actually, we used to look at female names, especially the ones short and high up in the alphabet. Naming a typeface is very difficult because there is a bunch of requirements names should fulfill and many good names are already taken.

We looked for a nice-sounding girl's name that would not be too difficult to pronounce in different languages and, of course, would not mean something weird. However, now we moved on to more descriptive names. For example, Protipo is the latest release. The name should more or less describe the style of a typeface. Or, for example, Tablet Gothic is more related to function of a typeface.

Is there a specific reason why you gave your typefaces female names?

They kind of seemed to fit and I did want to stress the female side of TypeTogether, and girl names usually sound very nice.

Do you think there is a difference between typefaces designed by a woman and a man?

That is a hard one. Of course, there exists this stereotype that women design fancy, curly, soft and warm shapes. But I can assure you that a good type designer, whatever gender, can do whatever kind of form and atmosphere. Perhaps the style of a typeface relates more to the character and

signature manner of an individual designer. Some people told me that they do recognize the style in our library. But José and I design together. I hate this kind of stereotyping. I prefer to say that as a designer one can acquire a recognizable signature. One very strong example is Gerard Unger. A lot of his fonts are basically variations of a similar concept. All good in their own way though.

What was your motivation to open up your own foundry?

I hated to be employed. Always. I prefer to be independent.

Why? Is it because you had to design for someone else?

Yes, exactly. Especially when I was working at DaltonMaag. At that time we did not really have a retail library and all our clients were custom clients. This can be tricky. There was too much influence from the client and you had to explain yourself. Of course, now I depend on clients too, because we do custom work as well. Nonetheless, I think it is a bit different than back when I was at Dalton Maag.

I realized that I had my own ideas and wanted to do my own thing, I wanted to be independent, not to be tied to one place. Mainly I really wanted to do my own designs. Always with a purpose but not necessarily for one particular client. It was a bit scary at the beginning and I would not have done it completely alone. I am very happy that our business partnership with José worked out so well. We have kind of found each other and complement each other. It would have been pretty hard on my own. It can be quite a solitary work, especially if you do not have a studio and do not work at collaborative spaces. That is one of the reasons why I like to collaborate and share the work with people I am able to appreciate and trust. I have no problems with other people working on my shapes. Twelve years ago it was not that common to work on a typeface with someone else. Most designers were working on their own, not letting anybody touch their curves.

Do you think that type design is becoming more popular?

Yes, I think it has something to do with web fonts. It made typography more popular and

brought it into the mainstream. People interact with the web so much more. That is just my theory that contributed to the fact that type and typography are salonfähig (German for "presentable, socially acceptable"). There's an increasing interest in typeface design by young people in general. I believe it is because of the new tools. It is so much easier these days to start drawing or sketching digitally. Typography became hyped. Lettering hype that happened in recent years also contributed to it. People got really hooked up on it and its craftiness. Type is really a craft, not an art.

Do you think there is a big difference between lettering and typeface design?

Yes, very much so. There is a huge difference. First of all, it is the way you approach the project. Lettering is always just a certain set of letters in a fixed environment and in a fixed sequence. You know what comes before and after. In a typeface you do not know that. You have to create a system. When later on you set words in different languages, letters will not fall apart and will still function as a system, homogeneously. That is why in type design consistency is super important. You have to make sure that details, proportions, and modulation coming from an imaginary tool are logical within the type system and follow throughout. Not just A to Z but the whole character set: punctuation, numbers, currencies, etc. That is the difference with lettering where each letter can respond to its neighbors individually. The purpose of both is also different. Lettering has a different application than type, at least compared to text type.

> Type is a tool, we should not forget it.

What does success mean to you? Is it important?

Well, I guess if your typefaces are used out in the world and in nice interesting projects. That is a very good feeling. I would describe that as success. It is not equal to money. I decided at some point to just live off of type and I am doing quite well but that is not a given. Nobody becomes a millionaire

with type design. Not a single person yet anyway.

Success to me has much to do with your own happiness and satisfaction. If you can be proud of what you do and if other people appreciate it. If other people take your work and use it in their own work to create something new. Type is a tool, we should not forget that. It does not stand on its own. It needs a context. It is there to serve.

Have you ever been unhappy with the way your typefaces were used by others?

Of course, plenty of times. Once I was in Prague riding on a train passing by some huge billboard. I had a glance at this board and saw some bad advertising. I saw it and thought, "Hang on, I know this typeface!" I realized that it was our typeface Ronnia that had been squeezed and made unrecognizable. In situations like this you cringe inside, but I learned not to be upset.

The other one was a right-wing political party in Poland. That's the thing about a font being a tool. You cannot control how and who it will be used by. You simply cannot—unless you are very protective and know every client. If you have your own web shop, you usually do not know who buys typefaces and what they do with them. From time to time we get some pictures from people who bought our fonts. They share the work they did with it. Sometimes it is awful and sometimes it is very nice and we post it on the blog. Actually I do not see it as a big problem. It is just a part of type life.

1. Interview with Zuzana Licko in this book page 187.
2. Typeface Bely by Roxane Gataud in this book page 238.

Maria Doreuli was born in Moscow, and studied graphic design at the Moscow State University of Printing. She also received her MA degree from the Type & Media course at The Royal Academy of Art(KABK) in The Hague. Since 2013, she has run the Contrast type foundry and currently works as an independent professional based in Moscow. Her projects have been honored by many awards, such as Granshan, Letter.2, Morisawa and TDC2.

How did you become interested in typography?

I do not remember being particularly interested in letters before the university. The first time was at the Moscow State University of Printing when I got to work with type. It all happened naturally; there was no turning point when I decided to specialize in typography and type design. It was probably the tutors who raised my interest. I was lucky to study under Alexander Konoplev's guidance. His assistant at that time was Alexandra Korolkova. During my sophomore year I started taking Alexander Tarbeev's classes and he made me curious about drawing my own letters.

What is the biggest difference for you between the Moscow Printing University and the Royal Academy of Art?

It is hard to compare. In the Moscow Printing University I did my bachelor's (6 years) and in the Royal Academy of Art I did my master's—just 1 year. Comparing Alexander Tarbeev's workshop with the master's program in The Hague, I found it pretty similar in terms of the teachers' attitudes. Of course, the Royal Academy gives a wider perspective, you get to meet more people, international colleagues, you immediately get an access to many libraries and archives. But these are mostly things not necessarily connected to the school itself.

What was the female/male ratio of students?

During my bachelor's in Moscow we only had a few male students. Probably around 6-8 out of the total of 50 students. In The Hague we had a rare 6/6 equality—it definitely felt very balanced.

Who were your idols or role models while studying?

I do not remember having idols or role models. I do not think that there is any perfect/genius person to follow blindly, but there are always things we can learn from each other. I am always trying to notice and pick different skills from people I admire.

Do you like to work more with Cyrillic or Latin letters?

I do not have any preferences in scripts. What is interesting to me is the design, the system behind the typeface. I am not a fan of working on large multiscript projects, because it takes much

more time as soon as you have more than one script in the project. But there is no way to avoid it—we need at least Basic Latin and Cyrillic characters in a typeface to make it usable in Russia.

What is the project you are working on now?

At the moment most of my time is dedicated to the launch of Contrast Foundry's web shop—the platform where we are going to sell our typefaces. We had a few very exciting projects to work on this year. Unfortunately, I cannot say anything more specific—turns out that type design is very confidential, those projects are under very strict NDAs and I cannot talk about them at the moment.

Are you often invited to talk at conferences?

The more you do certain things, the more you are asked to do them over and over again. I started getting more and more invitations to speak at events once I started doing it, posting about it on social media, etc.

Have you ever applied to talk at any conference?

The very first time was when I applied to give a talk with my colleague Krista Radoeva. It was AtypI 2013 in Amsterdam. It was not an easy one to start with. First, you have to propose a talk and this needs to be done around half a year before the event. Then your talk has to be accepted by the committee. Once the talk is accepted there is no way back. AtypI is a large event and you need to talk in front of a group of very well-known colleagues. It was scary.

Do you like to talk in front of an audience?

It depends. I cannot say that I like to talk in front of an audience but there are times when I am satisfied after the talk and there are times when I am not. I believe that each time I speak publicly, I am getting better at it.

Do you believe it is necessary to have an equal share of female and male speakers? Why?

My position about equality has changed over time. I used to be one of those who did not understand the problem. I also wanted to be invited as a professional, not as a woman. It may sound preten-

tious but I think that understanding the necessity of equality comes with education, seeing the world, meeting people from different cultures. It is hard to understand that there is a problem when you are bound by the society and only see the image in a way you were taught to see it. The equal amount of male and female speakers is necessary. It is a way to make everybody comfortable, a way to build a healthy society, a way to make women feel more comfortable standing on stage and speaking. I am not saying that anybody should be invited just because she or he is a person of a certain gender but it is a responsibility of every event organizer to care, to be aware of and try to find a good balance.

> My position about equality changed over time.

Aside from gender, there are other things to consider. We keep seeing the same people at events over and over again. Of course, as an experienced speaker you get a lot of invitations, people know you and come to the events to see you. But I think that a good event is the one with a healthy ratio of well-known names and new names. Organizers also need to look for talented people (both male and female). Maybe there are people who are born speakers, while others might not be as good at presentations the first couple of times. But presentation skills are something that can and should be developed. And we should all remember that it is not always about the quality of speaking skills, but also about the value of the work one does.

Do you believe that the typographic world was and still is male-dominated?

I once read a book written by an American traveling to the Soviet Russia. There was a whole chapter dedicated to female leadership in Russia. The author traveled to various cities around the country and he was impressed by the women who were in charge of big factories. This made me think that it was probably the Soviet regime that built

a

equality between men and women at work and this happened in Russia in the very early 20th century.

Typographic world is changing over time. We have a lot of very talented people of different genders. At the moment there are probably more women than men in the field in Russia. And there are probably going to be even more women in the future. At any design university you go to most of the classes are filled with girls. On the other hand, conferences and top management are still male-dominated. 100% of male speakers at event is considered normal. I often hear female colleagues saying that they do not have anything to talk about which, in my understanding, is a total lack of confidence, experience and maybe a lack of the need to show off too. This is something that society needs to work on—many women are still not confident enough to talk about their work. It probably comes from the time we grew up—we do not teach our girls to be leaders, to be confident and independent.

> I also wanted to be invited as a professional, not as a woman.

Do you know any female type designers that worked during the 20th century in Russia?

We had quite a good female representation in the type design field in Russia in the past. Lubov Kuznetsova and Galina Bannikova are both very talented type designers from Russia that worked during the 20th century, the authors of the iconic Soviet typefaces, mentors for many male professionals of today.

Louise Fili worked as a Senior Designer for Herb Lubalin. From 1978 to 1989, she was the Art Director of Pantheon Books, where she designed up to 2,000 book jackets. In 1989 she founded Louise Fili Ltd, a graphic design studio specializing in brand development for food packaging and restaurants. She has received Gold and Silver Medals from the New York Art Directors Club and the Society of Illustrators. Louise Fili's work is in the permanent collections of the Library of Congress, the Cooper Hewitt, and the Bibliothèque Nationale.

INTERVIEW CONDUCTED VIA EMAIL, MARCH 2018

Statistics show that there are twice the number of women applying to different programs in graphic design than men. Do you remember how it was when you were studying? Were there any fields that women or men specifically preferred?

When I was studying, the graphic design department was comprised of about 80% women. There were a lot of women in the illustration department, who, one by one, left the field. How many women illustrators over 50 can you name?

Who were your idols or role models while studying?

I looked hard for role models, and had a difficult time finding any. I was on my own.

Do you think there are too few visible female role models in the field of type design now?

I think they are starting to find their moment in history.

When you were working as Art Director at Pantheon Books, were there many women working with you?

Except in one instance, all of my assistants while at Pantheon were women.

What was the motivation for opening your own studio? Was the shift difficult?

I had been at Pantheon for 11 years, I had designed 2,000 book jackets, and I realized that I had accomplished what I had set out to do: to prove that book jackets did not have to shout to capture someone's attention. I was also interested in combining my interests in food with design. Fortunately, the shift was not terribly difficult, since I had already been freelancing for just about every other publisher in New York, and I already had a separate studio in my apartment.

I remember at the TDC 70th Anniversary: Type Over Time conference you mentioned that by naming your studio Louise Fili you wanted to send a clear message, "If you have a problem with me being female, then I have a problem with you as a client." Could you tell a little bit more about it? Were there fewer women running studios then? What was your concern?

When I started my studio in 1989, it was the pre-Google era. People had to find you in the phone

book, so you could not get too creative with a studio name. There were very few female-run studios. I could have called myself something like Fili Associates to pretend it was a bigger studio than it was, but instead I named it after myself, which I knew would be a liability for some, and it was. But I had no interest in working with those people—and still do not.

Have you ever had difficulties or problems in your career because you are a woman?

Yes. It has gotten much better, perhaps because I have been doing this for over 40 years. Just recently I was interviewed by a restaurant group where the interviewer asked me, "This restaurant is very masculine, and your work tends to be very feminine. Can you address that?" I was extremely insulted given that I had the most experience of the three finalists they were interviewing (two women and one man). I almost walked out of the meeting. I knew there was no right answer—he had tipped his hand. Of course, the man got the job.

Do you believe that the typographic world was and still is male-dominated? Have you ever seen this as a problem?

It has been male-dominated, but it is changing. There are many young women entering the field, which is very encouraging.

What is the most challenging project you worked on?

Elegantissima, a monograph of my work. It was like seeing my whole life and career flash by like a bad movie trailer. To look at all that work objectively—and to write about it—was challenging.

Do you use typefaces designed by others? Can you name typefaces you are using?

Most of my designs are logos, which are lettered by hand. I use typefaces, but there are too many to name.

Are you often invited to talk at conferences? Have you ever rejected the invitation and why?

Yes. I try not to book more than once a month (or less), as it is exhausting and can sometimes interfere with my work schedule.

What was the first conference you spoke at?

I think it was in California in the early 1980s. Not sure which one.

Do you like to talk in front of an audience?

Yes, as long as it is a responsive audience.

When did you notice a change in the lineup of conferences? When did the share of female and male speakers become more equal?

When I started speaking at conferences I was always the only woman in the lineup. Now it is definitely more 50/50. It has been a gradual change.

Over the last three years, media attention to the issue of gender equality in conference speakers has been rising. Despite this attention, it is still often imbalanced. Do you believe it is necessary to have an equal share of female and male speakers? Why?

Yes. Women need a voice and need to set an example. Young female designers need role models.

There is always something that keeps us going and motivates us. What is it for you?

Working! Especially on my own projects.

Martina Flor was born in Buenos Aires. She runs the Studio Martin Flora, one of the world's leading studios in lettering and custom typography, working for clients all over the globe such as The Washington Post, HarperCollins, Etsy, Adobe, Monotype, Vanity Fair, Lufthansa, Cosmopolitan and Mercedes Benz among many others. Martina Flor received her master's in Type Design from the valued Royal Academy of Art in The Hague, The Netherlands. Since then, she has dedicated a large part of her time to teaching lettering and type design.

INTERVIEW CONDUCTED VIA SKYPE, FEBRUARY 2018

I am wondering if you have always been self-employed. Have you ever worked for someone else?

I worked for someone else for 8 years. It was not always one company but different ones. I worked at an in-house design department, as well as at other non-design companies.

Was it difficult for you to make the shift from being employed to being self-employed?

Yes, it was. It is definitely different to be on your own. I have to take care of everything concerning having a studio. It was not only about design anymore, but also about invoicing, paying bills and administrative work. However, I feel that working for someone else pretty much prepared me to do what I'm doing now. I feel it was a very essential experience and a good training to create my own company.

Do you have people working for you?

Yes, I do have several people working for me. I have three colleagues, together with our intern there are four of us. At the moment we are all women, but we used to have men as well.

Do you spend a lot of time on promoting your work and on being present on social media?

Yes, I do. I have to say that social media and sharing my work has given me a lot of confidence. It has allowed me to get feedback and it has allowed me to create things for other people. It had a very positive impact on me. Showing the work that I was doing had a positive influence on the artwork that I was creating. The quality of the output became much better. So I kept on doing it. I remember back when I was not sharing my work with others I did not really have much progress in the quality of that work.

So, would you say that it motivates you to work better?

Yes, sure, when I know that certain things will have a certain exposure, I put more effort in my work. The same works in terms of clients. When I started to work with clients that have more exposure, it also had an impact on the quality of the work that I was delivering. The more my work is exposed,

the better my output is.
How would you describe your style of work?
As a designer, I do not have a focus or a certain style myself. I was educated as a designer. I think that I know my skills as a letterer and I like to think that with basic skills I can make every style, every letterform that is necessary for a project. I do not like to be attached to any style but to be able to work with as many as I need.

Do you personally have any idols? People or designers who you adore?
Yes, I do. I am very much attracted to what we call German design. Bauhaus and all the Swiss schools are my heroes. These are the people who I looked up to when I was studying. However, the work that I do now is completely opposite to that. Although I really admire this style and love the way it looks, it is not something that I do myself.

What does success mean to you? Is it at all important?
I think the concept has changed with time. Overall success to me is achieving my personal goals. If I look back at what I have done and think that I am much better at it now, it is a success. I am thankful for all the experiences that I have. They helped me to get to where I am now. Hopefully I will be thinking the same in a couple of years from now. It is important to feel that you're moving forward with your work.

From another point of view, I think it is already a success to be able to do work that you really enjoy. I think this is something that should not be taken for granted in this world. It is a big success to find something that you really like and to be able to earn money with this. It is not only about doing what you like, but it is about finding what it is. To find out what you really like is not as easy as it seems. So I feel very lucky and successful in this regard. I am glad to have found this field where I feel I am talented and I feel comfortable working and at the same time I can work full-time.

Do you separate personal and professional life strictly?
I do not make a strict division between them. I

think this is all my life. My life involves a lot of things like creating lettering, being with my son, spending time with my family and doing administrative work in my studio. Everything is a part of my life. There are moments or places where I do certain things. I have a studio where I have space and tools and certain environment to get my artwork done. There are places where I feel more comfortable playing with my son. I would say it is not about time, it is more about places where I get things done.

You offer a lot of workshops on lettering. How many people usually attend?

It is varies every time. Usually between 10 and 15 people.

Out of these people who come to your workshops, are there more men or women?

It has shifted over time. I would say that it is mostly women now.

Do you think it is somehow connected to the fact that you're female or to the style of your work?

I have not thought about it. I guess there is definitely some role model that I represent and I think that people coming to my workshop are not only interested in learning new techniques, but also in getting some inspiration, some insights about lettering world. They see me as a person who can share that knowledge with them. The fact that I am a woman might be the reason why there are more women attending my workshops.

You speak at conferences quite often. Do you apply there yourself or do you get invited?

Mostly, conference organizers approach me. I have also participated in conferences where you propose a talk. Nowadays it is mostly organizers who are approaching me.

Have you ever noticed a gender gap in the lineup?

Yes. That's definitely a problem with most conferences.

Do you think that typography was and is a male-dominated profession?

I really do not have the numbers on this.

What do your instincts tell you about it, for example,

when you go to conferences or events?

It is tricky. I believe that the amount of women or men at certain events does not necessarily reflect the amount of people working in this field. I think the reason why there are more men present in the typography scene is connected with a lot of facts. There is a complex cultural structure that has an impact on it. Men do more public speaking and they are taking over positions of power in big companies. I think the fact that women are not so visible does not necessarily mean that there are not a lot of women in the field. It is much more complex than that.

Have you ever had any negative experiences because you are a woman?

Yes, all the time. All my life. I only recently realized the scope of how much negative experience I had. It has been happening a lot during my life, but I was not really aware of it. I have been told offensive things on the street. I have been molested by men on public transport. It has also happened in my working spaces.

Has it ever happened in the professional environment?

Sure, I think this kind of behavior is ingrained in our culture. It is reflected or manifested in all the areas. It is happening on the streets, at work, at home and everywhere.

PHOTO BY: ERIC SCHRIJVER

Loraine Furter is a graphic designer and researcher based in Brussels since 2007, specializing in editorial design, hybrid publishing and intersectional xfeminism. She designs and edits paper publications as well as digital ones, and is particularly interested in the interaction between these media. Loraine teaches at ERG in Brussels and is currently involved in the development of a master's program on design and gender. Loraine designed an online database of open source typefaces designed by women called
Badass Libre Fonts by Womxn.

INTERVIEW CONDUCTED VIA SKYPE, MARCH 2018

I am quite interested in your project BADASS LIBRE FONTS BY WOMXN. How did you do it and what was the intention behind it?

Over the last few years I have been working on the connection between graphic design and the topic of feminism. I did not study this in the university. It is through people I met that I got introduced to the feminist approach to graphic design. Since I am a graphic designer, I always try to make sense in terms of graphic choices I make in the projects I am working on.

The project Libre Fonts started from a personal interest. It was really a self-initiated project that appeared as a result of different thoughts crossing my mind at the time. I started to collect fonts designed by women into one folder. Over these years I have been interested in the open source community as well and I am trying to work a lot with open source software. So, I started gathering open source fonts made specifically by female designers. In the beginning I wanted to find 3 or 4 existing open source fonts but later on I realized that there were many more. This folder and the way I collected material was not very efficient: it was not easy to access fonts, preview them, etc. Since these typefaces are open source, you can use them for websites and preview them on the webpage. It also allows you to have an interactive preview that can be modified. Since I gave quite a few type specimen workshops using websites in the past, I thought it was time for me to build an interface in which you could preview these collected open source fonts. I also thought it would make it so much easier to use them for me, for my collaborators and for everybody else. First, I did it as a local version on my computer. Then I thought that it was so stupid not to share it with others. The topic of sharing is also very important to me.

> I got introduced to the feminist approach to graphic design.

That is why I did not hesitate even a minute before doing it. Typefaces were already there. My aim was to make them visible.

There is this website—Typequality.com—that I think is amazing. But since fonts you can find there are proprietary it is hard to preview them on the screen. You cannot easily use them because you have to buy them or ask every foundry for a license. Although there already was a website featuring typefaces designed by women, I wanted to create something that would help to spread open source typefaces freely. Open source can encourage people to use typefaces if they are easily shareable. I hope this will assist typeface designers in getting noticed and maybe eventually in getting more commissions. It was an important point for me. Open source is quite often misunderstood to be "free beer" as they say. However, the fact that they are free is not the most critical part of my work. I am also very engaged in fighting for better working conditions for graphic designers. The economy of graphic design is very political. This is one of the reasons why on my webpage in the "About" section I wrote that for me it is very important to not only encourage people to use the fonts, but also to encourage them to pay the designers for what they do whenever they can, or hire them for further projects. Otherwise, it will be very controversial if I advertise free work of women. This is not what I want to do. Getting equal payment for men and women is already a big issue in the graphic design community and in many other spheres. This is why I am very excited about your project. We need more people to work on this topic.

Recently, I talked to a friend of mine who is an architect. They are working on a memorial to a big moment in the women's rights history of the United States. I looked at the history of typeface design and I stumbled upon a lot of articles asking where women in typeface design are. At the same time,

> Open source is quite often misunderstood to be "free beer."

there are not many articles digging deeper into this topic. There are a couple of names listed showing that there were women in the history of typeface design, but there is no discussion or analysis about what is actually happening in this field right now. There is no examination of why women are not that visible and when the community will reach the point when they are. There is a documentary called "Graphic Means. A History of Graphic Design Production" shot by Briar Levit.[1] It shows the shift that the industry underwent due to the development of new tools. The crew that worked on the movie was actually female. This is a very important documentary that addresses the topic of women in graphic design.

> I realized that I don't know of any women working in the sphere of type design before the digital era.

Anyway, back to my friend who is working on this memorial. When I was talking to them, I realized that I do not know of any women working in the sphere of type design before the digital era. This made me think about something so obvious, but at the same time hidden, something not being addressed. Before the computer age there were no famous women in type design, although there were actually women who worked in this field.[2] I think that the new technology and computers allowed women to enter the domain of typography. I think that women embraced these new tools that were neglected by others and it became their gateway into this territory. I am missing the analysis and literature on that. How come that Zuzana Licko[3] is more or less the first known female type designer? I think it happened because she entered the field that was disregarded by others. She is famous because she was a pioneer of this medium. She believed in the new technology and the power of computers.

Are you familiar with any other women who worked in

BADASS LIBRE FONTS BY WOMXN AA Aa ⓐ + -

ABeeZee by Anja Meine

Abhaya Libre by Sol Mata

Abril Fatface by Veroni

Almendra by Ana Sanfelip

Almendra Display by An

Amarante by Karolina La

Amaranth by Gesine Todt

Andada by Carolina Gio

Arbutus Slab by Karol

Armata by Viktoriya

Asul by Mariela Monsalv

Bitter by Sol Matas is a

Caladea by Carolina Giov

Cambay by Pooja Saxena

Cambo by Carolina Giov

the field of typography?

Recently, I stumbled upon the biography of Beatrice Warde, who is also known in the field of type design. She came before Zuzana Licko. Even though she did not design typefaces, she was a very prominent figure. Her story is extremely fascinating. She started as a librarian in the library specializing in typography. She published her research paper under a pen name of Paul Beaujon. After that Paul Beaujon was hired by Monotype. They were quite surprised when a woman showed up. I find those strategies she used very clever. I do not know if they were intentional or if it was the only possible way to get ahead at the time. She used the system and tricked it in order to do what she wanted. I also find it striking that in her essays she writes that printing and graphic design should be invisible. It makes so much sense to me, because it is her experience as a woman. You either have to be invisible, or hide behind some male name. I was very inspired by these stories that can become the new history of type design.

How come that Zuzana Licko is more or less the first known female type designer?

Another conspicuous person at the crossroads of feminism and graphic design is Sara De Bondt. Sara together with Catherine de Smet wrote and published a book called "Graphic Design History in the Writing." This compilation includes several texts addressing the history of women within the history of graphic design. It is one of the few publications that really address this question. There are some articles online that deal with this topic, but not many of them are published.

Sara De Bondt has been doing a lot of work that is relevant to feminism and at the same time she has a hard time speaking publicly. One time at a conference she asked us not to record her talk. I thought it was very touching. She hates to talk

in public about women in graphic design or to be invited to do it because she has often felt like a token woman. I can understand that. I think there is a difference between being invited as a feminist and being invited as a woman.

Getting back to your project, could you tell me how you found these open source typefaces?

I spent quite some time doing research. I also went through Google Web Fonts. I still have to reach out to communities and spread the word about my project. The project was very chaotic and started as a personal piece. I did not put a lot of effort in promoting it. I still have to look for more open source fonts designed by womxn.

The list of designers on the webpage has been growing.

Yes, it is growing. I also got contacted by people who told me that I forgot their typefaces. It is great that people contact me because I am not only interested in their typefaces, but also want to know more people who are working with feminist topics and with gender-related questions. Besides I am trying to get into the right places to make an impact. This year I organized Fig. Festival where we talked about gender issues. The bottom line is I would like to have a strong network to be able to make women and the feminist topic more present. So, no more all-male panels. That is why it is wonderful to be in contact with the people who designed these typefaces.

> A lot of people think that feminism is about being angry and sad all the time.

Do you ever think about the gender issue in typography?

I think in typography there is a lot that can be exciting. On the one hand, it is such a traditional and conservative field that it can be a little bit scary. The question of gender is not necessarily a priority. On the other hand, it can be very thrilling. For example, I invited Roxanne Maillet who conducted a workshop on making more inclusive glyphs to the graphic design festival that I organized early this February. People were drawing new letters find-

ing new ways of doing inclusive typography. They were not only using the binary system like dots and dashes to mark masculinity and femininity, but also really developing new ligatures and working on words that are not just "hers" or "his". We need this in the French language so much. We have "feminine" and "masculine" all over the place. It was so exciting. All this is not about typeface design anymore—it is about new letters and glyphs. It is really a challenge I am passionate about. A lot of people think that feminism is about being angry and sad all the time. Yes, sometimes it is like that indeed [laughing], but mostly it is the opposite because you have to create and find new stories. For me it is the main reason why I am doing it. I am so happy that I was introduced to the feminist approach. I never regret it although sometimes it is very sad indeed.

What do you mean when you say that you were introduced to the feminist approach?

I like to stress that I was introduced to this, because I think it is highlighting the fact that it is not there by default. It is hard to start thinking in this manner if you are educated in a system which is rather one-track. To learn to think in broader terms than just black and white is very important. Complex arguments are complicated but if you dive a bit deeper into it, it may become very interesting. This is not an easy journey that you can necessarily do by yourself. It came to me not from the graphic design field but through publication. It started when I went to a collective Wikipedia editing session that was organized by an artist and it had a feminist approach to it. Suddenly, it made a lot of sense to me that publishing is representation. And that representation can sometimes be very biased. It opened new horizons for reflection. I never thought about it. It helps me to find a place where I can research and find fascinating things. With three other graphic

> Publishing is representation. And that representation can sometimes be very biased.

designers and an artist we started, just for the record, a collective where we continued working on a gender representation online and finding out what it means when you can collaborate on this representation. I slowly learned with them. I was also teaching at the time and could not ignore this, for example, regarding the materials that I showed and printed out for the students. That is why I am talking about being introduced to the feminist approach. Besides I am trying to be a facilitator for those who are just starting this path. If your teachers do not care about this topic or cannot answer your questions, it can be very sad and frustrating. I believe that being able to give a nuanced answer to the students' questions is an advantage. I also think it is important to stress that you were introduced to this way of thinking by your teacher. This is not a natural self-starting process and I like to highlight this fact.

> Somehow we ended up having almost an all-male panel at the conference.

This is the reason you organized the festival, right? What is the festival about?

Of course, now I see things a bit differently than before. I am usually very busy and it was probably not a very good idea to get involved with the festival because it is always a handful. I was invited and said yes, although I really had a lot of work to do alongside with that. But by organizing a festival you get the opportunity to have agency on what to show. Festivals and conferences are very important. At conferences you often have buddies who speak. A festival/a conference is sort of a validation process. You can also invite other people who are going to benefit from this. It was the first time when I was participating as an organizer. Therefore, I wanted to wait a little bit and see what the first audition would be and then offer the ideas on how we could integrate the gender issue. We were a group of graphic designers who were not paid to do that. It was a

small-scale festival that started only a year before. Somehow we ended up having almost an all-male panel at the conference. Quite late in the organization process I noticed that and mentioned it to my co-organizers. Unfortunately, not much change happened: this problem remained unnoticed. We were communicating through Slack and had not met each other in real life. After a while one of the organizers offered to do a lunch with female graphic designers. I was shocked and said it was ridiculous to have the all-male panel at the conference and have a lunch with female graphic designers. I could not support that, just as I could not support the all-male panel. I told them that I would have to write about my experience participating in putting the conference together and ending up with the all-male panel. I think it is the worst thing you can do—organize a conference with male speakers only and not to say anything about it. Of course, it can happen and it is vital to share this experience. The good thing

> The worst thing you can do—organize a conference with male speakers only and not to say anything about it.

is that we were a small festival. All graphic designers who I was working with on this festival became aware of this issue and were ready to change it. In the end, we managed to revise the program and invite more female speakers. We also organized a round table discussion about this topic. We wanted to be transparent about our experience and I wanted to make sure that it would not happen again. That is why one day of the festival was dedicated to the topic of graphic design and feminism and to the importance of tackling this issue. The bottom line is it was a nice experience to go through.

Sometimes you are lucky enough to open your mouth, say that you do not agree with something and be heard. It was very helpful that I was working on this issue for a long time. Whenever I had to give

a list of female designers, I had a lot of relevant people in mind. As festival organizers, we reacted quite fast. I can imagine if you do not have this list of people prepared beforehand, it can be difficult to react right away. If there are no online platforms or books or lists of people you can choose from, it can be challenging to look for them. Therefore, it is great that you are doing this project about female type designers. If there is a book about it, then it is easier for everyone. I think a comprehensive list of resources would be very useful. We have to understand that we are doing the work for the benefit of those who will expand on it. Think about people who would start with all the information that you collected. It will be easier for them to go beyond.

1. Interview with Briar Levit in this book page 179.
2. Research on early female type designers in this book page 59.
3. Interview with Zuzana Licko in this book page 187.

PHOTO BY: MARCEL SCHWICKERATH

Jenna Gesse works as a writer, lecturer and graphic designer, focusing on typography and book design. She teaches at Lette Verein Berlin. Gesse's work has been awarded by, among others, the following institutions: Stiftung Buchkunst, Deutscher Designer Club, Art Directors Club, Federal Association for Print and Media, Type Directors Club, and reddot-Institut.

INTERVIEW CONDUCTED VIA EMAIL, APRIL 2018

When did you become interested in typography?

Since I was a child, I have loved stories and have always been fascinated by words. From the moment I was able to read and write, I started to write a lot of short stories and poems. My interest in typography started with the interest in words and language. During my studies [Graphic and Communication Design] I discovered typography as a tool to put a face to the content.

Do you have any special feeling towards particular glyphs? (love, hate, excitement, etc.)

There are many letter shapes which can make me very happy but I do not have something special in my mind. As for content, I do not like semicolons and I love dashes.

What role does typography play in your projects?

The star role.

You mentioned that you work a lot with type. Could you tell me how you choose typefaces for your work?

First, I look at the content: What is the topic? Is it historic or forward-looking, chilly or emotional, playful or strict? This already gives you some advice on your typeface choice. Second, I have to be clear on what function the typeface has to fulfill: do I need it for a long body copy in a book or for a short headline on a poster? After that I start trying out different typefaces with the original text. Print it out—in original size!—have a look, rework … until the penny has dropped.

If you are looking for a new typeface, where do you look?

I often ask friends who are more into typefaces than I am. I explain what I am searching for and they give me advice. If I see a typeface which I like a lot, I try to find out which one it is. Of course, I also get a lot of newsletters from different foundries and have a look at the MyFonts website from time to time.

What were the last 3 typefaces you used?

Franziska, Fabrikat, Teddings.

Do you use some typefaces more often than others?

Yes, definitely. I guess it has a lot to do with the viewing habits and requirements. The typeface

has to make the grade of your work. It has to fit the text perfectly, for example, a long body copy. If you found a typeface like that, it is like finding your perfect pair of jeans—maybe you do not wear them every day but you always feel comfortable in them.

What is the best source of inspiration for you?

To watch, to read and to talk to people. People with a sense of humor are the best.

Who were your idols or role models while studying?

I have never had idols or role models in a conventional meaning. Though I read a lot, I looked through a lot of different graphic design works, I never became a fan of a certain designer. I guess the influence of my friends, my teachers and my fellow students was much stronger.

Do you think there are too few female role models?

I do not care a lot about role models. For me values and virtues are more important. But if I try to think of any major 20th-century graphic designers to suggest for presentations in my class, for example, I realize how underrepresented women are. I hope that it will be completely different in 50 years! And I feel really uncomfortable with the increasing overrepresentation of machos in politics. I mean, what the hell?

I know that you also teach at Lette Verein Berlin. What kind of assignments do you give your students? What do you want them to take away from your class?

At Lette Verein Berlin I teach typography basics to graphic design students once a week. I teach them the first year of their 3-year-long course. So usually they are just beginners and we start with analogue exercises with paper, scissors and glue. These exercises help to get a sense of the combination of typefaces and sizes, of the layout on the format, of axes, focuses and the statements which could be made with these choices. In my class they learn how different the requirements on ty-

> I hope that the time will come when the gender of the speaker won't matter at all.

JENNA GESSE

pography can be and how they can use them in different ways. And, of course, I want them to know the meaning of serifs and ascenders after that year.

If you show them important and inspiring designers during the class, who are they?

As most of my students do not have a lot of previous knowledge, we start with the basics: Dada and Bauhaus typography, Tschichold, Pineles, Otl Aicher, Swiss typography, Paul Rand, Saul Bass, Carson, Scher, Spiekermann, Irma Boom, Erik Kessels, Sagmeister. In addition to that I show them stuff that impresses me—no matter who the creator is.

What is a female/male ratio among your students?

Two-thirds female, one-third male.

Are you often invited to talk at conferences?

From time to time—depends on the projects and topics I am currently dealing with. Until now, I talked about book design in most cases or was a part of book design juries. However, I never pushed to talk at conferences.

Have you ever applied to talk at any conference yourself?

No. I guess many women—including me—are too reserved. They want to be a hundred percent sure that the topic they talk about is really matter of the moment.

Do you like to talk in front of an audience?

Yes, if I know what I am talking about. If the topic thrills and inspires me, I like to talk about it—including in front of an audience. I am not afraid to tread the boards.

Do you believe it is necessary to have an equal share of female and male speakers? Why?

Unfortunately, finding ways to reduce hurdles for women seems to be necessary. These hurdles have been manifested in minds for centuries. Many women need help to become braver as so many mechanisms worked against them for such a long time. I hope that the time will come when the gender of the speaker will not matter at all because nobody would even think of being at a disadvantage due to their gender. Whoever is on stage should have something to say, no matter the pitch.

I wish that women supported each other more. I wish that women were not forced to decide between a career and a family. And I wish that we all did not cramp up and get stiff while trying to do everything right.

Golnar Kat Rahmani is a Berlin-based creative director and artist in the fields of typography and multilingual editorial design. She was born and raised in Iran, graduated in Visual Communication from Tehran University and Weißensee Academy of Art Berlin. Her recent initiative project "Type & Politics" aims at freeing Arabic/Persian type from its ideological connotations.

INTERVIEW CONDUCTED IN BERLIN, FEBRUARY 2018

When did you become interested in letters?

When I was 10 years old I started to do calligraphy. In Iran doing proper calligraphy is a very respected skill to have and an important part of our culture. There is a big national educational institution in Iran where you can study calligraphy and everybody who studies there becomes a great master of it. This university has branches in almost every city. I was attending one of them when I was 10 and I spent about a year practicing better handwriting. I was lucky that my father paid attention to it.

What did your studies look like in Iran?

I studied Visual Communication at the University of Tehran from 2001 to 2006. The education systems in Iran and Germany are very different. In Iran they focus more on educating you as an artist. It was more about expression and creativity. Our professors were more artists than designers. However, I think at that time the borders between art and design were blurred. We received common skills training needed for classic graphic design. When we worked with typography it was used in a more artistic way. We designed typefaces that were more experimental. We played with type. We made shapes out of letters and then stretched them to the right, left, up and down. Observing German students working on typography for their posters I was surprised to see that they did not change the design of the typefaces, simply applied the typeface to the text. I thought, "Why don't they work?!" To me it was similar to buying some colors and putting them on the canvas without mixing. So, I was thinking, come on, mix it and create your own color and use it. Now it makes sense to me after getting to know the German approach to work with typefaces. Also in Iran there was no such thing as copyright. Nowadays, of course, they are trying to make it in a more proper way. But back in the day there was no license and everybody could download anything and this concept of buying typefaces was really new to me.

Was it easy for you to move to Germany?

I had a difficult time figuring out how things were done here. My culture shock was the biggest one. I do not mean traditions, rather communication. In the sense of visual communication the world here is totally different. For example, for some posters I used a guy standing with his head off. In my culture it would mean something spiritual, something that goes up to the sky, to another spiritual domain. It would mean thinking. But Germans in my class saw it as somebody dead, someone stupid, brainless. It was very shocking to me. I never thought about these differences before. I knew there would be another culture, another language, another lifestyle and I was looking forward to getting to know it. I knew it would not be easy, but I did not expect these differences in meanings. I came to Germany with well-defined goals and I had to change and redefine them because I was trying to get used to the country. It made me so busy that I was away from doing my own thing till 2016. During this gap between 2009 and 2016 I was adapting, finding my way and dealing with visa issues. In other words, I was settling down. Since I am Iranian on a student visa I had to find a job that was related to my studies, so I was never really free in my choice. Foreigners' Registration Office did not even want to accept "web designer" as my job status, because my certificate said "visual communication." It took me some time to feel safe and then for the first time in a while I could start thinking about my own studio.

> We made shapes out of letters and then stretched them to the right, left, up and down.

Did you work for any companies after you graduated?

I graduated in 2013 and then moved to France. I did graphic design for my friends' animation production. But after that I had to move back to Germany because I could not extend my German visa with this French company. At the beginning of 2014 I was back and I got a good job with Deutsche

Welle at the design department. Our design team consisted of about 60 people and most of them were women, which was good. After I worked for them for 2 years as a freelancer, I founded my studio "Kat Rahmani" and was able to start working on my own projects again. I worked for Umweltbundesamt (Federal Environment Agency) and did layouts of Arabic and Persian education books. It is rare to find a designer in Germany who could work with both Arabic and Latin letters and at the same time consider their cultural backgrounds.

What would you do if you could do anything?

I cannot just do one thing. I love being busy with type design. But I do not think I can do only type design. I enjoy making graphics a lot.

Do you mean text type design or lettering?

I mean text type. Actually it is very interesting that you ask about it. In Iran there are a lot of type designers but most of them make very decorative and special typefaces that can be used for a title or a poster but not for a longer text. I see a lack of well-designed typefaces in Persian and Arabic typography. It is hard to find a good typeface for a project because there are very few good ones now. There are some designers from the West and they try to design Arabic typefaces. Their fonts are practical and useful but miss a fine touch because the designers lack the understanding of the language.

Are there any universities where you could study typeface design in Iran?

No, but some professors that we had could do it very well. As I said, there is a big institution offering calligraphy classes. Many people who studied graphic design attended it to gain calligraphy skills. That is why a lot of typefaces are very decorative. Now there are a lot of young students that try to design text typefaces. However, it is still quite difficult to find a good text typeface for a text in the

book. Moreover, if you want to make a bilingual book, there are really few typefaces that you can use next to each other.

It is hard to make Arabic and Latin typefaces look complementary on one page. It is a challenge and I would be very interested to work on such a project. I always wanted to develop a typeface for Deutsche Welle. Currently they are using a Google Font called Noto, but I think they need their own type and I would like to be commissioned to design a corporate typeface for them. For example, Apple has designed their own Arabic typeface for the computer system.

I know you will be giving a workshop at TYPO Berlin. How did you get invited?

I met Ana [Regidor] at TYPO Labs.[1] She is responsible for organizing both TYPO Berlin and TYPO Labs conferences. Later on we got together and I talked about the issues of Arabic typography. She asked me if I wanted to give a talk about it at TYPO Berlin and I agreed. However, I decided to do a workshop instead of the talk because I thought it would be much more fun. My workshop is about Type and Politics. It is about how political decisions are influencing our daily lives. Nowadays there is a big difference between something written in Arabic and in Chinese. We react differently to different languages having some clichés in our heads. Just because of the politics and media when people see Arabic letters, they think that it is something about bad, sad things and war. To them it is not about love, fun and life. Mass media, which portray whatever is happening in the Arab world in a mostly negative light, affect heavily the way people perceive letters. There is a lot of propaganda going on that leads to false conclusions. Just because this is another alphabet and it is Arabic, and Arabic is related to Islam, it is perceived as dangerous.

> It is hard to make Arabic and Latin typefaces look complementary on one page.

Politics influence not only Arabic letters but also people who are speaking and writing in this language. When people see me typing in Farsi on the U-Bahn [subway] I see that they feel strange. This is a kind of discrimination of people who use Farsi. I think that a lot of problems are the result of the lack of knowledge. Many people just do not see the positive side of things. For me one of the ways to demonstrate it is showing people the other aspect of the subject. For example, the beauty of Arabic and Persian type. It is important to introduce them to what it is and how it can be used. Therefore, I developed the project "Type & Politics" to depoliticize Arabic type. I am always interested in how we can influence this sad situation and introduce people to a new way of thinking. It breaks this wall of ignorance.

> Just because this is another alphabet and it is Arabic, and Arabic is related to Islam, it is perceived as dangerous.

If you see some cool graphics with nicely done Arabic words, you are not going to feel threatened. This is the purpose of the workshop I am going to host at TYPO Berlin. I will make an introduction to the Arabic typography and after that participants can make their own graphics using Arabic letters.

Do you have any idols?

Generally, in all things I do not like the concept of having favorites.

So you do not have a favorite color or anything like this?

No, because I cannot choose one or two. Sometimes in design you see something and you think "wow" and feel very inspired. Before I came to Germany I wanted to be a student of Uwe Loesch. I really like his work. For example, now I like the work of Mirko Borsche's studio, a graphic design studio from Munich. Another person whose work inspires me is Martin Venezky. His photographs are very inspiring. But there are so many other artists and designers that are good. I have a long list of studios

that are great. Every time I am bored, I can just click through the links and feel like I am at the gallery. That is why I do not have any favorite designers.

Have you ever looked at someone's work and thought, "I wish it were me who had done this?"

No, I have never had this thought. I know what you are talking about though. But I never wish it were me because I would do it in a different way. From time to time I wonder how I can be commissioned to do this project other people are engaged in. I always think I would do something else with this task. I do appreciate a lot of other people's work and think there are a lot of great artists, but I honestly never had this thought.

What does success mean to you? Is it important to you?

It was very important for sure and still is kind of important. The process of achieving something is like an adrenaline shot. It is very thrilling. Lately I have been thinking that success is wonderful and makes you happy for a moment but it is not my goal.

What exactly would be important for you to achieve? Some people want to win a competition and some want to start their own company.

I believe that everything is relative. For example, you are running to catch a bus and you make it and it makes you happy and you think, "Wow! I made it!" You achieved it, you are very happy for a second but then at the same time you still know that you have a lot of other things to do. It is something great to achieve, but this achieving process is never going to end. There is no end to it and that makes it interesting. There are some steps, or rather, there are no steps, because steps are coming one after another. But in this case there are some things that you want to do or places where you want to be eventually and you wish to experience them. It is the curiosity of having it or doing that.

> I believe that we are still living in a man's world.

Right now I am somewhere where I would have never imagined myself to be. At the same time I

realize that there are still so many things to do that sometimes I have a feeling that I'm just at the beginning. There are some images in my head of where I want to be and what I want to achieve and I know this is only a matter of time. I am not sure that I will ever reach them, besides that I do not know how my wishes will change in 5 years. I will not have the same dreams. And maybe in 5 years everything that I wish for now will not matter at all.

Do you invest a lot of time in promoting your work?

No, I do not have an Instagram account yet and even my website is not updated. I know it is not good. There are a lot of works of mine that need to be rephotographed. Working on the portfolio is a big project by itself.

Do you know a lot of female type designers?

Generally, famous designers that people know are men. I believe that we are still living in a man's world and that makes it easier for them to get ahead in life and climb up the ladder of success! Because I am a woman I know a lot of good female graphic designers and, of course, I know many good female type designers.

There has been a lot of discussion about female/male ratio of speakers at conferences. Do you think it is important to talk about these issues?

Yes. I think it is good to support women in this case. I do not like the idea that it might look like they are doing us a favor by letting us speak at conferences. There are a lot of issues that have to be addressed in different professions and they have to be addressed by the society. Of course, the situation in Germany is much more different than it is, for example, in Iran. As a woman you are constantly under pressure. You should be a woman, a mother, a model, you should be nice, natty, feminine, pretty and girly, you should be this and that and on top of all that, you should also be successful, earn a lot of money, be independent, you should be everything. Also, as soon as something goes wrong, the failure will most likely be attributed to your gender. People would say something like, "She makes

such mistakes because she's a woman" or "It did not go well because there was a female supervisor." I mean, not always... but also there is a tendency of not taking women as seriously as it should be. So many women are trying to behave like men in order not to be dismissed as lightweight. Then they are taken seriously but suddenly they are not feminine enough. That is why I am saying it is still a man's world, because you are not allowed to be yourself. It is not okay. Still, being a woman in Iran is much harder. You cannot compare both.

What I also always found difficult for women in work spaces is the networking. In comparison to men it is much more difficult for women to build connections. There is always so much prejudice around women's behavior. However, it is a whole different discussion. There are many studies about the unbalanced society we live in. In many countries you can still see the unfair treatment of genders. It also exists in Europe. Of course, I am not saying it is the fault of men. We women are a big part of it. We need to learn in order to be able to achieve equality! That is why I am okay with this situation that some conferences keep the ratio of female/male speakers even. There should be more awareness about this issue and there should be someone who helps motivated and active women to come on stage.

> There are a lot of issues that have to be addressed in different professions and they have to be addressed by the society.

People say that there are a lot of men talking at conferences because they want to do it and they are trying to do so and women just do not want it, why push them.

Quatsch! [German for "nonsense"] There are a lot of women who are talking at conferences and, of course, they are stressed and they talk about their feelings. Men would usually hide their emotions because "they are not allowed" to show them. It is great to have these 50% reserved for women.

Especially for those who are shy or not self-confident enough. They have to understand that it is possible, it is beautiful and great to be visible and other people will listen to you. If you make mistakes, it does not matter. I have to speak a foreign language in front of people I do not know. It makes me stressed too. Lately I have been giving this example to my friends—Obama and other countries that supported him bombed Libya and killed dozens of people. They destroyed the country and it is going through misery now. Once on TV he said that it was a mistake! If someone can afford to make a mistake like this, why should not I be able to make a mistake on stage?

Some women reacted negatively to these 50% reserved for female speakers. Now they think that they are invited only because they are women.

Who cares? Why is it so important? If I am not sure about my knowledge, it is my problem. How can I be sure about the reason to invite me to the conference? I do not know if it is my topic or the subject of Persian and Arabic that is very trendy now or my gender. Maybe it is a mixture of things. The most important is the fact that I got invited and it is good. I do not have to know why they asked me. It does not matter, I am not going to marry them. It is my problem if it bothers me.

If you make mistakes, it doesn't matter.

In the end I just think, "Okay, cool! They asked me." I also do not know why you are interviewing me. Of course, I understand that it can also be weird for some people. I am not supporting this idea of keeping places for women just because they are not able to do it themselves and this approach of "the world is watching us and we had to do it." But we have to look at it differently. Nothing is fair! Nothing is in its place. Nothing is the same for women and men. There is still no equality in this world. There are a lot of talented women but because of much inequality they do not get their chance to shine. We have to use this chance and fill those 50% with

talented, great and professional women.

I sometimes feel guilty for asking about female type designers or talking about this question because I have a feeling that some people got very tired of this topic.

I understand it as well. I think that feminism as a term is being used and abused too often. As well as, for example, "blonde hair"—as soon as you start talking about "girls with blond hair" people will roll their eyes. They are allergic to it. I have a feeling that you get the same reaction when you talk about feminism. I do not think that it is the right time for feminism now. Not here in Germany at least. Women try to adapt or copy male characteristics to become more equal. But it is a very wrong idea. Women are not men. I think the term "feminism" is overused that is why a lot of people especially men react in such a way and say, "We are sick of this subject." In practice there are still a lot of unresolved issues and that is why it makes sense to fight for change. However, we have to change the concept and the approach to this topic. Or we have to change the language and use new words, new terms, so that men will listen to us again. For example, even in the German parliament unequal pay is a hot topic.

1. Interview with Ana Regidor in this book page 195.

PHOTO BY: INGEBORG KNIGGE

Indra Kupferschmid is a freelance typographer and professor at HBKsaar, University of Arts Saarbrücken. She is an author, consults for the type and design industry and other clients who need help choosing fonts, as well as writing for several different magazines and blogs. Indra is a founder of the Alphabettes group, that aims to support and promote the work of all women in lettering, typography, and type design.

INTERVIEW CONDUCTED VIA SKYPE, MARCH 2018

When you teach, do you include female type designers in your program/lectures?

I do not teach a class where I specifically assign the students typeface designers to research on. Usually we are working project-based. Students will learn everything they have to know around this project and practice relevant skills. But if I think it is relevant to the topic or something we talk about, I mention them, of course.

Are the majority of your students female?

Yes. I think that is the case in most design classes. Sometimes as many as 80%, depending on the class. My school is probably not a typical example because all years are mixed together and everyone can choose from all classes, so the groups are always changing. When we are doing interviews with new student applicants, we are trying to put together a good mix of people. That also means making sure that we have a reasonable amount of men among them although, often, women have stronger and better presented portfolios and they are better at self-presentation.

Interesting. That reminds me of the situation with female speakers at conferences. Now, organizers are trying to make the proportion of speakers more or less even.

We do not aim for total parity, just for a healthy balance and not 14 women and one man for instance. That sometimes means giving the advantage to a guy, but it is not a fixed percentage or clearly defined.

Over the last three years the topic of the unequal share of female and male speakers at conferences has became popular again. What is your opinion on this? A lot of conferences are aiming to have a 50/50. At the same time I noticed that some people react very negatively to this.

Yes, usually men. I think I have not heard a single woman finding this a wrongful suggestion.

I spoke to some women in type design who aren't happy about it. They were sure that they were invited to conferences because of their work. Now they might be invited only because they are women. It offends them.

Yes, I had this situation as well, but the other

way round. In the past, I had the feeling I was often invited because they needed a woman on the line-up. People usually say that they invite others because of their good work or because they are interesting people. If you then see 90% of men speaking it says that women are not doing any good work or that they are not interesting. It does not have to be 50/50 although I think it would be fairly easy to find 50% of women. As soon as you start looking a little bit and asking other people in the industry, you can find women who would agree to speak. Of course, it could also be 40% and 60% or something like that. But if it is 10% to 90%, it is ignorance or bias.

I know that you often talk at conferences. How did you start? Have you ever applied to participate in conferences or have you always been invited?

I have never applied to a conference except if they had a call for papers, like ATypI. They usually contact me because of some work or research that I did, or writing, or they saw me speak somewhere else. If you never make anything you do public, or take part in public conversations, meaning if no one knows what you are doing, no one is going to ask you. Maybe through word of mouth of friends. You do not have to actively reach out to organizers, but it helps if you are present on social media, take part in the debate, write an article somewhere, or just present at events, exhibitions or openings. In other words, take part in the community, so people know what you are doing, know your face and your name.

Quite often if there is a call for papers for a conference, most applicants are men.

Yes, or at least the majority are men.

Do you think women are just not engaged enough or not interested in doing that?

I do not know. Men are often more confident that what they do is interesting for a conference. When women have an idea for a conference talk they often seem to question their own expertise at the same time they are discussing it. Unless they want to market something. If they run a type

foundry or other design company they are probably keener to speak at this event to promote their work. There are much fewer women running companies in this field though. Speaking in front of an audience can be stressful and scary. It also does not come easy to me. I am still nervous and do not seek out to do it more than I have to. I feel men like to be on stage more, but I should not generalize. I also know a lot of the women who love speaking in front of an audience.

> I was not a big feminist in the '90s and 2000s.

Invited conferences like TypoBerlin do not have a call for proposals; you would be asked to speak there. Nevertheless, some people still pitch themselves to conference organizers with an idea for a presentation. Also in this case the majority of those are men. Monotype, the organizers of TypoBerlin, is not motivating people to apply because they do not want it to be the official way to get on the speakers list. On the other hand, if this turns out to be a way to get on stage, it seems unfair when only the people bold enough to write to them get to speak, and others who follow the rules and wait for an invitation never get in.

Conferences that have calls for submissions, such as ATypI or TypeCon, say they are encouraging women to apply but it is not mentioned in their call for presentations specifically. I think there could be more outreach. Some of us even put together some ideas for ATypI on how they could engage more women or more first-time speakers. For example, coach people on how to put together a presentation. But that has not been picked up yet.

Did you have any role models or idols when studying?

Sure, but admittedly, at that time I did not think about whether they were male or female. I was not a big feminist in the '90s and 2000s. I am from this generation that grew up in the '70s and '80s taking emancipation for granted. We thought the debate was over, that equality was achieved. I never experienced any big problems myself, or at

least I did not think they were rooted in my gender. I was pretty ignorant of this whole topic and always felt free to do what I wanted. I owe a lot of this to my first teacher in primary school. For my secondary education I went to a Catholic girls school, which is not very usual for Germany. There I never had the feeling I could not do something. I majored in chemistry, never felt embarrassed in sports classes because there were only girls anyway. I do not know if this is different in a mixed school but at least I never had a moment where I thought, "This is something that women do not do or should not do or I should not dare do." But of course a lot of this depends on a personality.

Hardly any of my design role models in the 1990s were women, maybe Irma Boom, but back then it really was harder to name more than three female designers that people knew of. Luckily, that has changed a lot. Today I could probably name something like 60 women you could invite to big events. The more people you get to know, the bigger a group of people you can choose from. When people say, "There are no women in type." I say, "Well, you just do not know any. I know about 300 women in type." It always depends on the people you hang out with, what you are reading, who you are talking to. We all know, that even at conferences people often stick to their circle of friends. You have to actively look beyond to see what is out there that you did not know before. But you cannot say that something is not there just because you did not see it.

> Hardly any of my design role models in the 1990s were women.

You said that you were not a feminist and were never interested in this topic. How did you become involved?

I have become aware of it over time. Now it is a much more present topic then it was just 10 years ago. It was around 2015 when we had several big Twitter debates about women at conferences and similar things. Back then I was actually arguing

that there were no issues. I thought that if you just wanted to, you could speak at conferences. Later I realized that just because I did not have any problems, it did not mean that other people also did not have any problems. When some Americans told me what they had to deal with and what their situation was in design agencies I was very shocked. Also I have never worked at an advertising agency apart from one internship. I was mostly self-employed or freelanced, mostly in book design or type. It felt like there were 80% of women in book design. I never had a situation where I was the only female in the office. I never experienced the "bro culture" with making weird jokes about women, or drinking beer as the only social event. Of course, it helps if you like beer, like I do.

In the beginning I did not know what they were talking about. But I listened and believed their stories. Even if it is not my personal problem, I see that this is a problem in the culture of a lot of countries. Germany is certainly not free from that either. Just because I was lucky does not mean that other people in Germany do not feel suppressed or hindered. One evening, to channel the discussions and energy, I set up a group called Alphabettes. It was not planned, just happened. I sometimes do things without thinking the consequences through. This was a prime case. Before I knew it, I was the face of the movement that was completely accidental. Now people think I am a hardcore, fighting feminist. That is alright. I do not fear any repercussions. I am in a situation where I can help other people to get ahead.

Is it the reason why you founded Alphabettes together with other women?

Yes. It had started as an email chain and at some point there were so many people emailing each other that we needed a better medium for this so we continued talking via chat. A month later

we set up a blog. It is a place where we could put down our names and also publish our work. We wanted to have something that people could find and see that there are actually a lot of women in type—people they could invite to a conference or hire. As I said, it is not that there are no women out there. Just think about the many design students who graduate each year. Where do they go? They are not all going away or disappearing. We are just not seeing them because we either do not actively search for them, or they are not the loudest in the room, or not the loudest on the Internet / the loudest on Twitter. We wanted to make these people a bit more visible.

How does alphabettes.org work right now? If I would like to write an article could I apply and will it be reviewed and later on published on that page?

We do not even have a real review process. There are not many people behind it. The page is mostly organized by Amy and me, or rather "unorganized". If someone wants to submit an article or a header design they can write to us and, depending on our schedule, we would answer in a timely manner. But, for example, last week I was not at my computer at all. Sometimes it can take forever.

It was much easier when we were just 20–30 people and we all knew each other personally. Now we are around 220 and less active than we used to be back when there were 20–30 of us. But the good thing is, now we are a group representing all women in type, and not individuals speaking for ourselves. If there is bullshit going on we are calling it out for other people. We sort of have the backs of other female type designers. I feel just being present has changed a lot in the industry already. Everyone is more conscious. If a conference has difficulties finding a good mix of speakers, they can ask us for suggestions. On the other hand, it takes a lot of time and sometimes I just do not have this time.

> We sort of have the backs of other female type designers.

Sometimes it is frustrating to spend your free time doing that, but we know it is for a good cause.

Do you think that type design became more trendy?

Totally. Yes. Now lots of people want to study type design, become a typeface designer, participate in workshops or attend a specialized type program. Maybe they think there is a lot of money in this area but this is not the case for everyone. About 10 years ago, the whole type-on-screen and webfont movement put a lot more money into the industry. More work opportunities appeared, people can now sell their own typefaces on MyFonts. That was not possible in the '90s. Back then you needed a type foundry to publish your typefaces, now you can do it yourself. This is something that a lot of people got interested in. I am not saying that we have too many type designers or too many typefaces right now. But there are big differences in font quality, and not everyone will be able to live off of this activity.

Do you think the quality of typefaces dropped?

No, not necessarily. The technical quality probably became better. If you publish a typeface with a known foundry they will take care of all the production and quality assurance. You do not have to know anything about type production. If you are your own foundry, you have to do everything by yourself and it gets quite complicated. You have to make sure that all font formats are working properly, and including all OpenType features. This is a lot more work than you previously had to do as a type designer.

There is not only the technical quality but also the design quality of a typeface. I have a feeling that the latter got lower. There are so many similar typefaces out there that were inspired by previous, often successful typefaces. They are designed to look like Gotham, or Helvetica, or Brandon Grotesque. Any successful script font will be imitated 500 times. People see that these typefaces sell, so they want to hop on that wagon. They imitate a family that costs €500 and sell it for €100. I guess

there is nothing wrong with this, it is how the market works. I just wish that more typefaces contributed something truly new.

Is it still possible to make original typefaces?

Sure, of course.

In what way would they be original?

I cannot predict what people will come up with tomorrow. Still there are always newly released typefaces that make me think, "Oh wow, this is really something different!" And that is happening regularly. I have certainly seen one or two typefaces a year where I thought, "Wow! I would've never thought of this." And these are usually things that could not be derived from just sitting in front of a computer and starting a digital drawing. You have to take some inspiration from manual sketching or other creative processes, trying out new things. There are currently a lot of typefaces that are a bit extra chunky here and a little extra weird there to make them look more "original". This is not the originality that I am talking about. They are just all the same chunky, bold typefaces with weird edges. However, there is still some surprising work out there and it is probably going to continue. Those are maybe only 5% of all the typefaces released in a year. As long as there are creative people, there are new original paintings made, new original music created. Obviously, a lot of

> They are just all the same chunky, bold typefaces with weird edges.

other music is produced, too. It is either boring or sounds like something that you have heard before, but every once in a while you hear something and think, "Wow! This is really something new!"

Could you name typefaces that surprised you recently?

One recent typeface I saw, for instance, is from Bold Monday. They did a really good job trying out something different in the area of corporate typefaces for IBM. It is called IBM Plex and it is a series with a sans, a serif and a monospace and you would think that can only be boring. But they man-

J

aged to put some interesting details and features into the family. At the same time it is not so crazy that you cannot use it for a wide range of applications. I thought they found a really good balance.

All fonts on Future Fonts, for instance, are also fantastic. The header typeface we have on Alphabettes right now, Bizzarrini, is available there. It is a serif but it has interesting proportions: quite a low waist, some shapes seem to be upside down which gives it an interesting flavor. It feels refreshing. Most experiments I have seen on Future Fonts are interesting typefaces worth being finished and sold more widely.

What I also like about Future Fonts is that they care about equality. I saw a comment that I liked. When they launched, the ratio of designers was something like 7 guys to 3 women. One guy wanted to join them and commented on Instagram. They answered, "Yes, we can put you on the list but it might take a while because we are only admitting new people to Future Fonts based on the male/female ratio." Or something like this. Of course, you could complain that it is discriminating against men, but I think it is just admitting that other new talented type designers out there deserve to be on a platform like this, too.

Do you think there's a difference between typefaces designed by men and women?

No. I do not think so. Well, sometimes you see that a lot of lettering and script typefaces are designed by women. It might be closer to their line of graphic design, I do not know. I also heard other women say derogatory things about this field, or call them "the script girls" or "the lettering women." Script typeface designers are not taken as seriously as text typeface designers by some. However, there is a whole script typeface scene and market out there. It is a big area where a lot of women are active. If we are talking about text typefaces or other display fonts, I would not know if they were designed by a woman or a man.

I was wondering if this is really true that most script

typefaces are designed by women?

I do not know. Maybe calligraphy and nice lettering is something that women do more of than men. It may also be the area that is closer to the graphic design field they work in. Neither me, nor you would say that but some people argue that typeface design is more technical and that the technical part is more of a guy's thing. Monospace fonts, for instance, are something that guys love to do, mainly because they want their own programming font. Lettering, calligraphy and illustration are areas which women seem more attracted to. Scripts fonts look like a less technical field in type design but in reality, they are one of the most complicated if you want to make them well. They are quite time-consuming to produce, with sophisticated OpenType feature scripting, lots of alternate glyphs, swashes and other ornaments. For instance, all typefaces made by Ulrike Rausch of LiebeFonts look very cute. If you just glance at the fonts, you may underestimate her as a "cute script typeface designer" but there is a lot of technically complex drawing and OpenType scripting behind all that. I guess typeface design requires a certain personality rather than a particular gender. You have to want to work on something that is very fiddly for an extended period of time. That can be done by both women and men but not by every woman and not every man.

Briar Levit is an Assistant Professor at Portland State University, where she teaches typography, page layout, and studio design classes. Levit graduated from San Francisco State University, with a BA in Graphic Design, and from Central Saint Martins College of Art and Design (UAL, London), with a MA in Communication Design. More recently, her interest in designing for content-driven projects has lead her to direct and produce a documentary film — "Graphic Means: A History of Graphic Design Production."

INTERVIEW CONDUCTED VIA SKYPE, JULY 2018

In the movie people talk a lot about being union and non-union. Could you tell me a little bit more about the difference between these two?

Right, so this was definitely an issue in the US. It was also an issue in Great Britain. I am not sure about that but I think there were unions in Germany too. A Typographical Union was incredibly powerful and basically women were not allowed to join it. The Union started with letterpress and when the Linotype came out, the Union included Linotype operators. As phototypesetting developed, a lot of those Union typesetters were not interested in continuing into that technology. Many retired. Some maybe transitioned. Many of these New York shops decided to just allow people to learn to typeset without being in the Union. And that was kind of a big deal. There were some threats by Union folks essentially saying, "This is our territory, you should not be letting people take our jobs." There were tensions between those two worlds. That is why it was a big time for a woman to enter the industry because finally there was a way in without this block of the Union stopping them. When the unions would go on strike, you know, during the 30s and 40s, in the newspaper sometimes they would bring women in and they were essentially scabs. It is a union breaker. It is someone who is essentially breaking union lines to go work for the company. So they would bring in women to come and do typesetting with lower quality typesetting materials with the strike-on. Strike-on is like a sort of glorified typewriters. They were not doing Linotype, they were using glorified typewriters to do the typesetting while the unions were on strike. That was early on in the century. But it was not until the 70s that women really broke into the industry in terms of typesetting.

Why would Unions not allow women to work? Did they

want to protect their working places?

I do not really know if it was literally in their rules. It may have been. It would be interesting to find out if it was literally written down: "No women." My understanding is that women just were not allowed. You do not have a lot of women who were typesetting on Linotype. If they did, they were probably learning independently or in some side way, not in a professional way, maybe in some smaller shops. But you know, it was just sexism, I mean, it was rampant. They were very protective of their jobs and they did a lot of things to protect their jobs. You know how nowadays designers make an ad and submit it to the magazine? Well, it used to be that the printer would design the ads. When advertising agencies started developing and making their own ads, the unions would insist on re-typesetting the ad, even if it was already turned in to them, and breaking it apart just to have half the work done by a union person. There were a lot of absurd practices to sort of maintain more work in their shops. I feel them, but I also question a lot of their methods.

But it wasn't until the 70s that women really broke into the industry.

I saw in the movie there were several types of Linotype machines. There was one with a strip and another one is where you had to type in the text kind of blindly?

Yes, so the strip with the box is when you type it in first and then it spits out that strip. That strip is essentially coded with all the text and then you can enter that strip into another machine which would spit out your type. So it is like a two-step process.

So you basically first code and then put the coded tape in another machine?

Well, first you type in all the text and the machine is spitting out what is called "coded tape" and you can even do that with a Linotype machine. You know these big Victorian machines, they can do that too. It looks very futuristic but they were doing

that. It works kind of in the same way that a player piano does. It is pretty similar to that. The blind typing is just a matter of them entering in the text and they have no visual feedback to know for sure that they got it right. They found out after the fact. The corrections are harder that way. Also there were just so many methods. For example, Letterpress is a basic process. The printers are slightly different, but overall you understand the fundamental rules and that is it. But with phototypesetting they had to have different patents. All the machines worked differently and it is very hard for me to explain the methods, because there were so many methods of how it worked. Also all the machines are not mechanical like the Victorian ones. You know, they're just big plastic things. You cannot see the mechanics of it. So, it is all abstract. I am working on a book, companion to go with the movie to get into some of the details.

So they could bring in a "girl" to do this kind of typesetting.

Do I understand correctly that the "cold type" is actually photosetting?

Yes, although you could also say that on-strike type is cold type. I mean, it did not require to be made from hot metal. So, typewriters could be considered cold type too.

In the movie there was one quote from Frank Romano, "So the first reason why phototypesetting took over was in the newspaper industry, where they attempted to move away from the Union. Phototypesetting was seen as a way around that. And now combine that with the movement to offset lithography—this was a revelation. Also the newspaper industry had moved toward tape operation. They could produce coded tapes, run it through a Linotype machine and set the type automatically. You could use a "girl" for your typesetting. Essentially, a euphemism for a non-union, inexpensive person." I was wondering why he was saying that you could use a cheaper worker for this job?

THE LINOTYPE MACHINE 1886, © LINOTYPE: THE FILM

Well, for one reason, because a lot of these Monotype operators did not want to do it. They saw it as typing and they did not want to do it. Women said, "We will do it." And it was not just typing; you still had to know the grammar and all the right punctuation. In their mind they acted as, "Oh, this is below us." So they could bring in a "girl" to do this kind of typesetting.

So you can say men saw it as too easy a job?

Yes, but in fact, I do not think it is any easier. And in fact, as time progressed, you actually got more control with phototypesetting. In other words, you could really control spacing. I think it became more complicated, because it was more nuanced, more details. With Linotype you do not have as much control with the spacing as you do in photo-type. With metal you cannot overlap. Whereas with phototype you can get very close, you can overlap type. It is them being resistant and being a bit like ostriches, like head in the sand kind of thing.

Another quote from the movie that I found very interesting is from Scott Kelly, the owner of one cold type shop, he said, "In our shop it was primarily women. The reason for that was that New York typographic industry was primarily union men. We were an open shop and not a union shop. The men operated Linotype machines. Cold type machines were essentially glorified typing to them. So, they did not want to do it. People who knew how to type and knew how to do this were excluded from other shops and gravitated to the open cold type shops. So it was probably 80% women." So I was wondering whether an open shop was against the Union?

It just meant that you did not need to be a Union member. The Union might have seen that as "against the Union" but never mind, they were just saying you can come, we will train you and you do not have to be a union member.

Was it important to a client whether it was a union or a non-union shop?

It is possible that someone might have cared about that. My guess is people just wanted a type shop that had the best typefaces and the best

quality. Maybe someone who was a little bit more traditional and cared about supporting unions. It is hard to say.

Is that true that your filming crew was completely female. Was it your intention?

Yes. So my crew was 4 people. Me, I directed and produced, and then I had a director of photography, who I had known and worked with in the past, and an editor and a motion designer. So that was the core crew and it was women and that was a choice. I feel like when you have a choice, even if you have a little bit of power, even if it is for a little indie movie, why would not you use that especially in film, where women are so underrepresented. The statistics are astounding when it comes to women behind the camera. People are doing research and getting actual statistics on how many women are directors, cinematographers (that is the same as director of photography) and editors. Documentaries have higher numbers than narrative film. But I think everything counts. Every time we can increase these numbers, it counts. I am so glad I had an all-female crew.

How long did it take you to finish the movie?

Well, the total time was about 3 years or maybe 3.5 years. And editing was maybe a year of that. I mean, we were shooting and editing a little bit towards the end.

Zuzana Licko is one of the most well known female type designers. Her early fonts revolutionized digital typography. Together with her husband, Rudy VanderLans, Licko started the design company Emigre in 1984. In 2011, five digital typefaces from the Emigre Type Library were acquired by MoMA New York for their design and architecture collection. She is the recipient of an honorary PhD degree from the Rhode Island School of Design in 2005, and she received the Typography Award from the Society of Typographic Aficionados in 2013.

INTERVIEW CONDUCTED VIA EMAIL, MARCH 2018

In the email you said that you have always felt outside of the mainstream. What do you mean by this?

I immigrated to the US with my family from Czechoslovakia when I was seven years old, so I started school not speaking English, which separated me from the rest of the class for a while. Later, I was in the minority as a girl in a high school trigonometry class, and then again in college computer programming classes. So, finding myself in a male-dominated profession of digital type design did not feel unusual.

When evaluating the statistics, one finds that there are twice more women applying for programs in graphic design and there are twice more men applying for programs in product design. Do you remember how it used to be when you were studying? Were there any fields that women or men specifically preferred?

I do think there were fewer women in the architecture program, but I really did not pay that much attention to the gender balance. However, I did have a gender-related realization when the architecture students were being solicited to volunteer on a construction site. I thought this would be a great learning experience, and I wanted to go but did not feel I could physically do the work. So, I realized this would always put me at a disadvantage in understanding construction, if I ever expected any of my building designs to be realized. This was one of several reasons why I switched my major from architecture to visual studies.

Do you believe that the typographic world was and still is male-dominated? Have you ever seen this as a problem?

The history of type design is rooted in the use of heavy machinery and industrial materials such as lead founding, which had traditionally been considered men's work. Today, of course, the discipline of type design is rooted in digital technology, so it has become available to any visual artist who embraces computer technology. But here again, type design is one of the more technical specialties within visual design. Specifically, a type designer does at times benefit from some understanding of computer pro-

gramming; perhaps it is no coincidence that this is another field that women traditionally seldom enter. But I think this may be changing with the current generation.

Have you ever had difficulties or problems in your career because you are a woman?

I am often asked this question, and I am never sure how to respond. There are all sorts of difficulties that each of us has to work through, and I never considered gender to be at the top of my list. Perhaps I had more immediate problems that were more within my control to solve. Looking back, I guess I managed to sidestep the gender issue because I have worked in areas that others were not so interested in, so I mostly worked alone, or with one other person. This was not intentional but this was the path of least resistance, and it suited my interests. At the very beginning of my career, I teamed up with Rudy VanderLans to form the Emigre type foundry, which allowed me to take fate in my own hands, so to speak. Neither of us was ever reliant on others to be promoted or to be told what to do or how to behave. I never had to hold out my hand for loans or investments. We built our business slowly and went our own way. I do not feel that being a woman has particularly helped or hindered me. I just had to work really hard.

> I don't feel that being a woman has particularly helped or hindered me.

How do you pick names for your typefaces? Do you have a specific approach?

While our typeface names often refer in some way to the design, those sources vary. The name may allude to a historical reference, a technical feature, an ornamental description, etc. The naming process is different for each typeface, as individual as the typeface design itself.

Why did you name your Baskerville revival font after Sarah Eaves. What was the intention behind it if there were any? When and how did you learn about Sarah Eaves?

I felt that naming it Baskerville would be mis-

leading because this typeface design is not a strict revival. So I needed to find a different name, but one that would in some way relate to Baskerville. I read about Sarah Eaves in a book documenting Baskerville's era, and thought "Mrs Eaves" had a lovely ring to it, so the name stuck.

Do you know any other examples of forgotten women in the history of type design?

I am not sure she is forgotten. I learned about her by reading the available literature, and I think you might be exaggerating her importance. To clarify, Sarah is the woman who initially moved in with Baskerville as a live-in housekeeper as he was setting up his printing and type business. She eventually became his wife, as Sarah Eaves, after the death of her first husband.

Who were your idols or role models while studying?

Charles and Ray Eames were the first designers I ever heard of, when we watched the "Power of Ten" in high school. At the time, I did not know they were designers, I just knew they were the makers of that fascinating short film. Later, when I started studying design in college, I aspired to the work of Emil Ruder, Herbert Spencer, Jan Tschichold and Paul Rand.

Are there any current type designers whose work impresses you? Could you name some?

The sheer volume of typefaces released these days has made it impossible for me to keep up with all of the new work. While not all of it is innovative, I am amazed by the volume of high-quality work. This is undoubtedly the result of highly trained graduates emerging from all the new type design programs and their access to today's sophisticated tools.

Do you think there are too few female role models?

I do not know. When I was entering the design profession over 30 years ago there already were plenty of female role models. I found the work of April Greiman, Lucille Tenazas and Kris Holmes to be inspiring. But my role models of women making their way go back to my childhood when I witnessed

women running their own shows and entertainment companies, such as Lucille Ball, Carol Burnett, Marlo Thomas, and Mary Tyler Moore.

What would you call your style of work?

Most of my inspiration comes from the particular medium that I am involved with at the time. I search out a problem that needs to be addressed or a unique result that a production method can yield. My interest in making type was initiated by the need for legible and visually interesting bitmaps for the early Macintosh computer screen and dot matrix printer. Today, the Macintosh tools are so much more sophisticated, and are much more tailored to specific tasks. It is a very different environment, which is opening other areas of creativity. For example, after I design a pattern font, today I can also have it custom woven or printed on fabric in any quantity, via the Internet. I never imagined being able to do that 30 years ago.

> I don't enjoy it, so I stopped public speaking after several appearances early in my career.

Are you often invited to talk at conferences?

I am invited often, but I am not a natural entertainer. I do not enjoy it, so I stopped public speaking after several appearances early in my career. I am a visually oriented person, so verbal communication is challenging for me.

Have you ever applied to talk at any conference yourself?

No, because I do not feel I am helping anyone if I force myself to do things I am not good at.

Over the last three years the topic of an unequal share of female and male speakers at design conferences became evident. What is your opinion on this? Do you believe it is necessary to have an equal share of female and male speakers? Why?

It seems there are fewer women than men in the spotlight. Maybe this is because women are taught to be less pushy than men, and are therefore less aggressive at self-promotion. Or maybe it is not as important for women to always be at the

center of attention. It definitely is not important for me, I have always shyed away from being in the spotlight. I am perfectly happy to be in my studio, being creative. I am probably not the right person to answer your question.

What success means to you?

When I am happy and satisfied with my work.

Do you spend a lot of time on promoting your work?

Emigre magazine, designed primarily by Rudy VanderLans, was a stroke of luck and a virtuous circle. It became the main promotional tool for my type design. The fonts were initially created to give us more control over the magazine design, to make the typesetting economical and more interesting. Then, when the magazine showcased the fonts, it created a market for making more fonts, which went back into the magazine. The magazine allowed us to test the new fonts in a realistic setting, using actual texts. Today we continue to promote the fonts with type specimen catalogs.

PHOTO BY: NORMAN POSSELT

Ana Regidor is passionate about events. In 2015 she joined Monotype and organized the TYPO Berlin conference. Starting from 2016 Ana also led the TYPO Labs, Europe's biggest conferences dedicated to graphic design and font technology. Now she works independently as an Event Manager for events such as re:publica Tech Open Air in Berlin and EDCH in Munich.

INTERVIEW CONDUCTED IN BERLIN, OCTOBER 2018

How many TYPO Berlin events have you organized?

I have organized four TYPOs and three TYPO Labs. I held various positions and responsibilities during these years. In 2018, I was part in curating the TYPO Berlin program.

How big was your team?

We were a team of 6 and each of us had different responsibilities such as sponsoring and logistics, budgeting, merchandise, content management and communication, crew and speakers' management and the production of the actual program.

Was this the first time that you took care of the program?

Yes, this was the first time that I took care of the program. When I started at TYPO, I was assigned to crew management and it also included additional event management tasks. I loved it! I have met so many people within these 4 years. Last year I spoke to Benno [Bernd Rudolf], Conference Manager of TYPO Berlin, where I mentioned that, "I know I will be very busy this year," (I was also a conference manager for TYPO Labs) "but I still wish to also work on the program and speakers' management." Benno immediately agreed and accepted my initiative and willingness for more responsibilities. I feel that I was very lucky because I had a lot of freedom and I was working with amazing people who gave me the opportunities and chances to grow in the right direction.

Do the speakers get paid for the talks? Are transport and accommodation expenses covered?

All travel costs and accommodation are covered by us. There is a certain amount of spending money offered as well. This amount is the same for everyone. It does not matter what stage you are speaking on, big or small.

You mentioned that it was personally important to you to have a good balance of speakers?

Yes, it is very important that there is a good balance of speakers. For example, on their blog Alphabettes publish the rankings of the conferences where they rate them based on the percentage of female speakers participating each year, from the

highest to the lowest percentage. This is where I further looked into TYPO Labs. I discovered that it was listed almost at the bottom of these rankings. This is where I immediately knew that I had to improve that. The last 2 years showed gradual improvement under my care. However, I must admit that it was extremely difficult to find women who were experienced to speak about font technology. This became a big challenge for me. You will find around 3 to 5 women within this field, and they are highly sought after by other conferences as well. Even if the results were limited at first, I definitely started to make people think about this issue and that it is an issue. In the end, I was happy with the results of these specific conferences and I believe that for the future the search for professional female speakers will become a lot easier.

However, despite these challenges, I had one speaker I was really pleased with, Verena Gerlach. She shared with me that she was working on something interesting and valuable and that she was ready to present it at TYPO Labs. At the conference she presented a very nice project about Variable Fonts together with her student Maciej Połczyński.

For TYPO Berlin I noticed that over the last few years there was a significant difference in the ratio of female and male speakers. Only 30% of women attended. This was another area I wanted to improve to make it all more equal.

What would you recommend to someone who is trying to put a conference together and is looking for female speakers? Where should they look? Who would they ask?

There definitely is a lot of research and effort required because the options are limited. I personally asked around in the type community. They do send me a lot of references. At the beginning the usual recommendations were a list of men. Generally the search results seem to be very moderate

even within the type community. But I kept pushing for female speakers.

Another recommendation of mine would be to look through the line-up of other conferences. This is how I found the majority of the female candidates out there. I am always looking for someone new as well. I would recommend getting in touch with Alphabettes. I also asked around in my own personal network of acquaintances and friends. In general, it is a lot of networking and you have to always be easily available for people to reach you.

I also think it is useful to check at design universities if any potential students are working on any interesting and innovative projects. Then, of course, you give an equal chance to both female and male students in these cases. This year there were 2 students from the UDK, Alix Stria and Judith Holly. They both run the Basics Blog. The program was already completely full and I did not know how to tackle the new additions because I believed they would be valuable to the event. This is where I decided to put them on the waiting list. Because someone is always expected to cancel and this is exactly what had happened. Therefore, Basics Blog was added to the program. This year we also used the coffee breaks and lunch breaks to host more speakers. If I had been aware that this year was to be the last for these conferences, I would have pushed to fit in more speakers.

> This year at TYPO Berlin I managed to gain a 49% female representation.

My aim was to organize a conference with a 50/50 turnout of male and female speakers. But I did not want to accept everyone just because they are female. They have to also be a person with an interesting topic. This year at TYPO Berlin I managed to gain a 49% female representation. I was very happy with these results as all those women had high quality topics and presentations.

When you are looking for potential speakers, do you normally only look for people who have been partaking in other conferences or do you also search for people who have never had experience in public speaking?

I use both methods. Usually if I look for a speaker, I take a look at their webpages and I further search online to see if they have spoken at other conferences. This is to see about their prior experiences and determine what stage would be most suited for them. If I do not find anything on their webpage, then I usually ask them a set of questions directly. If they tell me that this is their first time speaking publicly, I would probably give them a smaller stage so that they can feel comfortable.

Can the speakers choose what stage to present at?

No. The assignment of stages also depends on the topic that they are talking about.

Can people apply to talk at TYPO Berlin? Despite TYPO Berlin being a curated conference do you still consider people who apply?

The TYPO program is 80% curated but we are definitely open to suggestions. If someone applies and has a strong topic or workshop, then we do invite them. These events are always a mixture of people who contacted us themselves, who were referred to by their friends or who belong to the typography scene in Berlin.

For example, Dina Amin was a recommendation from various acquaintances. Petra Dočekalová with her wonderful calligraphy workshop was recommended by a teacher from UMPRUM. Juju Kurihara contacted us and offered a Japanese calligraphy workshop. Golnar [Kat Rahmani] and I just met at CreativeMornings Berlin and the result of that was an exciting workshop Type & Politics.

Is it more difficult to get a woman to speak in front of an audience? Do they reject these offers more often?

Not really. Almost all women that I invited to take part in TYPO Berlin agreed to attend it. The only issue, as highlighted before, is that female speakers are more difficult to find.

That is a very interesting insight. I have heard a lot of

people stating that women are less likely to agree to speak at a conference.

I would not say that that is the case completely. Upon getting to talk with prospective speakers more, I noticed that usually when you ask a man if they want to participate, they are always quick to say "yes", even if they are not as experienced with the topic, or even if they do not have anything prepared yet. With women the experience is completely different. When they are asked if they are willing to speak, they first come back with answers like, "I do not know if I have anything ready for this..." As an organizer there was a bit more effort in pushing for a definitive confirmation.

I am currently working for re:publica and last year they had 365 male speakers and 364 female ones. If you take a look at their call for proposals, it is not the same ratio of men and women who applied. There is a lot more effort to be made on the organizer's behalf. If the proposed topic is not what we are looking for, we end up going above and beyond to consult the candidate on adapting it. We had a situation where a proposal was not fitting the program, but we wished to have the speaker, so we eventually asked the participant to change the format of her talk, for it to be considered. She appreciated the chance and came back to us a few hours later with many alternative workshop proposals. I have experienced quite a big difference in communicating with women versus men. Women tend to be more organized and send me all the materials that I need, such as contracts, images, etc. in a much faster manner.

> Almost all women that I invited to take part in TYPO Berlin agreed to attend it.

Were there any cancellations made this year?

There was only one cancellation made this year. This was due to the son of one female speaker who became ill. These are things that you have to

take into consideration. There are always a lot of people who would like to speak so any cancellation will become a possibility to improvise.

I believe that another way to accommodate some female speakers is to perhaps contact them more in advance to give them enough time to plan their trip. If you contact a mother even 2 months before the conference, it will be too short a notice and she will not have enough time to prepare.

Are kids allowed at the conference?

If someone needs to come to the conference with their baby, then of course it is possible to do this. If a speaker needs a babysitter for the time that she is giving a presentation, then I think it is important that it is taken care of. I would personally make sure to see about providing a babysitter.

Did you have any speakers this year that took part in the conference last year?

I think there were about 10% of speakers returning this year. One of them was Chris Campe. Last year, her brush lettering workshop was a big success and we decided to offer it again this year. She continuously works on new stuff and always brings something new to each conference.

Were there any speakers from Monotype?

Andreas Frohloff has been offering a calligraphy workshop since the beginning of TYPO. Nadine Chahine spoke at TYPO Berlin Brand Talks last year. Amélie Bonet also spoke at TYPO Labs last year and Marianna Paszkowska talked both years at TYPO Berlin and TYPO Labs. Currently, she is the most suitable person to explain what Variable Fonts are all about.

What did learn from organizing typographic conferences?

Four years ago I had not even downloaded a typeface, nor had I thought that there were so many people working on such a thing. Now, I have personally met the maker of Calibri and his wife! I have learned an incredible amount and I have got to know a lot of interesting people along the way. I feel that I belong to the type community now.

Fiona Ross specializes in type design and typography primarily for Arabic, South Asian, and Thai scripts, with a background in languages and PhD in Indian Palaeography (SOAS). She is Professor in Type Design (part-time) at the University of Reading (UK); and a typographic consultant, type designer, and author. Her most recent design work has been in collaboration with John Hudson and Neelakash Kshetrimayum for clients Harvard University Press and Ananda Bazar Patrika. For her work in type design and education, Fiona received the SoTA Typography Award (2014) and the Type Director's Club Medal (2018).

INTERVIEW CONDUCTED VIA EMAIL, JUNE 2018

When and how did you get interested in women's role in the development of type design?

I have been working in this field for 40 years, and feel that women's role has not been accurately documented. I have a Leverhulme Trust-funded research project about women in type, not necessarily "female type designers." My colleague Dr Alice Savoie and I will be presenting on this subject at the ATypI Conference in September 2018, and our talk will answer more questions. However, here is a small description of this project. Women's pivotal role in the development of type design is little known. Me and my team aim to change this, with an in-depth study of women in type-drawing offices, 1910–1990.

Type design plays a fundamental role in visual communication: it is crucial to the textual representation of languages to afford literacies to global communities. Histories to date have largely overlooked type design's importance, and concomitantly the key contributors to the type design and manufacturing processes that developed in the 20th century. Women were often central to this development, particularly in Britain within the major type-manufacturing companies of Monotype and Linotype. Our project will provide the first sociohistorical account of women's role and responsibilities in type-drawing studios from 1910 to 1990 as experienced within the two companies: the Monotype Corporation and Linotype Limited (formerly Linotype-Paul Ltd and Linotype-Hell Ltd).

> Women's pivotal role in the development of type design is little known.

A pilot study in 2016, which included visits to assess relevant archives, determined the scope of the project, its feasibility and the appropriateness of our research methodology. Focusing on the Monotype Corporation, whose type-drawing office was established in 1910, we were able to confirm the availability of relevant archival records

and key personnel for interview. Our preliminary investigations and interviews have already yielded valuable undocumented information about women working in this field and the significant roles they occupied. We were able to confirm that during the 20th century women in type design, as in allied industries, increasingly took over roles traditionally held by men, which were vital to supplying the needs of the print industry. The Monotype and Linotype type design departments, which had divergent practices, were both run or staffed principally by women from their inception. However, the details of these women's positions and activities have been overlooked, and in particular their precise contributions to the type-design process during the rapidly changing social and technological environments of the period.

Our team will document agencies of change for women working in these type-drawing offices against three interconnected contexts: in terms of social history; in relation to technological developments; and in terms of contributions to typeface design. Using data gathered primarily through interviews, the analysis of historical records, and the examination of technical drawings and typeface proofs, we will determine accurate histories of the development of typeface design and manufacture.

The findings will transform our understanding of women's activities and status within the design-based industries from 1910 to 1990, making a profound interdisciplinary contribution to social and design histories while informing current type-design practice.

When and how did you become interested in letterforms?

From my studies of Sanskrit and Indian palaeography.

Who were your idols and role models while studying?

I studied languages not design: so no idols or role models for Indian-script type design. I admired the work of the Nirnaya Sagar Press and the Gujarat Type Foundry.

Were you aware that you were the first female manager in the company at Linotype, when you started there? Did you see it as a challenge?

Yes, I was aware as there were no women managers, and I was called the "Head of the Department" for a long time doing the same role as Manager before they changed my title. Not a challenge as it did not affect my role.

Have you ever had difficulties in your career because you are a woman?

Yes, but that was largely standard during the era I worked in at Linotype Ltd (UK) from the late 1970s. Assumptions were made about us women and our roles; attitudes were difficult to change we had to work extra hard to prove ourselves and to gain respect.

Linotype was unused to women graduates—there were not that many graduates at Linotype when I started—and we had to deal with some unwelcome attention and remarks on a daily basis, particularly at the beginning of my time there. My response was simply not to engage with these remarks—silence can have a remarkably strong effect—and to continue to treat whoever we were talking to with the respect with which we wished to be treated. I believe there was some notion that people should not "mess with Fiona's crew". We did our jobs well, and through this earned respect from colleagues in other departments; the clients liked the designs, our beta-testing procedures were thorough, and the fonts worked.

Also the pay was less as promotion was difficult and although benefits, such as pensions, were possibly available to us, I do not recall being offered them. I did fight hard to improve the pay of my team and being "women" and "artists" meant it was a fight.

Do you believe that the typographic world was and still is male-dominated?

It was, particularly as it grew out of the industrial print sector, but my team at Linotype in the early '80s for many years was all women; and we stayed together for over a decade. The gender balance is changing and I see a good balance of women on our MA courses; in key roles in academia (e.g. professors in my Department at Reading); and increasingly in high positions in the industry (e.g. Deb Gonet, the Vice President of Type at Monotype). Change takes time.

What is the most challenging project you worked on?

At Linotype, the Sinhala Araliya project, but only in terms of meeting tight deadlines due to unrealistic promises from the Sales Department of delivery times. We got it done and we did a good job.

Since then, the Aldhabi Arabic project: see why: www.vimeo.com/51580484

What does you working process look like?

It varies according to the project. I work collaboratively. I usually undertake the research, art-directing, critiquing, open-type features, and testing aspects. Working on any project, I always begin with a research phase. This is conducted in line with the brief. Thereupon the character set is specified with the client and depends also on the typeface style (e.g. ligatures or not, contextual alternates, etc.)

What is your least favorite part of the project/work?

I enjoy it all.

Do you think there is a difference in the typefaces designed by women and men?

No.

Do you think gender can be assigned to a typeface?

No.

Are you often invited to talk at conferences?

Yes.

Have you ever rejected the invitation and why?

Yes, on account of ill-health or prior commitments.

What was the first conference you spoke at?

I think it was Type 90 in Oxford, arranged by Roger Black.

Have you ever applied to talk at any conference yourself?

Only this year for ATypI as it is part of our research project.

Do you like to talk in front of an audience?

No. But I do enjoy giving talks to students or visitors to our Collections. I spend most of my week happily working alone in my cottage, not talking to anyone so public speaking does not come naturally to me. My focus is on my outputs (designs and writing) and teaching. I really am not keen to be in the limelight, although receiving the two awards (SOTA and TDC Medal) has meant a very great deal to me.

> Public speaking does not come naturally to me.

Over the last three years the topic of the unequal share of female and male speakers at design conferences became more evident. As far as I am concerned, it is still not always 50/50. Do you believe it is necessary to have an equal share of female and male speakers? Why?

It is definitely something to strive for, but relevance to the conference topic and merit (although experience can inculcate good presentation skills) should also be weighed in the balance. I think gender balance is improving, and so I am currently more concerned about the seeming lack of diversity of the speakers but this is also slowly improving.

PORTRAIT BY: SHARON WERNER

Carol Wahler has served as Executive Director of the Type Directors Club since 1983. Carol's type background stems from her work in her family's various businesses that began in the period of Ludlow typesetting in the 50s and lasted through today's digital world. For her contributions to the field she was given the SoTA 2018 Typography Award by the Society of Typographic Aficionados.

INTERVIEW CONDUCTED IN NEW YORK, MAY 2018

I have heard that your father was a printer. Is that true?

Yes, my father was a printer and then he decided to go into Ludlow typesetting instead of printing in the early 1950s.

Is that how you became involved in printing/typography?

I never looked at it that way. I grew up in a family that owned a typesetting business called Cardinal Type Service. My parents, my three brothers and I had to work. It was a family business, so everyone worked. I would work during school vacations and many weekends. I started at age eleven. I did not set type, but would watch the process of setting slugs from my brothers. My mother taught me bookkeeping; how to answer the telephone and speak to customers. I had to learn to take copy and corrections. Life is a learning experience. Everything you learn early on will be used later. In 1969, my husband Allan joined Cardinal to establish their marketing and sales programs. He was selling type. But first he had to learn the craft of setting type, before he could sell it.

Have you studied type design or anything similar?

I went back to school later in life. My father gave me a choice of getting married in two years when Allan graduated from college, or I could to go to school for four years and then get married. I was going to major in chemistry, but I wanted to get married. I knew that my husband would have his master's degree and I felt we would have nothing in common, and of course, it bothered me. He promised me that I would go back to school. So, we got married, and two years later started our family. We had two children. As the children started school, I wanted to find something, because I felt personally, something was lacking in my goals. I attended a seminar for women. This seminar said that most women live 79 years on average. You either became a housewife, a nurse, a teacher or a secretary. That

was what women did at that time. I was a housewife. By the time you reach half of your life, you realize, you are ready for your second half. I wanted to go to school, and my husband, true to his word, encouraged me to follow my dreams. I was accepted as an art student. I could not believe it! One of my first classes was American Art, and I fell in love with Art History. That one class hooked me. I became an Art History major. It took me seven-and-a-half years because I went part-time. First, I got my associate's degree and then achieved my goal of receiving a BA (and graduated Magna Cum Laude).

How did you start working for TDC (Type Directors Club)?

I realized that one thing leads to another. My husband was an excellent tennis player and was captain of both his high school and college tennis teams. One day he needed his tennis racket restrung. And he thought why do not we get a stringing machine and do it ourselves. Then we started a tennis shop and established pro shops at several local country clubs. We had it for about five years. One day Allan was walking down 52nd Street in New York City on his way to a client presentation, and passed another tennis shop, called the Racquet Shop. Our shop was also called the Racquet Shoppe, just spelled differently. Impulsively he went inside and started talking to the owner. When Allan mentioned that he sells type, he was introduced to Jack Odette, who was at that time a principal at a major design studio.

Coincidentally, Jack was a board member of the Type Directors Club. Several years later he became Vice President and Director of Communications Design at Citibank. He became Allan's largest client.

One day Jack called Allan and said that he was Chair of the TDC29 competition. At that time, entries were received at a type shop vendor of the chairman. Since Allan was a vendor of Jack's, packages were sent to Cardinal Type Service.

Allan told me packages of entries were coming in and asked me to help in case anything was

needed. When I arrived 180 packages were in my husband's office. I could not just leave them, so I thought to organize them. But how do you organize something, if you do not know what it is? So I alphabetized them by the entrant's last name. When Jack came in he was impressed that I did that. He said to me they needed somebody to open the packages and enter the entries. He asked me if I would want to do that. I said, "Sure." And, thus TDC and I began our long, happy relationship.

> **Thus TDC and I began our long, happy relationship.**

It was not only a case of being in the right place at the right time, but being able to take advantage of an opportunity. At that time, Jerry Singleton the TDC Executive Secretary for 20 years, retired. Bud Ellis replaced Mr. Singleton, as the TDC Executive Secretary, and he began giving me more tasks, such as working during the judging, sending letters to the winners, recording all the credits for the book, and collecting winners for the travel exhibits.

Jack called one day. Now, remember I was going to school, working part-time, and had two children. Jack asked me if I wanted to be an Executive Secretary/Director. I asked what I had to do and he said, "I don't know, but will find out." I had only a few credits left before graduating, so I said yes! TDC needed to have an office space. My brothers rented them a desk in my husband's office. And that is how it all began.

One year into the job, TDC Board member Klaus F. Schmidt, my mentor, called me and asked "How would you like to be the Executive Director for the Advertising Production Club of New York?" My initial response was "I cannot" and he said, "Yes, you can. You can do one board meeting, you can do two. You do one lunch meeting, you can do two. You can do it, Carol!" That is exactly what he said. And there was no conflict of interest. So I became

Executive Director for the TDC and the APC. Then the president of the APC called me and asked, "Carol, how would you like to be the Administrator for SWOP (Specification for Web Offset Publications)? I had three clients all by myself. After many years, it is only the TDC, but then, the TDC has been my love after my husband and family.

I know that you also organize conferences. Which conference was the most exciting for you?

Actually my first two conferences were the most exciting. Type 1987 was a TDC conference, and my first conference experience running such an event. I worked with Roger Black. We had 350 people from around the world. I met Neville Brody, Adrian Frutiger, Erik Spiekermann, and Hermann Zapf. That is only a few of the wonderful and great type designers. We honored Adrian Frutiger with the TDC Medal at that time.

Roger Black was responsible for ATypI (Association Typographique Internationale) hiring me to work on their Type90 conference which took place in Oxford, England. We had over 700 attendees. I had to live in England for one month. Can you imagine running a conference of that size with no emails? It was phone and faxes. I met the world at Type90.

Were there any women invited to participate in Type90?

The ones that come to my mind immediately are Louise Fili, Zuzana Licko, and Carol Twombly. Yvonne Schweimmer-Schedding, a writer, was present and participated in interviewing for articles about the event.

Do you personally pay attention to the ratio of female and male speakers? I have seen that at the Type Drives Culture conference there were not many female speakers.

Yes, I pay attention to the ratio because the club and the board want to be as fair as possible and honor the contributions of both men and women to the fields of type and typography. We have to constantly work on this and do the best we can in our event planning. As a volunteer organization that depends on the hard work of the board and the friends of the club. Sometimes time and circum-

stances leave us with ratios that are unintentionally not ideal, but we try to balance this out later in other events and programs.

When we were working on the theme for "Type Drives Culture" we asked Milton Glaser to be the keynote because Milton is, like the TDC, associated with the history of design in New York City, and we also wanted some star power to draw attention to the conference. Various threads of our conference planning—which included thinking about politics, music and history—had led us to start the day on a historical note. Keep in mind that when the TDC started in 1946, typographic and design jobs were held mostly by men. Thankfully, the ratio has become more balanced over time. But whenever we focus on history, the ratio skews towards men.

> Whenever we focus on history, the ratio skews towards men.

Unfortunately, right before the conference, one female speaker had to drop out at the last minute and her associate was a male. We also wanted to bring in a speaker from the entertainment industry on the west coast, where the TDC is slowly building contacts, and the person who was strongly recommended to us was a man.

I am very proud of the TDC's recognition of women, including the TDC Medal, given to Paula Scher, Louise Fili, Zuzana Licko and Fiona Ross in recent years, and the TDC Beatrice Warde Scholarship, given to women in honor of an exceptional woman.

You said you have never had problems in your career and that you never noticed it was a male-dominated field?

I never thought about it. The other organization that I worked for is the Advertising Production Club. They were all men working in advertising agencies and me. We would meet Tuesdays for lunch and they were always talking about sports. I grew up in a male-dominated family. I had and still have no problem working with people, male

or female. Additionally, other organizations such as the ATypI, Art Directors Club, Society of Publications Designers, and the Society of Typographic Aficionados (SoTA) had female Executive Directors.

Who was the first female member of the TDC?

It is very funny, two board members brought their classes to visit the club and I gave my presentation. Both asked me the same question in two days. Therefore, I needed to find out. In the archives we have minutes from board meetings that took place from 1956 through 1961. The minutes are notes taken during the course of a board meeting. It is a written transcript of what was discussed, what projects were approved and what members were accepted. I went through them and guess what, it turned out that Beatrice Warde was the first female member of the TDC in 1960. She worked for Monotype starting 1927 and wrote under pseudonym Paul Beaujean for many, many years. I got so excited and called Graham Clifford, at that time the TDC Chairman of the Board and I told him. He said we should name a scholarship after her, for women only. I go, "YES!" So I called Gwen Steele from Monotype directly after and said we give a $1000 scholarship. And she said, "We don't. We give a $5000 scholarship!" Now, we have the TDC Beatrice Warde Scholarship, sponsored by Monotype for female students going from 3rd to 4th year. There is a committee of seven women who review all the entries.

Have you ever talked at a conference yourself?

My first invitation to speak was in Taiwan in 2010. I have never done that before. I was invited to open the TDC exhibition and speak. My presentation was about the history of the club. Since then, I have been invited to Seoul, Paris, Shanghai and Sao Paolo. I have been a panelist at SoTA conferences, and have introduced speakers at these conferences.

Chapter E

Showcase of Typefaces

UFO alarm!

Annual School tests for 7 and 11 years old

250% greatness

***financial* reviewers**

GROTESK

Česká televize

Conference will be held in **Kopenhagen** in 2009

"la grande esperanza"

Falsches Üben von xylophonmusik quält jeden größeren Zwerg irgendwann einmal

👍/👎 📶 **online**

ты мой герой!

124 εκθέματα

Adobe Caslon Regular
Adobe Caslon Italic
Adobe Caslon Semibold
Adobe Caslon Bold

For her Caslon revival, designer Twombly studied specimen pages printed by William Caslon between 1734 and 1770.
Adobe Caslon Pro is the right choice for magazines, journals, book publishing, and corporate communications.

टाइ

फ़िक

डिज़

ADOBE DEVANAGARI, HOLLOWAY, HUDSON, FIONA ROSS

กลับม

และแผ่นดินไ

ในรอบปีที่ผ่านมาซึ่งก็มีทั้งเหตุการณ์
ระทึกขวัญจากภัยพิบัติคลื่นยักษ์สึน
ในเอเซีย พายุเฮอริเคนแคทรีนาที่

ในรอบปีที่ผ่านมาซึ่งก็มีทั้งเหตุการณ์ระทึกขวัญจากภัยพิบัติค
ยักษ์สึนามิในเอเซีย พายุเฮอริเคนแคทรีนาที่สหรัฐ และ
แผ่นดินไหวครั้งใหญ่ที่ปากีสถาน. แต่ถึงกระนั้น ก็ไม่ได้เป็นปี
ความสิ้นหวังรันทดเสียทีเดียว อาทิ ที่จังหวัดอาเจะห์ในอินโด
และซูดาน ตอนนี้ก็มีการลงนามในข้อตกลงสงบศึกกันไปเป็น
เรียบร้อยแล้วหลังจากที่ต้องเจอสภาพสงครามภายในที่ยืดเยื้อ
นาน ส่วนที่อิรักนั้น การเลือกตั้งก็ผ่านพ้นไปด้วยดี. ทางขบวน
ประกาศเรื่องนี้หลังจากการหารือระหว่างกลุ่มผู้นำของทางขบว
กับประธานาธิบดีซูซิโล บัมบัง ยุดโดโยโนของอินโดนีเซียที่เม็
ดา อาเจะห์. ประธานาธิบดียุดโดโยโนบอกว่า นี่เป็นหัวใจสำคัญ
ความสำเร็จในการฟื้นฟูอาเจะห์หลังประสบภัยจากคลื่น (14/1

ABCDEFGHIJKLM
NOPQRSTUVWXYZ
abcdefghijklm
nopqrstuvwxyz

АБВГДЕЁЖЗИЙ
КЛМНО
ПРСТУФХЦЧШЩ
ЪЫЬЭЮЯ
абвгдеёжзий
клмно
прстуфхцчшщ
ъыьэюя

ঐক

বর্ণ পরিচয়

পরিচয় কান ইন্ডিয়াঁ ঐকবি নন্দ কাত্রা পাপু নজর চাই নুয় কণা কারণ

পত্রিকা কাত্রা ইকার নাই কিন

ঐকা চাই জান কিরণ নয় রজক কি আকার কাক কণা কী পাই বাবা নয়ন রাজা বাপু চারা রবি জীবন চারি রীণা বিচার পাঁচ যাইবা ঐকার নাই কিন আনন্দবাজার পত্রিকা বর্ণ কা রিনি পরিচয়

ইকার কিরণ

ABP 2015 BENGALI TYPEFACE,
NEELAKASH KSHETRIMAYUM & FIONA ROSS

Abhaya Libre Font *

SRI LANKA
is an island country in South Asia
A diverse and multicultural country,

is home to
many religions,
ethnic groups, and languages.

RICE AND CURRY
«PUTTU & KIRIBATH»

Sinhala • Latin • 2015

Гротеск Дереза создан специально для акцидентного набора в детских книгах и журналах. Книги для самых маленьких полагается набирать гротеском, и в пару к основной гарнитуре хорошо подойдет бойкая дополнительная.

розенкрейцеры

Та легенда гласит, что рецепт первой «Воды королевы Венгрии», на основе розмарина, был подарен королеве Венгрии Елизавете монахом. Принимая воду внутрь, больная королева выздоровела.

парфюмерия

A MAKER OF CRINOLINES AND CORSETS

мелисса

The Romance of Perfume

Plants have always abounded in their country and the Hindu have adapted their scents in their own religion.

RESEAT

В пятидесятые годы французская парфюмерия достигла наивысшего своего подъёма. Тогда во Франции работали самые талантливые составители духов – парфюмеры.

fragrances

Mirta is a clean text type well-suited for use in typesetting of smart volumes and kids' books. Fine and well-balanced antiqua face is complemented by surprisingly vigorous sophisticated italics.

ádēfġħî
ķl·lōpñŕ
štüỹẓ'þ

Araro'y **SALTILLO U+A78B / U+A78C [ꞌ] [ꞌ]** It is a glottal stop **consonant.** Typists who are unfamiliar with Unicode frequently uses an apostrophe instead, but that can cause problems in computers because **it is a punctuation mark, not a word-building character,** and the ambiguous use of it for two different functions can make automated processing of the text difficult.

It's winter **APOSTROPHE U+0027 [']** This character is a **punctuation mark**. In English it is used for several purposes: marking of the omission, marking of possessive case of nouns and marking of plurals of individual characters.

'Invierno' **QUOTEMARKS U+2018 / U+2019 [' ']** They are **punctuation marks** used in pairs in various writing systems to set off direct speech, a quotation, or a phrase. The pair consists of an opening quotation mark and a closing quotation mark, which may or may not be the same character.

HEBREW WORD FOR WATERMELON	ARABIC WORD FOR WATERMELON

אבטיח	بطيخ

▼

▼

▼

▼

ARAVRIT WORD FOR WATERMELON

ARAVRIT, LIRON LAVI TURKENICH

Translation
CONTRAST
A flat brush calligraphic feel
한글과 라틴, 멀티 스크립트 서체
Humanist look
평행이동에 따른 굵기차이의 원리
Roman, Italic, Hangul

«Areon»: A Latin and Hangul type family with translation contrast

«Areon» is a typeface supporting two scripts: Latin and Hangul. It can be to be used as a text typeface for editorial design. This project began by exploring the relationship between Latin and Hangul, and the subtle side of inverted and low contrast. It is a warm and lively typeface, with an informal touch, inspired by flat brush calligraphy. It is a typeface with a strong personality that shows a quirky and humanist look. It consists of three styles: Roman, Italic, and Hangul with six weights for each: from Light to Extra bold. Areon can be used for body text and headlines in a wide range of situations. Its name comes from the Greek mythology. In a Greek myth, Areon was a poet and musician whose name meant "enchanted" and "melodious".

«아리온»: 평행이동에 따른 굵기 차이의 원리를 적용한 한영 멀티 스크립트 서체

«아리온»은 한글과 라틴, 멀티스크립트 타이포그래피와 획의 평행이동 원리에 대한 관심에서 나온 실험의 결과물이다. 획의 평행이동에 의해 가로획과 세로획의 굵기 대비차가 거의 나지 않으면서 오히려 가로획이 일반적인 글자들에 비해 두꺼워 보이는 형태에 흥미를 가졌다. 가로획과 세로획의 미묘한 굵기 차이 안에 작은 납작붓 형태의 캘리그라피 느낌을 담아 휴머니스틱한 인상을 구현하고 싶었으며, 얇은 굵기에서 두꺼운 굵기까지 다양한 자족을 보여주고자 하였다. 나아가 같은 인상의 한글 서체도 동시에 제작하여 한글과 라틴 두 가지 버전을 서로 조화롭게 구성하고자 하였다. 단단하면서도 캘리그라피의 맛이 담겨 활기 넘치는 인상을 지닌 아리온은 로만, 이탈릭, 한글 총 세가지 세트로 구성되며 라이트에서 엑스트라볼드까지 각 여섯종의 글자가족을 이룬다. 아리온은 부리계열과 민부리계열의 형상이 적절하게 섞인 구조로 되어있으며 획에 특유의 디테일을 선명하게 남겨 필기체의 느낌이 두드러진다. 아리온은 본문 텍스트를 위한 용도로 제작되었으나 표제까지 다양한 용도에 적용이 가능하다.

The film is a po
tion of liberal d
past and impli
stars' unadorn
have been put
er over the title
simplicity: "Str
Post". These ar
intended as Lin

OJOURN

1,395,456,78

1,395,456,780

AWAR
AWARD **AWARD**

503

5037

Base 900: TYPE SPECIMEN

Dechlorination
THIN

Nonentangled
LIGHT

Pontifications
REGULAR

Reimplanting
MEDIUM

Bookmobiles
SEMIBOLD

Unprocessed
BOLD

Starchmaker
BLACK

BEGA, SABINA CHIPARĂ, DIANA OVEZEA

Blossom &
Pomegranate juice and fresh Basilic
printemps
DE LA MONTAGNE FLEURIE
autrichien
les baleines bleues dans les nuages
jolie fleur du jardin
RAWNALD GREGORY ERICKSON THE SECOND — STRFKR 2009
Flying Butterflies & Needles
flume
Papaye & Hibiscus

BILINGUAL LETTERING, TIEN-MIN LIAO

CONCERT
562-8972
Cosmetic
Interior
Compare
Smaragd
Mercury
Stilleto

BIZZARRINI, DIANA OVEZEA

BREE, JOSÉ SCAGLIONE & VERONIKA BURIAN

Bridge

— an editorial typeface —

BRIDGE CONSTRUCTION

o O

Head · Text

Take (the) Bridge for your Head-line.
Take (the) Bridge for your Subhead-line.

Take (the) Bridge for your text in xBold.
Take (the) Bridge for your text in Bold.
Take (the) Bridge for your text in Medium.
Take (the) Bridge for your text in Regular.
Take (the) Bridge for your text in Italic.

BRIDGE, MONA FRANZ

Britney typef

Ravishing
Light

Handson
Regular

Ceremor
Bold

Pompor
Ultra

BRITNEY, SABINA CHIPARĂ & DIANA OVEZEA

Nibbling on young seedlings

MAGNOLIOPSIDA

45 degrees above first leaflet

Rose

FEATURED THORN ON STEM

For arrangement and display

PETALS

THE CLIMBERS AND SHRUBS

Thorn

easily wedged into fingertip

अक्षरयोग
retrouvailles
ਛੋਲੇ ਕੁਲਚਾ
विश्वविद्यालय
tšellomängija
Quintillionth
ਮੁਸਕਰਾਇਆ
CHIKKI चिक्की ਚਿੱਕੀ

A chunky type family in Devanagari, Gurmukhi & Latin available exclusively from Mota Italic!

EXPERIMENT W

IMP
MO

THE MAIN D
ARE VERY BIG X

H THE REVERSED BRO

AUS
NST

GN FEATURES OF THE
EIGHT AND NARROW P

...er 1.0, was a transitional product, featuring an i...
...der system. Consumer releases of Mac OS X in...
...on API; many could also be run directly through...
...hed in 2001 with Mac OS X 10.0. Reviews were
...rformance. With Apple's popularity at a low, the
...w versions of their software for Mac OS X. Ars Te
...releases in retrospect as 'dog-slow, feature poo

* * * * * * * * * * *

f Mac OS X. Siracusa's review
ave gone from years of uncer-
ply of major new operating
ly shocked executives at Mic-
as fast file searching and im-
ad spent several years strug-
mance.

evolved, it moved away from
applications being added and
sic to be a key market, Apple
player and music software for
and GarageBand. Targeting
arkets, Apple emphasized its
cations such as the iLife suite,
ment through the Front Row
ri web browser.

e offered
MobileMe
an selling
tore.

ncluded modifications to the

Some applications
titlebar appearanc
of the interface, w

List of macOS versions a

Operating system

10.13	High Sierra
10.12	Sierra
10.11	El Capitan
10.10	Yosemite
10.9	Mavericks
10.8	Mountain Lion
10.7	Lion [note 1]
10.6	Snow Leopard
10.5	Leopard
10.4	Tiger
10.3	Panther
10.2	Jaguar [note 2]
10.1	Puma
10.0	Cheetah [note 3]

① ↑ Mess
Afterwards, users
US$19.99, or 10

Electrotyp
Battlegrou
Clannishn
Microelem
Acetylacete
Hypothala
Antiperson

DIN NEXT STENCIL, SABINA CHIPARĂ

خط مدينة دبي

A Typeface for the City of Dubai

ا ا ب ببـ ة ة تـ تتت ث ثث ج ججج ح ححح خ خخخ د د ذ ذذ ر ز زز س سسس ش ششش ص صصص ض ضضض ط ططط ظ ظظظ ع ععع غ غغغ ف فقف ق ققق ك ككك ل لل ل ممم ن ننن ه ههه و ى ى ي ييي لا لا

من الذكريات الباقيات، يا رضا، ليلة بتّها في خان محمود أحمد في ساحة البرج، بيروت. كنت برفقة شيوخ ثلاثة: جدّك بو نجم، وجارنا بو سليمان، وبو علي يوسف. القصة طويلة تبدأ بزيارة الشّيخين لجدك وهو يتعشّى على السطح لبحث أزمة الشرانق. أهل ضيعتنا ينتظرون اقبال موسم الشرانق لينعموا بزيارة بيروت للتبضع السنوي. وكان الموسم حسناً، فاستبشر الرجال، وفرحت النساء: ستنزل الى بيروت ولكن سماسرة الشرانق أرادوا فرض سعر لم يرض به المنتجون، اذ ترامى الى سمعهم ان أسعار الحرير في ليون، فرنسا، مرتفعة جداً، وهذا ظلم واستغلال. قرر المشايخ الثلاثة النزول الى بيروت ليفاوضوا التاجر الكبير، المشنوق ونسيت اسمه الأول وكانت دكانته في سوق البازركان. وبينما هم يتحدثون عن الشرانق وأزمتها، وعن غدوتهم سحراً الى بيروت، كنت اتوسّل

둥굴널쩍이
둥그스름히
둥둥방망이
둥투럭돼지
둥싯거리다
둥글레조개
둥글넙데데
둥근범꼬리

Kummerspeck

ON THE WATERFRONT 1954

The term rétro was soon applied to nostalgic French

1865

SPRING

(Diaphanous)

célèbre professeur

*In its curved & imperceptible fall, the sun sank low and changed form**

Rex!

Modern wine culture derives from the practices of the ancient

Preassign

Fact is a workhorse open sans serif type system inspired by the great Frutiger typeface. While the Regular style is slightly modernized but still quite close to Frutiger, changing the weight or width makes differences of the design more pronounced. The style range of Fact includes weights from Thin to Black and widths from Compressed to Expanded. Fact type system contains 48 upright styles with variations in width and weight and 8 italics of normal width.

A tribute to Adrian Frutiger (1928-2015)

252 FAUNE, ALICE SAVOIE (DESIGN)

ROXANE GATAUD (KERNING FONT MASTERING)

mo
KITC
mari
Japanese

Franz Sans

powerful & pleasant

Music 🎵 was my first love! I feel good 👍
Ice, ice ❤ baby! Birds 🐦 can fly so high
I'm a blackstar ★ Fly me to the moon ☾
Get up ↑ get down ↓ get funky, get loose
Loving 🖎 you 🖅 with my whole heart ♡
Need a dollar $ The photos 📷 on my wall
Sail on, Sailor ⚓ You are my sunshine ☼
Nightcall ▯ **Why don't you talk 💬 to me?**
Yeah, I'll keep on ✎ writing love letters ✉
Our house 🏠 in the middle of a street

powerful & pleasant goede smaak
MASSGETREU Heimatgefühl
cælum **çok iyi arkadaş** błogość
Paixão très chic magnifique

nnnnnnnnn

FRANZ SANS, MONA FRANZ

خط عناوين خاص بجريدة النهار

يا جبل ما يهزك ريح صلب وقوي، منحوت بدقة

ء آ اً أ أً ؤ إ إً ئ ئً ا ب ببة ة تتت ث ثثث ج ججج ح ححح خ خخخ د دً ذ ذً ر ز زً س سسس ش ششش ص صصص ض ضضض ط ططط ظ ظظظ ع ععع غ غغغ ف فقف ق ققق ك ككك ل للل م ممم ن ننن ه هه هه و وى ى ي ييي اً أ لا لاً لاآ لاأً لاإ لاإً ؟! 0123456789

العالم العربي نفض عنه غبار الظلم والقهر والأسى وهبّ واقفاً مطالباً بالحرية

ربيع العرب قد جاء أخيراً فكيف تجري رياح التغيير والى أين تشتهي السفن؟

Louise Nevelson[001] Eva Hesse[002] Bar
Georgia O'Keeffe[005] Sonia Delaunay
Lee Krasner[009] Helen Frankenthaler
Louise Bourgeois[013] Alma Thomas[014]
Yayoi Kusama[018] Carmen Herrera[019] J
Sobel[022] Chakaia Booker[023] Rosy Key
Shinique Smith[027] Lisa Corinne Davi
Anne Appleby[030] Jane Frank[031] Aurèl
Albizu[034] Tomma Abts[035] Elizabeth M
Deborah Remington[038] Ethel Schwal

258 JUNIOR, SELINA BERNET

ROMA • MILANO • NAPOLI
CATANZARO • GROSSETO
TORINO • PALERMO • BARI
PIACENZA • ALESSANDRIA
FORLI • CROTONE • TIVOLI
SANREMO • PESARO • PISA
MONCALIERI • FIUMICINO
BRINDISI • TRENTO • SIENA
ROMA • MILANO • NAPOLI
CATANZARO • GROSSETO
TORINO • PALERMO • BARI
PIACENZA • ALESSANDRIA
FORLI • CROTONE • TIVOLI
SANREMO • PESARO • PISA
MONCALIERI • FIUMICINO
BRINDISI • TRENTO • SIENA
ROMA • MILANO • NAPOLI
CATANZARO • GROSSETO
TORINO • PALERMO • BARI
PIACENZA • ALESSANDRIA
FORLI • CROTONE • TIVOLI
SANREMO • PESARO • PISA
MONCALIERI • FIUMICINO
BRINDISI • TRENTO • SIENA

懐石のコースもございます

おしながき 日本料理

新鮮なお造りに焼物と煮物を

車海老の天ぷら 栗きんとん

市場から直送の新鮮なお魚をご賞味ください

個室もご用意たします 白アスパラガス

日本酒も揃えております

茶蒸し 和風のカルパッチョ

鯛のあら炊き 手打ちのお蕎麦

江戸前寿司 百合根団子

サヨリの塩焼き 海胆焼き

甘鯛の飯蒸し 焼き鳥

ワイン・焼酎・ウィスキーその他

プロポーショナルかな書体

かづらき

ゆるしをこふうたをくちずさみ

अ आ इ ई उ ऊ ऋ ॠ ऌ ॡ ऐ ए
ओ ओ औ औ आ अं ॐ क ख
ङ च छ ज झ ञ ट ठ ड ढ ण त थ
न प फ ब भ म य र ल ळ व श ष
ह ळ क्ष ग़ क़ ख़ ग़ ज़ ड़ ढ़ फ़ य़
० १ २ ३ ४ ५ ६ ७ ८ ९ ? । ॥

अ आ इ ई उ ऊ ऋ ॠ ऌ ॡ ऐ ए
ओ ओ औ औ आ अं ॐ क ख
ङ च छ ज झ ञ ट ठ ड ढ ण त थ
न प फ ब भ म य र ल ळ व श ष
ह ळ क्ष ग़ क़ ख़ ग़ ज़ ड़ ढ़ फ़ य़
० १ २ ३ ४ ५ ६ ७ ८ ९ ? । ॥

KLABAUTER BLACK
LOWERCASE K

KLABAUTER BLACK, LOUISA FRÖHLICH

The One Piece of A
Young Women Ne

One of the most impo
American women ma
careers has nothing to
internships, or degrees
they choose to spend
one piece of advice th
women are never told
all the difference: The
of labor that often co
and motherhood has

ABCDEFGHIJ
KLAURAMPQ
UTVXYZ1246
26abcdefghij
orstuvxyz147
ABCDEFGHIJ
LMNOPQRST
VXYZ123456
zabcdenfghti
lopqrstuvxyz

Laura ht is an editorial typeface, it is an integral tool for magazine design where des ers require a wide choice of weights and variables for building functional typographi hierarchies and reading rhythms. Its narrow structure gives this typeface a high degr of legibility and performance. *The roman and italic are independent, both in lowerc and uppercase, so that the combination of the clear, direct and rounded square rom and the sharpened cancellaresca make it an expressive and polyphonic font system*

Lion Pleasure aka Louise Parnel

ceramic teeth

PORCELAIN, ENTIRELY HANDCRAFTED BY PERILOUS LANE

Precious porcelain stones

emeraudes

rubies, pearls, and diamonds

SHINE BRIGHT

Look at this cup that can hold the ocean

All that is gold does

SUNLIGHT! THE MOST PRECIOUS GOLD TO BE FOUND ON EARTH

Lionz

LISBETH THIN

A powerful conjurer, who had a bear for his mascot, thought he would like to go to the Moon. He had his hands tied up and a rope fastened around his knees and neck. Then he sat down at

LISBETH LIGHT

A powerful conjurer, who had a bear for his mascot, thought he would like to go to the Moon. He had his hands tied up and a rope fastened around his knees and neck. Then he

LISBETH REGULAR

A powerful conjurer, who had a bear for his mascot, thought he would like to go to the Moon. He had his hands tied up and a rope fastened around his knees and neck.

LISBETH SEMIBOLD

A powerful conjurer, who had a bear for his mascot, thought he would like to go to the Moon. He had his hands tied up and a rope fastened around his knees

LISBETH BOLD

A powerful conjurer, who had a bear for his mascot, thought he would like to go to the Moon. He had his hands tied up and a rope fastened around

अक्षरलोपनकला

Zweckmäßigkeit

एक्सिलसिट कंटेंट

Kvĕtiny tulipánu

Lini लिनी from Mota Italic

LL Unica77 **Greek**

Η LL Unica77 είναι η αναβίωση της Unica και βασίστηκε στα πρωτότυπα σχέδια της δεκαετίας του 1970. Δημιουργήθηκε σε συνεργασία με τους Maurice Göldner και Christian Mengelt (που ήταν μέλος της Ομάδας '77 και εξουσιοδότησε αυτήν την **εφαρμογή της Unica**) για το ελβετικό χυτήριο Lineto. Σύμφωνα με τον σχεδιαστή τύπου, Albert-Jan Pool, η Lineto (σε αντίθεση με τη **Monotype**) **καταβάλλει τέλος αδείας στην ομάδα '77. Οι αλλαγές στο Haas Unica περιλαμβάνουν πρόσθετο σήμα Euro, με κατακόρυφους τερματικούς σταθμούς όπως στο Univers και στη Neue Helvetica. Αυτή η έκδοση χρησιμοποιεί στιλιστικές εναλλακτικές λύσεις για να προσφέρει μια έκδοση με στρογγυλές κουκκίδες**

LL UNICA 77, GREEK BY IRENE VLACHOU, DESIGNED BY CHRISTIAN MENGELT/TEAM'77, ASSISTANCE BY MAURICE GÖLDNER/LINETO

LO-RES

9s/10s/20s

American Computing
DIGITIZATION
Audio Compression Algorithms
Megapixels
Sequoia Supercomputer System

Operating System
Floating-Point Operations Per Second
Preferences
Internet Protocol Address

Semiconductors
MEGAPIXEL
SYSTEM
psychoacoustics

Magasin

Brownies & Cup Cakes!

À la France

Electroencefalografistas

Wolfgang

Gottlieb·Mozart

Tipogràfics

The world in few words

MAGNET

G &

[(#?*!&)]
0123456789
abcdefghijklm
nopqrsßtuvwxyz
ABCDEFGHIJKLM
NOPQRSTUVWXYZ
NOPQRSTUVWXYZ
ABCDEFGHIJKLM
nopqrsßtuvwxyz
abcdefghijklm
0123456789
[(#?!&)]*

Thin and *Thin Italic*

Regular and *Regular Italic*

Bold and *Bold Italic*

Black and *Black Italic*

abcdefg
hijklmn
opqrstu
vwxyz

MAGNET, INGA PLÖNNIGS

MAIOLA, VERONIKA BURIAN & JOSÉ SCAGLIONE
GREEK: IRENE VLACHOU & GERRY LEONIDAS
CYRILLIC: MAXIM ZHUKOV

A rock fo
an iso
scenic, o
tacular su
outcr
formation
ally the
of weath

mation is
ated,
spec-
face rock
p. Rock
are usu-
result
ring and

For her journey to Jerusalem, Makeda took

camels

መከዳ መልከ ፌደል

Schmuckstücke

סוגים שונים של בשמים וזהב

spices

ወደ ኢየሩሳሌ ስትሄድ የከበረ ድንጋይ፤መርቄ፤ሻቱ

תכשיטים רבים

and precious stones

SO/SU syllable

Maroni is a font family for the Afáka syllabary. It has been created for the translation of Ndjuka archives written with the Afáka writing system. **Maroni Regular** has been drawn for a lecture use. **Maroni Demi** is adapted for syllables translation. The weights fit with the **Fedra** typeface of Peter Bilak. According to the handmade glyph's form's variations of the archives the **Maroni** typeface family propose two stylistic sets.

Maroni Regular

da a opo wa(n) sitali. ☀ a(n)ga faya
« Then he made appear a star. ☀ with fire. »

Maroni Demi

feifi tenti na sigisi

taki foe a b c

te joe sabi en da(n) ju

sabi taki Djoeka

« Fifty-six symbols of the A.B.C.
When you know this, then you know (how) to speak Ndjuka »

MARONI, EMILIE AURAT

N.º 2018

"Fancy gloves, though, wears old Macheath, babe. So there's never a trace of red."

MESSER

ABCDEFGHIJKLMNOPQRSTUVWXYZ
abcdefghijklmnopqrstuvwxyz0123456789

ABCDEFGHIJKLMNOPQRSTUVWXYZ
abcdefghijklmnopqrstuvwxyz0123456789

ABCDEFGHIJKLMNOPQRSTUVWXYZ
abcdefghijklmnopqrstuvwxyz0123456789

Francisco **New Y**
yo London *Phila*
Paulo **Amsterda**
ano Ürümqi **Mu**
kjavík **Taipei** Bar
ago *Beijing* Mex
os Angeles **Syd**
a **Berlin** *Bangko*
aneiro **Montreal**
en–Düsseldorf Is

SIGNATURE
Combinations
Universal Stencil →

WITH MONOLINA YOU CAN EASILY COMBINE OUTLINES WITH STENCIL & SHADOWS

Banãnâ 8¢
Marmellade
ROUND & NIB PEN
Atramentová machuľa

©MONTIAC
€₡₤£$¥₿Ł
Tectónica
№ 123560
ÁĂÂÄÀĀÅÃ
Formulae
#8÷4=90%
UPRIGHT

ROMA MILANO
ACIREALE BO
LUCA CHIETI
PADOVA RAV
MESSINA VELLE
CATANIA BAR
BOLOGNA LU
AREZZO TREV

MONTECATINI, LOUISE FILI, RACHEL MICHAUD, NICHOLAS MISANI

here is a certai

hat it wa

s TALENTS *of* RIDICU

t pleaded excuse fo

uch the rathe

NEW YORK

that nasty wee

determinate

ID THE SPAN

nd smiled at her apprehensio

ands *of an* inform

MOROUSLY IS THE VERY REASO

MRS EAVES, ZUZANA LICKO

Multi

Multi™ is a versatile sans serif typeface family designed for editorial design, on paper and screen, presented in two optical sizes: **Multi Display** for titles and **Multi Text** for text.

Designed by Laura Meseguer

MultiDisplay 7 weights and 2 styles

| Thin | Light | Regular | Medium | Bold | ExtraBold | Poster |

| Thin Italic | Light Italic | Regular Italic | Medium Italic | Bold Italic | ExtraBold Italic | Poster Italic |

MultiText 3 weights and 2 styles

| Regular | SemiBold | Bold | Regular Italic | SemiBold Italic | Bold Italic |

MULTI-SCRIPT LETTERING, NOOPUR DATYE

NASHVILLE, CYMONE WILDER

لن يكن أحدنا حتى نتحرر جميعاً

...en uns ist frei solange nicht alle frei
...Lazarus

NICHT OHNE MEINEN GLAUBEN, GOLNAR KAT RAHMANI

289

NEW CZECH LETTERING, PETRA DOČEKALOVÁ

सभी करैक्ट्स को आप टंकित करते हैं, अस्थायी तौर पर इलैक

सभी व्यक्तिगत कम्प्यूटर-आधा

देवनागरी

को मनमाना रूप देने की प्रक्रिया तक को! सभी व्यक्तिगत कम्प्यूटर-आधारित शब्द सं

चिप्पड पर अवस्थि

भीतरी अवयव इलैकट्रॉनि

काल, গাঢ় ধূসর, গোলাপী, লাল, নীল, বাদামী, সাদা

:একনজড়ে সেটটির কারিগরি বৈশি

বাংলা

টেকনোলজি টেকনোলজি টেকনোল

ইংরেজি বাংলা অভিধ

সাড়ে ১৪ঘন্টা টকটাইম এবং একবার ফুল চার্জ দিয়ে আপনি ৪০ঘন্টার অডিও চালাতে

ଓଡ଼ିଆ

ଓଡ଼ିଆ ଭାଷା ଓଡ଼ିଶାର ପାଖାପାଖି ଅନେକ ରାଜ୍ୟରେ କୁହାଯାଏ । ପଶ୍ଚିମବଙ୍ଗର ମେଦିନ
ଆହୁରି ଅନେକ ଅଞ୍ଚଳ, ଝାଡ଼ଖଣ୍ଡର ସିଂହଭୂମି ଜିଲ୍ଲା, ଆନ୍ଧ୍ର ପ୍ରଦେଶର ଶ୍ରୀକାକୁଲମ, ବିଜ
ବିଶାଖାପଟନମ ଜିଲ୍ଲା, ଛତିଶଗଡ଼ର ପୂର୍ବ ଜିଲ୍ଲା ଓ ନାଗପୁରର ଅଞ୍ଚଳରେ ବହୁଳ ଭାବରେ
ଏହାଛଡ଼ା ବେଙ୍ଗାଲୁରୁ, ହାଇଦ୍ରାବାଦ, ପଣ୍ଡିଚେରୀ, ଚେନ୍ନାଇ, ଗୋଆ, ମୁମ୍ବାଇ, ଜାମସେଦପ
ରାୟପୁର, ଅହମଦାବାଦ, ଦିଲ୍ଲୀ, କଲିକତା, ଖଡ଼ଗପୁର, ଗୁଆହାଟୀ, ପୁନେ ଓ ସିଲଭାସା ଆ
ଓଡ଼ିଆଭାଷାର ମୂଳ ଉତ୍ସ ହେଉଛି ଗୁଣ୍ଫାଲେଖ । ୨୦ହଜାର ବର୍ଷ ତଳେ କଳାହାଣ୍ଡି
ମିଳିଥିବା ଚିତ୍ର, ନୂଆପଡ଼ାର ଯୋଗୀମଠରୁ ୧୦ହଜାର ବର୍ଷ ତଳର ମିଳିଥିବା ଚି
ଝାରସୁଗୁଡ଼ାର ବିକ୍ରମଖୋଲରୁ ମିଳିଥିବା ୩୫୦୦ବର୍ଷ ତଳ ଗୁଣ୍ଫାଲିପି ହେଉଛି ଓଡ଼
ମୂଳ ଆଧାର । ଯୋଗୀମଠର ଚିତ୍ରଲିପିରେ ନାଲଙ୍ଗୀ ରଙ୍ଗରେ ଲିଖିତ "O" ଲିପି
ଓଡ଼ିଆ ସମେତ ସମସ୍ତ ଭାରତୀୟ ଲିପିମାଳାରେ ଅବିକଳ ଭାବରେ ବ୍ୟବ

> **Noto Sans Oriya Variable has been designed and**
> **engineered by Amélie Bonet and Sol Matas, a team of**
> **two independent type designers.**

୨୦ ଫେବୃଆରୀ ୨୦୧୪ ତାରିଖ ଦିନ କେନ୍ଦ୍ର ସରକାର ଓଡ଼ିଆ ଭାଷାକୁ ଶାସ୍ତ୍ରୀୟତାର
ଦେଇଥିଲେ ଓ ମାର୍ଚ୍ଚ ୧୧ତାରିଖ ଦିନ, ଏ ନେଇ ଗାଜେଟ ନୋଟିଫିକେସନ ଜାରି କରୁ
ଏହି ମାନ୍ୟତା ପାଇବାରେ ଓଡ଼ିଆ ହେଲା ଷଷ୍ଠ ଭାଷା । ୨୦୧୪ ମସିହା ମାର୍ଚ୍ଚ ୧୧ତାରିଖ
ଭାଷାକୁ ଶାସ୍ତ୍ରୀୟତାର ମାନ୍ୟତାପାଇଁ ରାଜପତ୍ର ବିଜ୍ଞପ୍ତି ଜାରି କରାଯାଇଥିବାରୁ, ୨୦୧୫
ଦିନଟିକୁ ଶାସ୍ତ୍ରୀୟ ଓଡ଼ିଆ ଭାଷା ଦିବସ ରୂପେ ପାଳନ କରିବାପାଇଁ ଓଡ଼ିଶା ସରକା
ଓଡ଼ିଆ ଏକ ଭାରତୀୟ ଭାଷା । ମୂଳ ଓଡ଼ିଆ ଭାଷା ପାଲି ଓ ଔଦ୍ର୍ୀ ପ୍ରାକୃତରୁ
ହୋଇଥିବା ଭାଷା ବିଜ୍ଞାନୀମାନେ ପ୍ରମାଣ ଦିଅନ୍ତି, ଏହି ଭାଷା ଭାରତରରେ ୨,
ଅଧିକ ବର୍ଷ ଆଗରୁ କୁହାଯାଉଥିଲା ଓ ବୌଦ୍ଧ ଧର୍ମର ତିପିଟକ ଓ ଜୈନ ଧର୍ମ
ଭାଷା ଥିଲା । ଓଡ଼ିଆ ବାକି ଭାରତୀୟ ଭାଷାମାନଙ୍କ ତୁଳନାରେ ଖୁବ କମ ପ
ଆରବୀ ଭାଷାଦ୍ୱାରା ପ୍ରଭାବିତ ।

> **The new version of Noto Sans Oriya has a wide range**
> **of weights and widths; from Thin to Black through**
> **Regular and Bold; from Normal to Extra Condensed**
> **through Condensed. Noto Sans Oriya is available as**
> **a Variable font, allowing access to all the weights and**
> **widths in between the 12 pre-defined styles.**

କ କ କ କ କ କ କ କ କ କ କ କ

Noto Sans Oriya is made of 4 weights and 3 widths.

NOTO SANS ORIYA, AMÉLIE BONET & SOL MATAS 293

WORD

Shortword

ШЕРЕМЕТЬЕВО

етимологічно

the earliest Asturian texts

Flight № 1253

DER HERAUSGEBER

Cada idioma té el seu

Покровский

Murr geheißen

Латиниця стала основою

§79. Οὐρανικόληκτα καὶ χειλικόληκτα, καταληκτικὰ εἰς -ξ, -ψ, -ς, μονόθεμα

ΜΕΡΟΣ ΠΡΩΤΟΝ
ΦΘΟΓΓΟΛΟΓΙΚΟ
ΚΕΦΑΛΑΙΟΝ Α΄
ΦΘΟΓΓΟΙ ΚΑΙ ΓΡΑΜΜ

§ 1. Τὰ γράμματα τῆς ἀρχαίας γλώσσης εἶναι 24, τὰ ἴδια μὲ τὰ 24 γρ νέας Ἑλληνικῆς. Ἀλλὰ ὑπὸ τῶν ἀρχαί δὲν ἐπροφέροντο πάντα τὰ γράμματα ὣς ὅπως τὰ προφέρομεν ἡμεῖς οἱ νέοι ἀ τοῦτο πολλάκις ὁ ἴδιος φθόγγος τῆς ν (π.χ. ὁ φθόγγος ι) φαίνεται παριστα διαφόρους λέξεις ἢ εἰς διαφόρους συλ δίας λέξεως μὲ διάφορα γράμματα (π η **ἤ** τὸ υ): ῥίς, μῦς, μυστήριον.

Σημείωσις. Τὸ ἀρχαιότατον ἀλφάβητον περιελάμβανεν ἓν ἀκόμη

Regular
Regular Italic
Bold
Bold Italic

The spectacle before us was indeed sublime.

Apparently we had reached a great height
in the atmosphere, for the sky was a dead black,
and the stars had ceased to twinkle.
By the same illusion which lifts the horizon
of the sea to the level of the spectator on a hillside,
the sable cloud beneath was dished out,
and the car seemed to float in the middle
of an immense dark sphere, whose upper half was
strewn with silver. Looking down into the dark gulf
below, I could see a ruddy light streaming
through a rift in the clouds.

La Falaise
Les vrilles de la vigne
golden
REINE, LOFOTEN, NORWAY

Dans la température liquoreuse d'une sieste sauvage, l'œil s'égare sous les rameaux vibrants. Bercé par le bouillonnement chaud d'un vent sous la trame, le mirage

I'm the luckiest palooka alive

William H Macy
the charmed li
a character a

Ronnia, Veronika Burian & José Scaglione

LA ROSA DE FO[C]

ABCDEFGHIJK
ÑOPQRSTUVW
ÁÀÄÉÈËÍÌÏÑ
ÓÒÖÚÙÜ

A CUSTOM TYPEFACE
FOR THE CREDIT TITLES
OF **THE ROSE OF FIRE**
A DOCUMENTARY ABOUT
BARCELONA BY MANUEL HU[ERGA]
DESIGNED WITH **NUEVE OJO[S]**

INSPIRED BY THE STREET N[AME]
PLATES OF BARCELONA ST[REETS]

ROSA DE FOC, LAURA MESEGUER

EXTRA!

♠LITERARY DAILY QUOTES

VOL. NO. XXXVIII MONDAY SEPTEMBER 9 PRICE 10¢

♥♥♥

"A LITTLE MAGIC CAN TAKE YOU A LONG WAY."

☞ROALD DAHL

A Á Ă Â Ä À Ā Ą Å Ǻ Ã Æ Ǽ B C Ć Č Ç Ĉ Ċ D Ď Đ Ð
E É Ĕ Ě Ê Ë Ė È Ē Ę F G Ğ Ĝ Ģ Ġ H Ħ Ĥ I IJ Í Ĭ Î
Ï İ Ì Ī Į Ĩ J Ĵ K Ķ L Ĺ Ľ Ļ Ł M N Ń Ň Ņ Ŋ Ñ O Ó Ŏ Ô
Ö Ò Ő Ō Ø Ǿ Õ Œ P Þ Q R Ŕ Ř Ŗ S Ś Š Ş Ŝ Ș ẞ Ə
T Ť Ţ Ț U Ú Ŭ Û Ü Ù Ű Ū Ų Ů Ũ V W Ẃ Ŵ Ẅ Ẁ X Y
Ý Ŷ Ÿ Ỳ Z Ź Ž Ż Δ Ω μ π 0 1 2 3 4 5 6 7 8 9 ₀₁₂₃₄₅₆₇
₈₉ 0123456789 0123456789 0123456789 AON ½ ¼ ¾ *
\ ` ˙ ¨ ; , ¡ ¿ # . , ? ˀ " " ; : / _ ˏ o { } [] () ⁽ ⁾ — – - - « » ‹ › „ "
" ' ' , ¢ ₵ $ € ƒ £ ₼ ₹ ₤ ¥ • / = ‗ ‾ + − × ÷ ± ≠ > < ≥ ≤ ± ≈ ~ ¬
∅ ∞ ∫ Ω ∆ ∏ ∑ √ ∂ μ % ‰ ⁺ ⁻ ↑ ↗ ↠ ↡ ⇃ ↯ ↰ ↔ ↕ ◇ ☜ ☞
♠ ♣ ♥ ♦ @ & ¶ § © ® ℗ ™ ° | ¦ † ℓ ‡ e ^ ˉ ˊ ˇ ˋ ˚ ˙ ˝ ˜ ¸ ˛

WALTER GROPIUS

♥♥♥

"WHEREFORE ART THOU ROMEO?"

WILLIAM SHAKESPEARE

№ÄfjǽR&

ഉഫീദുംബ

श्रद्रअद्धमात्र

ਲਕ੍ਮਯਬ੍ਹਾਂਗਿੰਦ੍ਹਿ

છાજીયદ્દલંકાં

ಜ್ಞಠ್ಥಿಕಢೋ೯

Sama Multi-script | Available in 6 weights
Supports Devanagari, Kannada, Latin, Gujarati,
Gurmukhi and Malayalam

SAMA, NOOPUR DATYE, MAITHILI SHINGRE,
SULEKHA RAJKUMAR, DIVYA KOWSHIK,
UNNATI KOTECHA, VAIJAYANTI AJINKYA
MRUNMAYEE GHAISAS

설경산수도
설맞이하다
설장구놀이
설구이하다
설령개현삼
설더구하다
설립상구조
설설고사리
설악가라목
설리번원칙

SEOL SANS, MINJOO HAM, AKIRA, KOBAYASHI, ADRIAN FRUTIGER, MONOTYPE STUDIO

Silverspoon

copperplate, silver knife, gold plate

Lemon-Rosemary

established 2013

527.64%

Scented Candles — only $3.89

summer vacation

COFFEE

Freshly brewed 2 times/day

EINDEXAMEN

awesome and available at futurefonts.xyz

last chance

to buy the *discounted* 0.9 version of

Silverspoon

源ノ角ゴシック

Source Han Sans

Source Han Sans は、アドビと Google が協力して開発したオープンソースの Pan-CJK 書体ファミリーです。デスクトップでの利用には Typekit から入手可能で、さらに GitHub からも入手できます。評価の高い Source Sans ファミリーのラテン文字、ギリシャ文字、キリル文字も含まれます。ファミリーのそれぞれのウエイトにつき、(OpenType 形式が対応可能な最大数) 65,535 のグリフ (字体)、ファミリー全体で、およそ 50 万のグリフをカバーします。

この新書体に課せられた条件は厳しいものでした。前記の幅広い範囲の言語をカバーし、それら言語を用いる地域ごとのグリフのバリエーションにも対応する必要がありました (ひとつの漢字に対して、4 つの地域別のバリエーションが必要となる場合があります)。従来のように紙に印刷するだけでなく、現在多く利用されるタブレットやモバイルデバイスで表示する場合の読みやすさを向上させることが重要課題でした。

東京を拠点とするフォント開発チームのシニアデザイナーである西塚涼子は、新しい書体ファミリーの基本デザインを作成しました。西塚涼子によるデザインは、シンプルで線幅の太さがかなり均質な画線で構成される、比較的現代的な様式です。その結果、タブレットやスマートフォンなどの小型デバイスでも読みやすくなります。そのシンプルさにもかかわらず、伝統的なサンセリフの書体デザインに固有の優美さも残しています。そのため、ソフトウェアのメニューにあるような単一行の語句、短いテキストから、電子書籍などでの長い本文テキストにいたるまで、十分な読みやすさを確保します。

SOURCE HAN SANS, RYOKO NISHIZUKA, JOO-YEON KANG, PAUL D. HUNT, SANDOLL COMMUNICATIONS, AND SOO-YOUNG JANG. FROM ADOBE ORIGINALS

兰陵美酒郁金香,
Simplified Chinese

蘭陵美酒鬱金香,
Traditional Chinese

蘭陵の美酒はチューリップの香り、
Japanese

울금향 그윽한 난릉의 좋은 술을
Korean

明朝体Pan-CJKフォントを実現。

源ノ明朝は、アドビフォントとしては2番目のPan-CJK書体ファミリーであり、Serif書体として源ノ角ゴシックと対をなすものです。どちらのファミリーも、東アジアに住む15億人の人々のための、統一された書体デザインへのニーズに応えるためにリリースいたしました。源ノ明朝は、東アジアで用いられている4つの言語（簡体中国語、繁体中国語、日本語、および韓国語）で必要な文字をサポートします。それぞれ7つのウェイトを持ち、各ウェイトに含まれる65,535の字体は、各言語の多様性を尊重するとともに、共通化できる部分については積極的にデザインの一貫性を高めるようデザインされています。

流
Traditional Chinese

流
Japanese/Korean

流
Simplified Chinese

SOURCE HAN SERIF, RYOKO NISHIZUKA,
WENLONG ZHANG, SOOHYUN PARK, YEJIN WE
& DONGHOON HAN

سهولة القراءة

خط خاص لشركة سوني العالمية

ا ا ب ببب ة ـة ت تت ث ثث ج ججج ح ححح
خ خخخ د ـد ذ ـذ ر ـر ز ـز س سسس ش ششش
ص صصص ض ضضض ط ططط ظ ظظظ ع
ععع غ غغغ ف ففف ق ققق ك ككك ل للل
م ممم ن ننن ه ههه و ـو ى ـى ي ييي لا ـلا

من الذكريات الباقيات، يا رضا، ليلة بتّها في خان محمود أحمد في ساحة البرج، بيروت. كنت برفقة شيوخ ثلاثة: جدّك بو نجم، وجارنا بو سليمان، وبو علي يوسف. القصة طويلة تبدأ بزيارة الشّيخين لجدك وهو يتعشّى على السطح لبحث أزمة الشرانق. أهل ضيعتنا ينتظرون اقبال موسم الشرانق لينعموا بزيارة بيروت للتبضع السنوي. وكان الموسم حسناً، فاستبشر الرجال، وفرحت النساء: ستنزل الى بيروت ولكن سماسرة الشرانق أرادوا فرض سعر لم يرض به المنتجون، اذ ترامى الى سمعهم ان أسعار الحرير في ليون، فرنسا، مرتفعة جداً، وهذا ظلم واستغلال. قرر المشايخ الثلاثة النزول الى بيروت ليفاوضوا التاجر الكبير، المشنوق ونسيت اسمه الأول وكانت دكانته في سوق البازركان. وبينما هم

Walter Gropius

unity of crafts

underlying idea

idealism

Gesamtkunstwerk

BAUHAUS CURRICULUM

manifesto of 1919

ШКОЛА

ВАСИЛИЙ КАНДИНСКИЙ

Баухаус в СССР

типографика

experimental laboratory

Alber
er wh
ily in t
in **life**
She p

was

work

extiles

with

oduce

Çağdaş sanatın önde gelen isimlerinden Gülsün Karamustafa, 1970'li yıllardan beri içinde bulunduğu toplumsal hayatı, insanları yansıtarak üretiyor sanatını. Kendisiyle SALT'taki sergisin den ve sanat hay hakkında konuş fırsatı bulduk. tatlı bir kadın Gülsün Hanı evine kabul İşte pek h öportajı

Ten 明朝 {cho}

粉雪が巻き上がり

貂 "Marten!"

Adobe Originals
TenMincho

*min
st Tk
ℓℓℓℓℓℓ
あ朝 てん

TEN MINCHO, RYOKO NISHIZUKA & ROBERT SLIMBACH

RHYTHMIC
@ND FLUID
{TYPE.FACE}
LATINGANG
+ABC & XYZ
4.20 * 18:57†
¥EN3/FLOW
JUT? POET
#LET'S_GO

وإج

düe

Arabic typeface designed in naskh style for a German logotype.
German typeface: Tetraktys

ар-
тво

· 👑 · 31 · 👑 ·

◆ АЛЕКСЕЙ КАРА-МУРЗА ◆
«Варварство постоянно
влезает в цивилизацию»

· 👑 · 40 · 👑 ·

◆ РОБЕРТ КУПЕР ◆
«Материальная сторона
ивилизации есть секретное
варварство»

· 👑 · 46 · 👑 ·

◆ ЭДГАР МОРЕН ◆
О европейской
традиции варварства

· 👑 · 53 · 👑 ·

◆ ЛЕВ ГУДКОВ ◆
«Сам себя варваром
н
не будет»

· 👑 · 62

◆ АЛЕКСАНДР
О том, как пе
национальну

· 👑 · 74

◆ МАКСИМ
«Варварст
катастроф
разрыв преемс

· 👑 · 84

◆ МАКСИМ С
О прои
внутреннег

ПОЭЗИЯ → · 👑 · 13

◆ АБДЕЛЬЛАТ
Царст
варва

Zarathustra

is a modern revival of a typeface from the early XXe, designed by belgian artist Georges Lemmen for the monumental book Also Spartch Zarathustra (1908).

Zangezi
light
semilight
regular
bold
italic
sans

Colophon
Onomatopee 184

Author, Editor and Graphic Designer
Yulia Popova
www.yulia-popova.com
www.instagram.com/yuuuuuuuuulia/

Supervision
Prof. Wim Westerveld
Matthias Hübner

Copyeditor
Ekaterina Borisova

PRODUCTION
Published
Onomatopee Projects
Lucas Gasselstraat 2a
5613 LB Eindhoven
The Netherlands
www.onomatopee.net

Print
KOPA
Industrijos g. 12, Biruliškių km., Karmėlavos sen., Kauno raj., LT54469 Lithuania

Cover
Digital print
Matt lamination

Paper inside
Munken Pure

Fonts
Geometria by Gayaneh Bagdasaryan, Vyacheslav Kirilenko.
Released 2013.
Font is provided by Brownfox.

Maiola by Veronika Burian.
Released 2010.
Via Adobe Fonts.

ISBN: 978-94-93148-32-1

Special thanks
Alphabettes,
Axel von Wuthenau,
Dan Reynolds,
Elisha Cohen,
Florian Hardwig,
Irina Popova
Jan Middendorp,
Oliver Meier,
Sonja Knecht,
Typostammtisch Berlin,
Verena Gerlach.

Photo credits
Page 6:
Gayaneh Bagdasaryan by Vika Bogorodskaya;
Veronika Burian by Norman Posselt;
Petra Dočekalová by Tomáš Princ;
Roxane Gataud by Kathryn Solnsteva.

Page 7:
Laura Meseguer by Sophie Eekmann;
Alice Savoie by Louis Lepais;
Liron Lavi Turkenich by Liron Erel.

Follow this project
www.instagram.com/womenintype/

Copyright © 2021 Yulia Popova
All rights reserved. No part of this publication may be reproduced, distributed, or transmitted in any form or by any means without the prior written permission of the publisher.
Second edition.
First published in 2020.
Printed in Lithuania